FRACKVILLE
VOLUME II

IMAGES of America

Frackville charter

To the Honorable the Court of Quarter Sessions of Schuylkill County. The petition of the undersigned inhabitants of the town of Frackville in said County of Schuylkill respectfully represents that the said town contains a collection of houses collocated after a regular plan in regard to streets and alleys and that the petitioners reside within the limits thereof as hereafter set forth and described and that the same contains not more than two hundred free holders, that they are desirous that the said town should be incorporated by the style and title of the Borough of Frackville according to the following boundaries.

Viz: Beginning at the Southeast corner of the Borough of Gilberton thence south six degrees thirty minutes east one hundred and fifty-nine perches to a corner thence north eighty three degrees east, one hundred and seventy perches to a corner, thence north eighty and one fourth degrees east, one hundred and twenty perches to a corner, thence south nine and three fourths degrees east two hundred and fifty perches to a corner, thence south eighty and one half degrees west three hundred and fifty perches to a corner thence north nine and one fourth degrees west, twenty perches to a corner, thence south eighty one and one fourth degrees four hundred and six perches to a corner, thence north thirty seven and one half degrees west thirty five perches, thence south seventy five and one half degrees west twenty two perches to a corner, thence north six degrees west fifty five perches to a corner thence south eighty two and three fourths degrees west, three hundred and two tenths perches to a corner thence north. Sixteen and one half degrees west two hundred and forty two and seven tenths perches to a corner thence north eighty one degrees east, one hundred and eighty perches to a corner thence north thirty seven and one half degrees west twelve perches at or near the southwest corner of the aforesaid Borough of Gilberton, thence north eighty one degrees fifty seven minutes east three hundred and ninety eight perches to a corner thence north eight degrees west twenty perches to a corner thence north eighty two degrees east three hundred and ninety seven perches to the place of beginning a plot or draft whereof accompanies this petition.

The petitioners further represent that they are a majority of the free holders residing within said limits. They therefore pray the Court to cause this their application to be laid before the Grand Jury of said County and if a majority of said Grand Jury after a full investigation shall certify to the Court that the provisions of the Act of Assembly in such case made and provided have been complied with and that it is expedient to grant the prayer of the petitioners that the Court will confirm said judgment and that upon compliance with the several conditions required in said Acts of Assembly the said town of Frackville may thenceforth be deemed an incorporated Borough by the style and title aforesaid entitled to all the rights and privileges provided in said Acts and they will ever pray.

Daniel Frack
Samuel Frack
D. B. Frack
J. D. Hadesty
F. J. Keffer
E. Riegel
H. H. Price
X (John Harris)
E. Leymeister
H. D. Berkheiser
W. S. Moorhead
J. F. Price
Richard Chappel
Paul Daubert
H. Seitzinger
Issac Kalbach
Wm. Cowen
Jacob Katz
Stephen Wachter
Richard Morgan
C. M. Stuart
Jas. D. Lawrence
Christian Reese
X (Uriah Maderia)
Reuben Wagner
James Fatkin
Benjamin
Isaac Jenkins
Wm. Evans
Ralph R. Greener
Alfred Seitzinger
Wm. Evans, Jr.
X (James Wentzel)
Samuel Yoder
W. E. Deisher
X (Joseph Nelms)
George Ruchler
Fred C. Sanner
Peter Sanner
Samuel Snyder
Jacob Rodrian
Theabald Leiser
William Hadesty
Anthony Crush
X (John Cowen)
Robert McNeilley
Wm. A. Bretz
Matthew Beddon
J. A. Beatty
John Weistner
Winfield Hoffman
Jos. Spurr
Benjamin Morgan
Bernard Leddy
P. C. Myers
Thos. J. Myers
Geo. Berdanier
Wm. S. Groff
W. R.
David Thomas
James Thomas
John Thomas, Jr.
Wm. Guynn
Jno. G. Berk
John Richards
Wm. Fennel
James Garvis
Theodore Moyer
James Blackwell
Wm. Richards
Justice of Peace
Henry C. Wagner
William Wagner
Jacob Rauch
Wm. B. Hillary
X (Richard Ellis)
X (Michael McGragh)
Wm. Harris
Jacob
Thos. Robertson
X (Thomas Rilley)
X (Anthony O'Malley)
Edwin Timmins
John Tregise
Henry Garland
Thomas Trezise
X (Peter Hoffman)
John A. Copeland
J. J. Heilner
Frederick Thomas
Henry Schofield
Josiah Penrose
Charles Miller
George Weir
D. W. Troutman
Thos. Beddow
William Taylor
John Bateman
Wm. Tayler
Wm. Bassett
Frederick Smith
William Wortsh
Thomas Evans
Enoch Roberts
Wm. F. Payne
Philip Merkel
George J. Hyde
Daniel Yoder
Percival Zimmerman
X (Jacob Watkins)
Frederick Peglow
X (Henry Parry)
John F. Barth
Peter Yoder
David Crawford
William F. Reber
John Bartosch
William H. Schaefer
Gottfried Frielli
Walter R. Nice
Jas. B. Haughton
S. M. Flowers
F. M. Steinwich
F. K. Rick
James Stewart
Robert Stewart
Levi Heortzag
Rudlof
Daniel Dillman
J. M. Hadesty
W. E. Seitzinger
Daniel Seitzinger
John O. Malloy
Samuel Harris
George Bastian
S. C. Urich
J. W. Hesser
J. Brassington
Henry Wagner
Samuel Berdanier
X (John Eckes)
James Price
Hamilton Seitzinger
John F. Harris
Jacob Rubrecht
Nicholas Stupsky
John Young
George Young
Wm. Anspach
Joseph H. Long
John F. Becker
Louis T. Boehmer
George Summers
Thomas Breedon
William Bassett
Thomas Campbell
X (William Drike)
Wm. F. Brocious
X (Owen Mowery)
Wnfld. Christian
X (Henry Owens)
Franklin Klees
William Bronis
Wm. Hickman
X (Christian Eckert)
William Wallace
Lawrence Mangam
William Ball Heim
Henry Parton
John Davis
Michael See
Philip Hahn
John M. Thomas
William Stewart
Henry Dudley
John Seddon
William Hodgert
Thomas Forter
John O'Holloran
James Harris
John Weisflog
Thomas Phillips
J. P. Keantour
W. Kuhn
J. Brightbill
Thomas Saltes

IMAGES
of America

FRACKVILLE
VOLUME II

Lorraine Stanton

Copyright © 1999 by Lorraine Stanton.
ISBN 9781531601317

Published by Arcadia Publishing
Charleston, South Carolina

Library of Congress Catalog Card Number applied for.

For all general information contact Arcadia Publishing at:
Telephone 843-853-2070
Fax 843-853-0044
E-Mail sales@arcadiapublishing.com
For customer service and orders:
Toll-Free 1-888-313-2665

Visit us on the Internet at www.arcadiapublishing.com

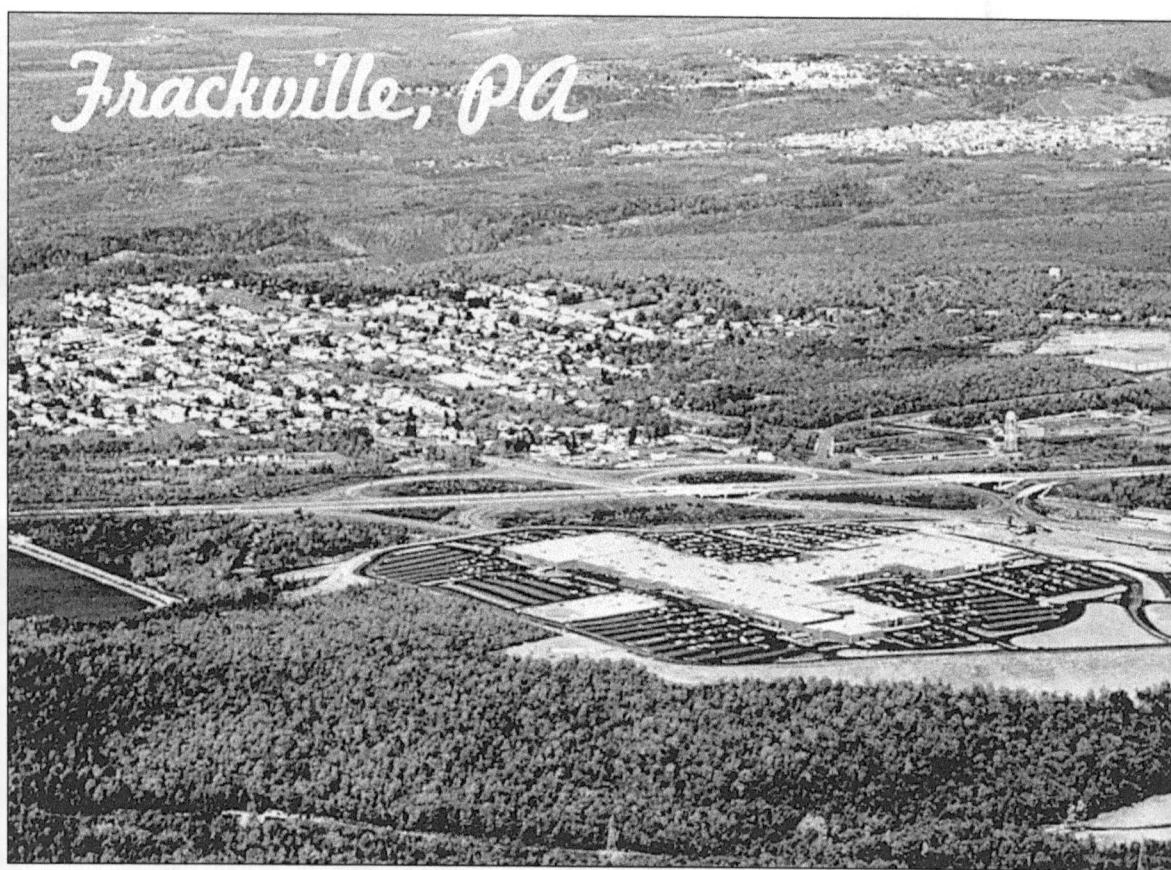

This is a 1998 aerial view of Frackville, Pennsylvania, with the Schuylkill Mall in the foreground. The cloverleaf exit of Interstate 81 at Route 61 occupies the center of this autumn scene, and the town of Shenandoah appears in the background.

Contents

Introduction 7

1. Residents 9

2. Businesses 25

3. Organizations 49

4. Events 67

5. Recreation 85

6. Etcetera 101

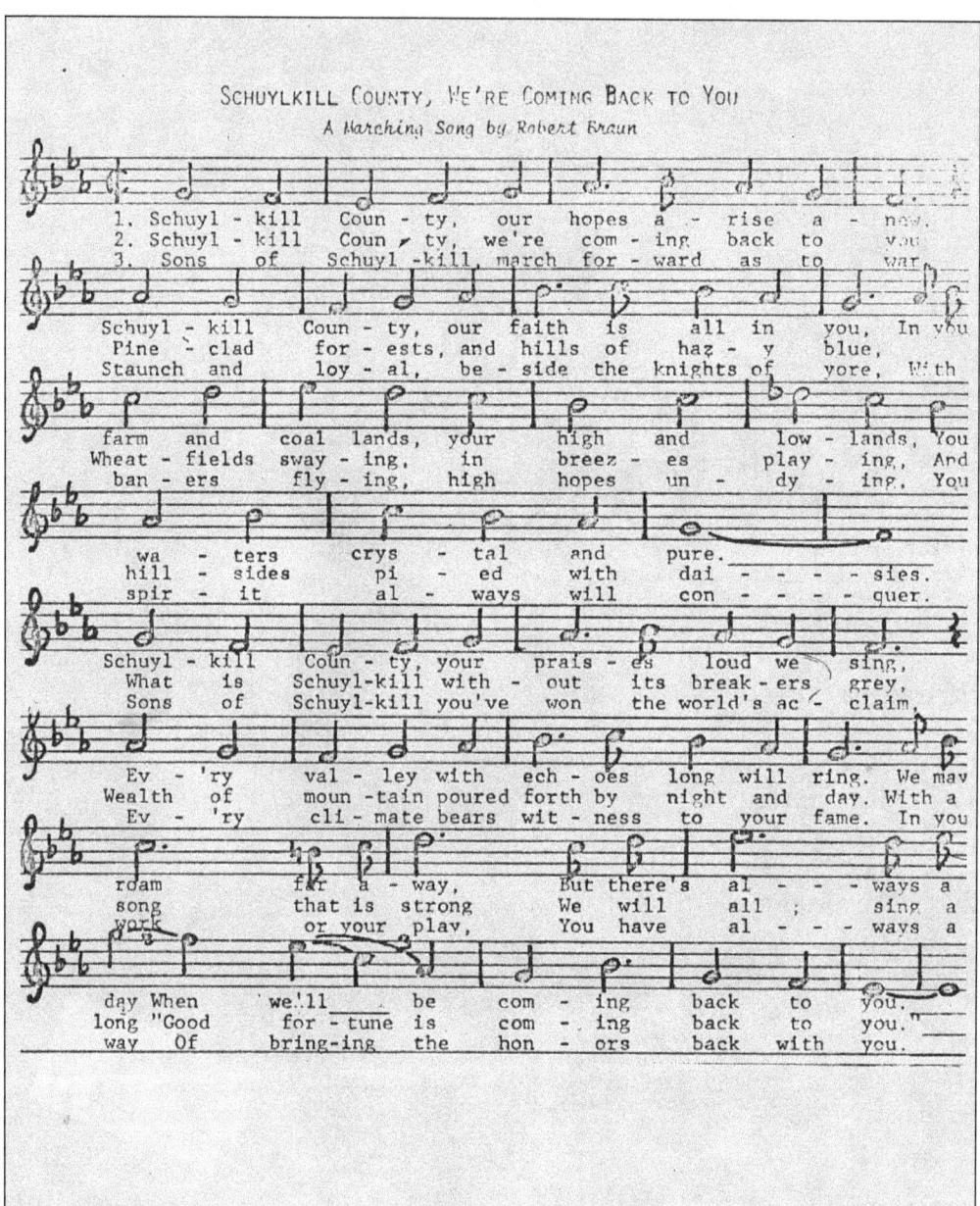

Introduction

For the past 25 years, I have been collecting photographs and researching and writing about community events in the local newspapers. This time and effort has produced almost 200 files on Frackville and its residents, as well as many pictures personally collected or given to me by residents.

My first book, *Images of America: Frackville*, was well received by the community, and a second volume was requested. While researching my files, I found not only many pictures of residents with church groups and clubs but also pictures of shop owners with their businesses—some still located here—so many residents may find either their own picture or that of a family member included in this volume.

Frackville has had active organizations that have assisted our borough in numerous fundraising projects. Baby parades, patriotic parades, July Fourth celebrations, Halloween parades, a centennial celebration, and several firemen's conventions have all been celebrated in Frackville. We have also had numerous activities for children through the years, and many adults have given their time and energy to supervise them. The pictures in this volume will remind you of some of these events.

I have included a chapter titled "Etcetera"—a collage of pictures recording the social history of our community and its residents in a simpler time. I hope that all these photographs will add a human interest to this volume, as well as show future researchers what was done in the past.

Also included are historical facts unknown to many residents and of interest to anyone researching the borough. These facts include the Charter of Frackville and its signers, a list of Civil War veterans and Frackville war dead who gave the supreme sacrifice, and a list of postmasters and mayors from the borough's incorporation to the present.

All the photographs contained herein come from my personal files. As you view them, stepping into the past, I hope you enjoy this Frackville community album as much as I enjoyed compiling it.

With the merging of our local newspapers, our community no longer receives the news coverage it once did. Therefore, as events occur, I urge all organizations to assign a historian to record their specific events, to take pictures of pertinent happenings, and to keep files for their individual groups.

Finally, I would like to acknowledge Deborah Stanton Janov for her help with text editing and encouraging me to work on this volume.

—Lorraine Stanton

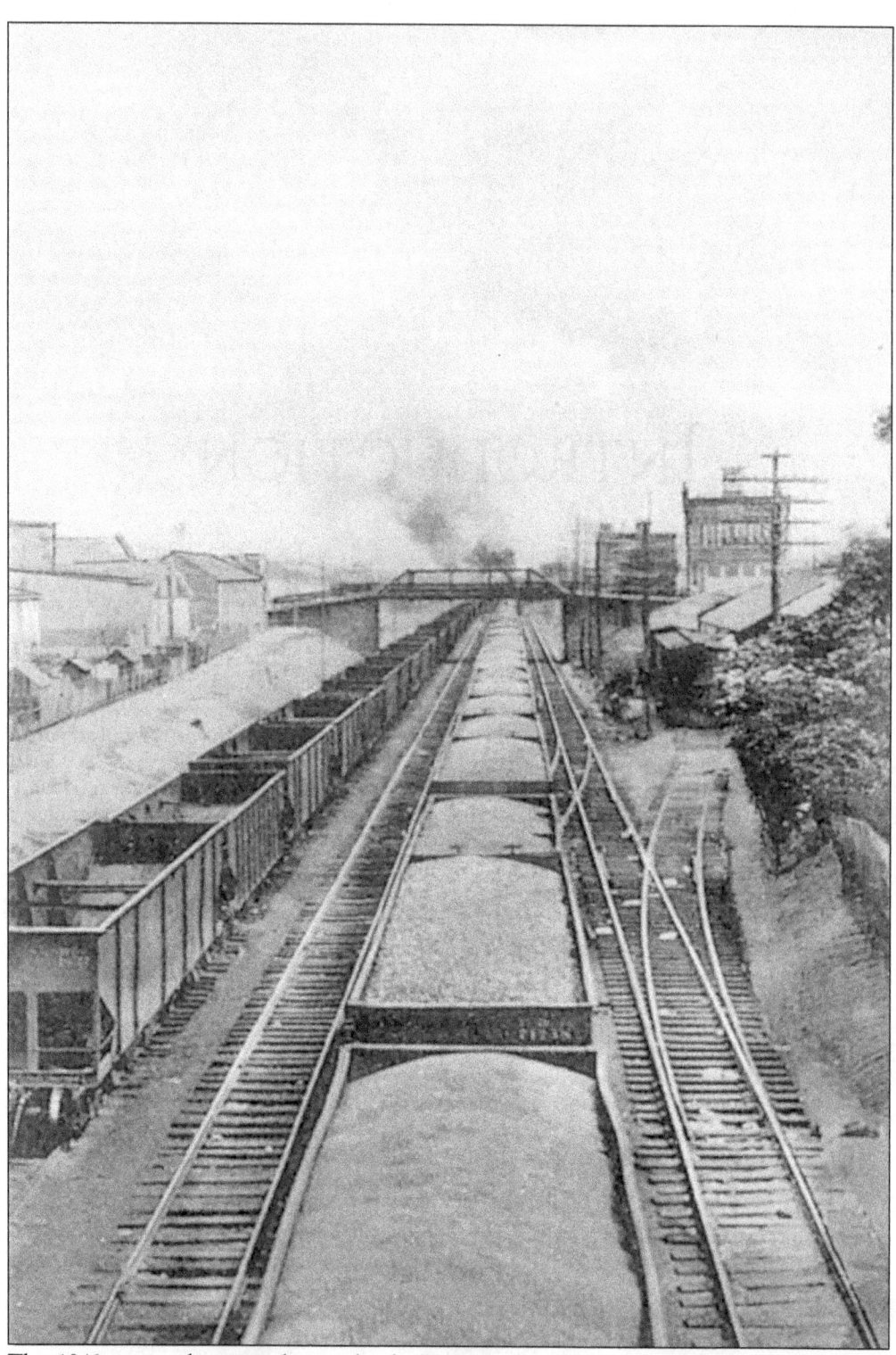
This 1940s postcard presented to me by the Timmins family shows Reading Railroad coal cars loaded with anthracite coal. The Goodwill Hose House is on the right in the picture.

One

RESIDENTS

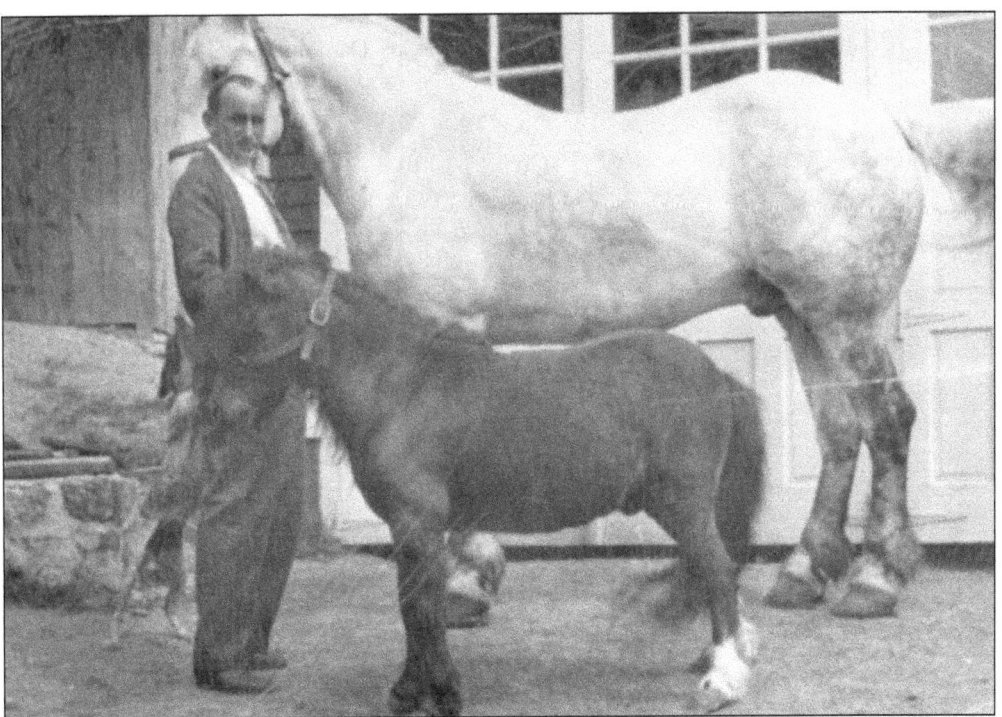

Daniel Hannibal Frack, grandson of the founder of Frackville, Daniel Frack, was a lover of animals. He is pictured with two of his horses in front of the stables on North Lehigh Avenue. Mr. Frack led many of the parades that were held in town.

George Palsgrove (left) sits with Daniel H. Frack and some of the dogs the Frack family had at their 139 North Lehigh Avenue home.

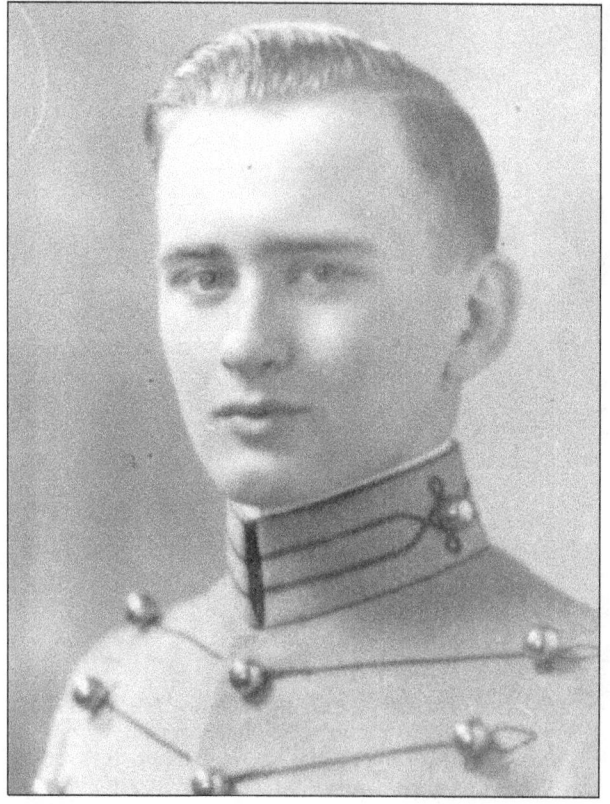

Edward Frack, the great-grandson of Daniel Frack, was born on January 16, 1910, attended Frackville schools, and graduated from Bucknell University in 1933. He is pictured here as a West Point Cadet.

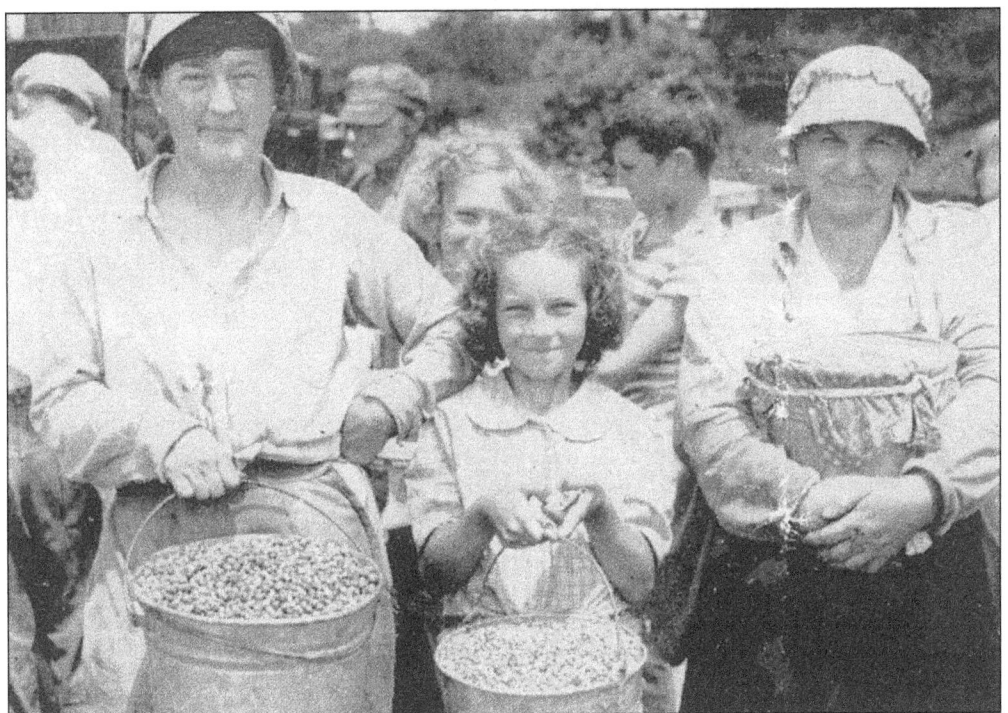

Every July and August the hills of Schuylkill County were filled with huckleberry pickers. Mrs. Anna Belluch (left) and Katie Spotts (right) were two of the prolific pickers of yesterday.

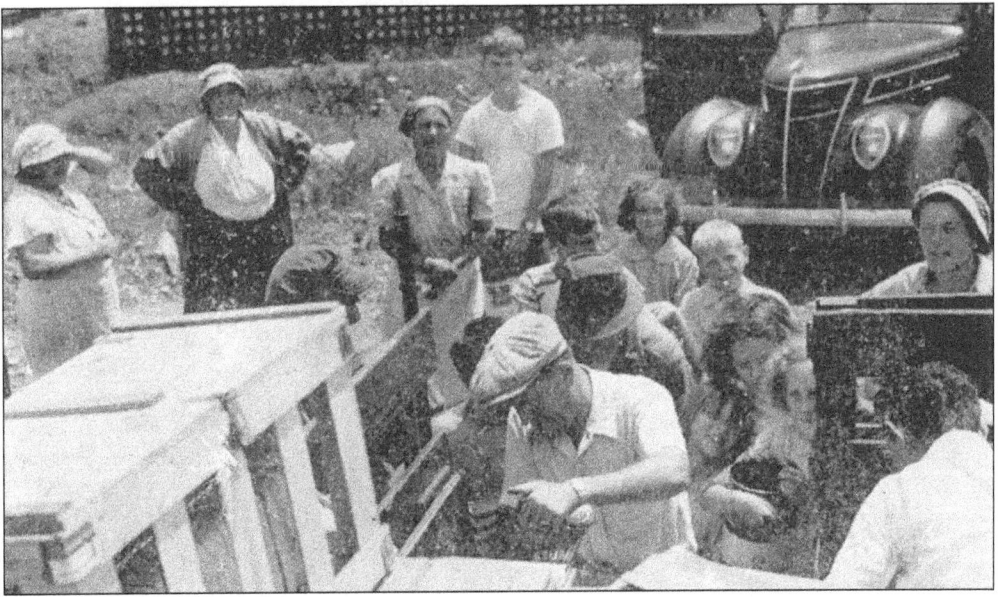

A 1929 news clipping reads, "There were some stirring events at Frackville when a difference arose between the huckleberry pickers and the buyers over the price to be paid. The price had been twenty-three cents a quart but the buyers refused to pay it and the pickers refused to sell for less. The parleys became loud at times until the dealers departed and 300 pickers were left with their berries. After a while the dealers returned and made an offer of seventeen cents a quart which was accepted."

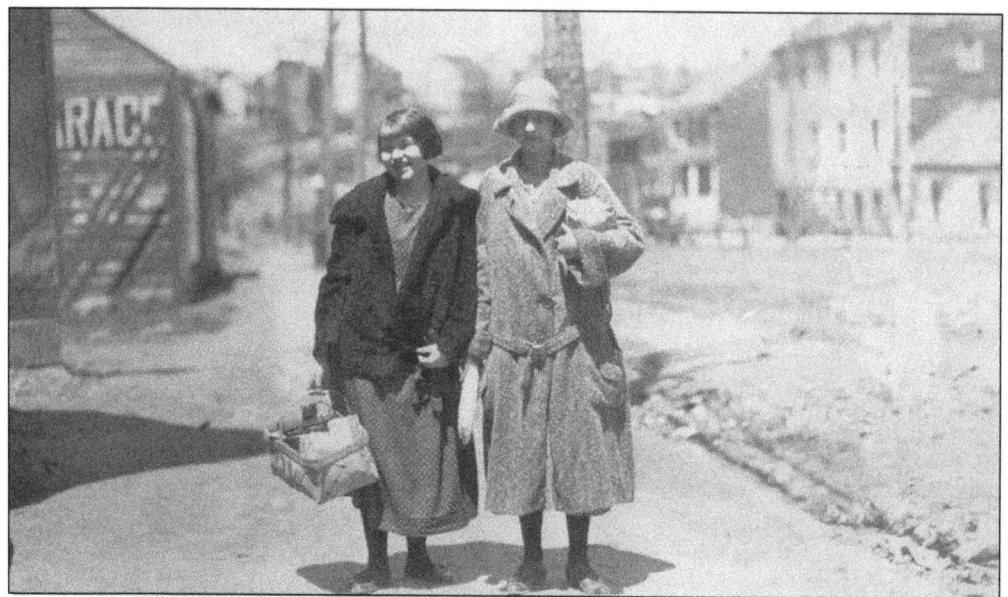

Since there were very few cars in town and driving was not fun on the bumpy unpaved streets, going to market in the 1920s meant one had to walk a half mile or more to shop for groceries. Matilda Kowker (left) and her friend are seen walking on North Lehigh Avenue. Matilda is carrying a grocery basket, which most residents used to carry their items.

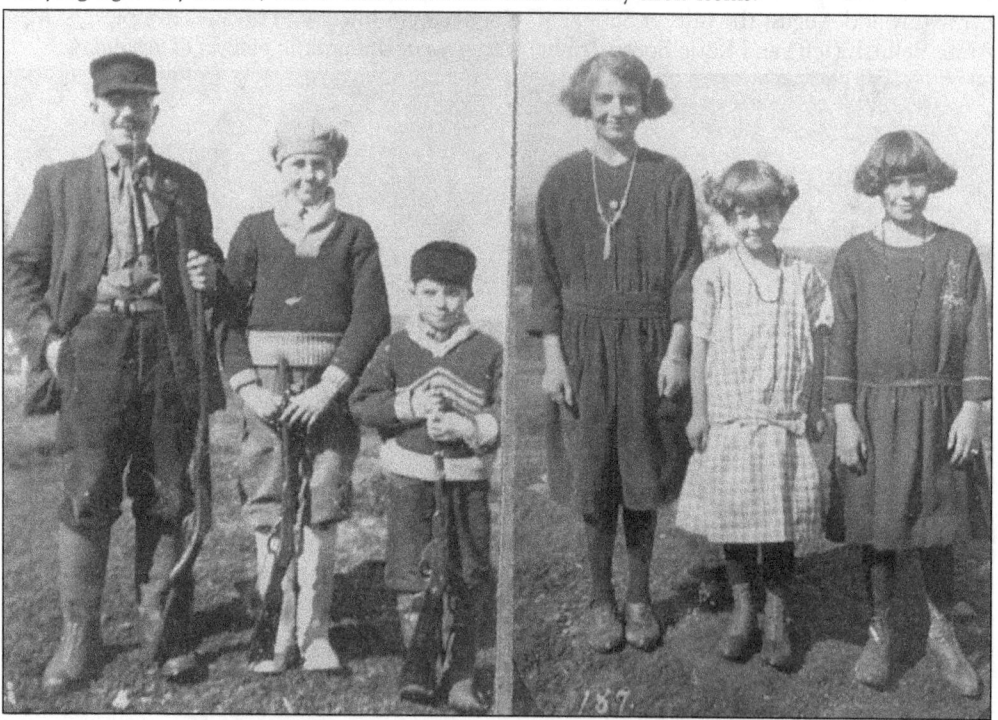

Wearing a cap and boots, Andrew Poplauskas (left) poses with his family on North Nice Street in March 1924. "Pop" and the boys apparently just returned from hunting or target shooting—he with a shotgun and they with air rifles. Note the white boots on the lad in the center and the high-button shoes on the young ladies in the right photo.

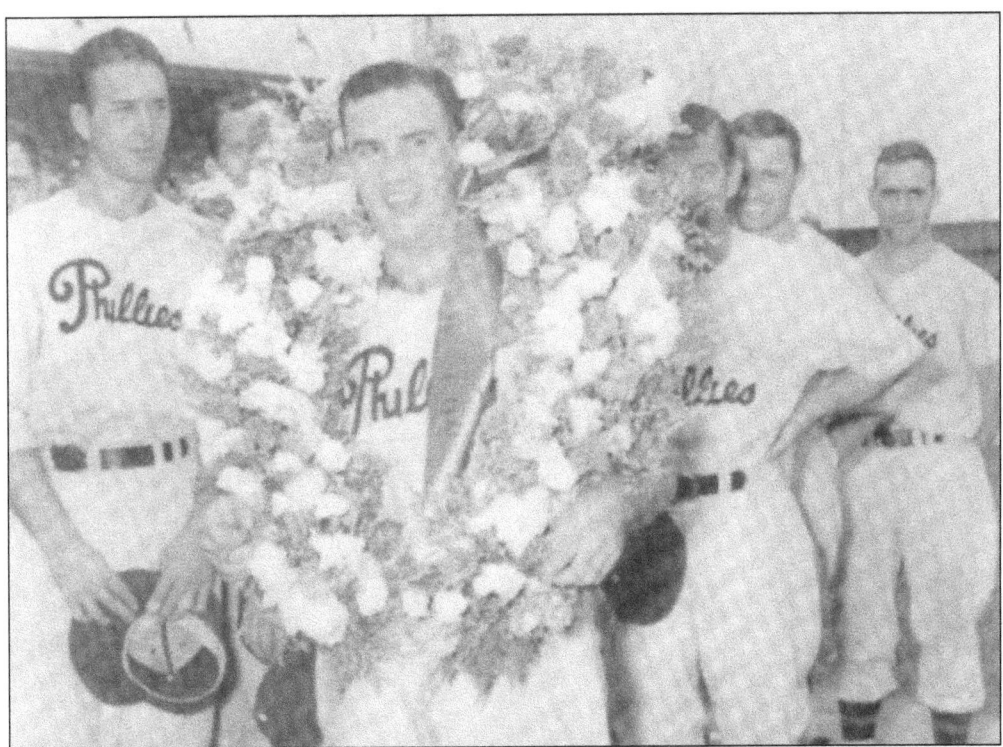

Ron Northey (center) is pictured on July 18, 1943, when he was honored by the Philadelphia Phillies. He played a total of 12 years in the major leagues, with five different organizations, and held a National League record for 9 pinch-hit grand slams in his career. Ron died on April 16, 1971, just ten days short of his 51st birthday.

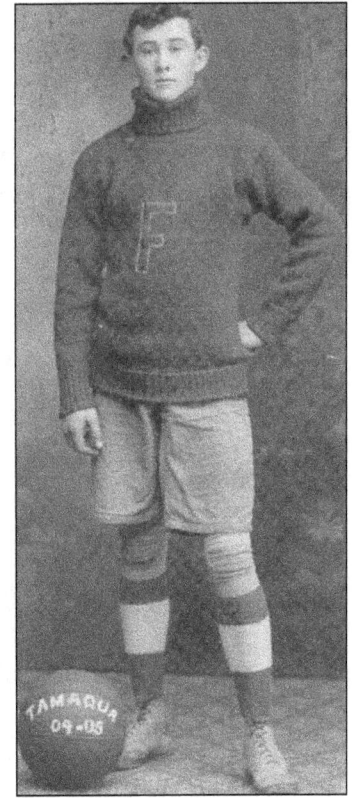

"Charley O'Donnell was so good in basketball that he went direct from Frackville's varsity team to a professional Tamaqua club in 1904. He was renowned for his cleanliness in personal habits and conduct on and off the basketball battleground. He served as Postmaster of Frackville from 1934 to 1939!"

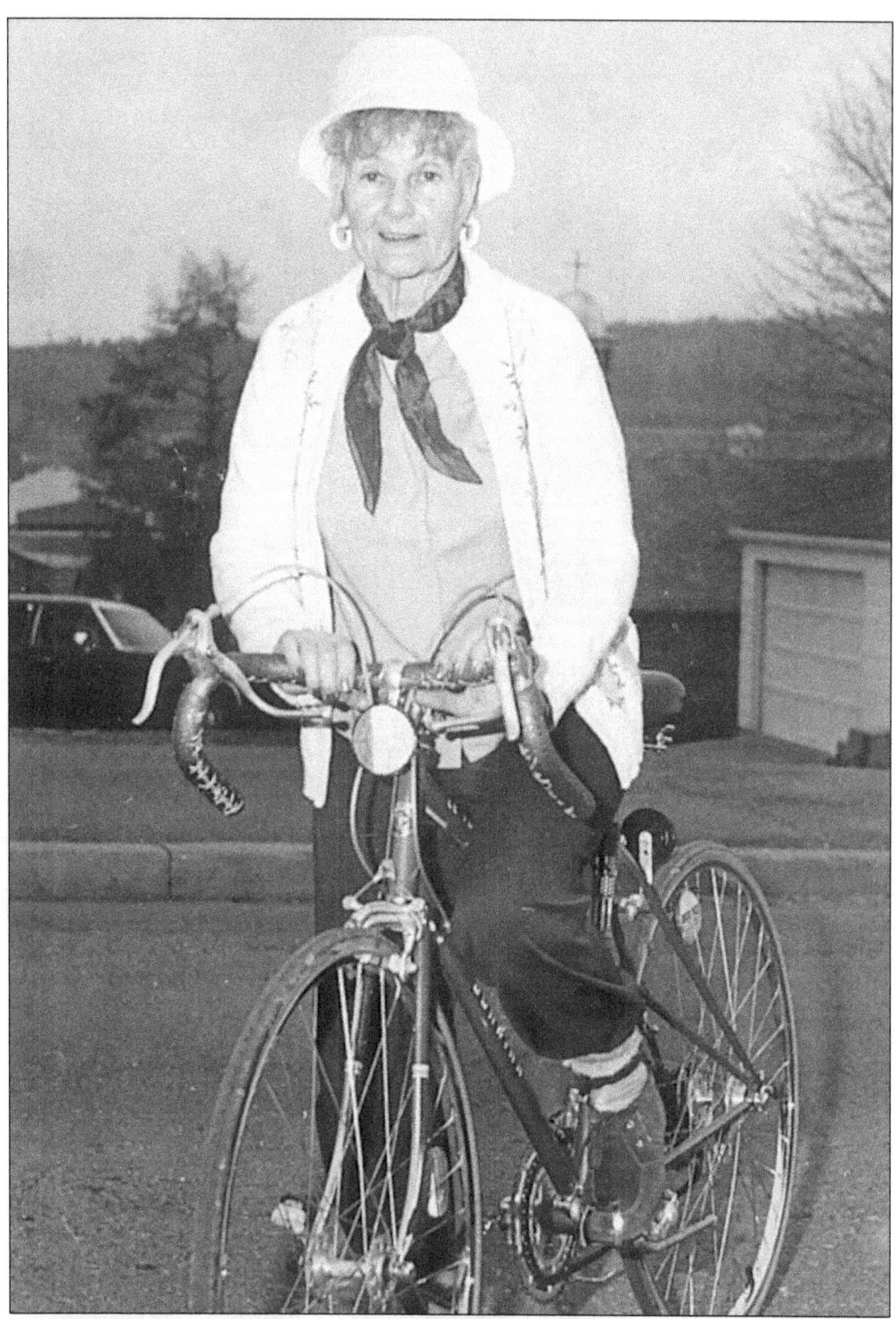
In 1979, at the age of 69, Lillian Price prepared to ride her bicycle 500 miles in the Pennsylvania Bicycle Tour to raise money for youth scholarships. Mrs. Price was regularly seen around town jogging or roller-skating.

Dr. Oscar H. Mengel was born February 24, 1880, and graduated from the Frackville schools in 1896. After graduating from the University of Pennsylvania, he had his medical office at 66 North Balliet Street. It is estimated that he delivered 3,000 babies during his medical career.

Edmund L. Clifford was born in Mahanoy City on September 30, 1869, but lived in Frackville until the death of his father in 1884. He was associated with the *Pottsville Republican* and compiled a list of all county veterans who served in World War I in a book entitled *Schuylkill County, Pennsylvania in the World War*. He died November 26, 1945. Anyone researching their county ancestors who fought in World War I will find their names listed in this book.

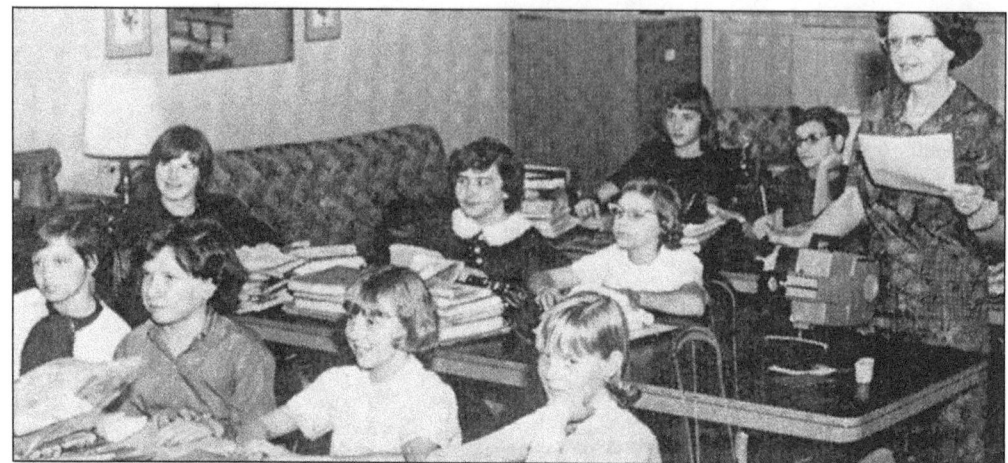

Jean Leddicoat Hall graduated in 1937 from Frackville High School and received her degree from Indiana University of Pennsylvania in 1941. She is remembered as the home economics teacher with more than 29 years of service.

Robert Hall (left) graduated from Frackville High School in 1931, received his degree from Penn State University, and began teaching in 1937. He taught algebra, plane and solid geometry, trigonometry, and physics for many years and retired in 1975. Lillian Beard (right) graduated in 1888 from Frackville High School and began teaching that year. She taught at the Lincoln School until she retired in 1938. She died on February 11, 1962.

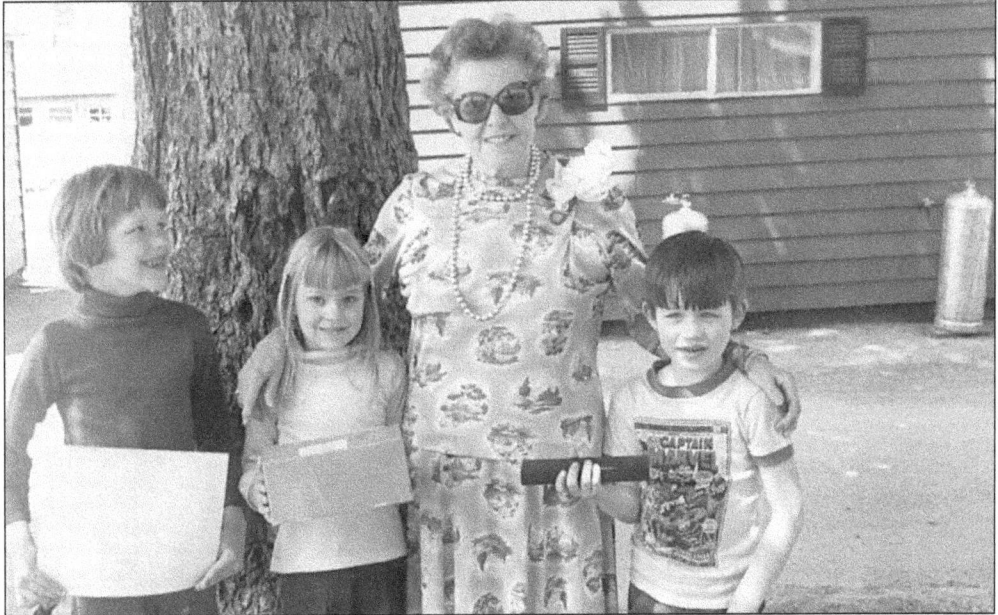

Pictured in front of the Memorial Monument, at the entrance of the Frackville Memorial Park, Lori Ann Gavarick (left) and Jane Bar presented gifts to Mrs. John Socker for her retirement in June 1976.

Gregory Wabo, Lori Zack, and Edward Crosby present gifts to well-known kindergarten teacher Jeanne Morgan at her retirement in June 1976.

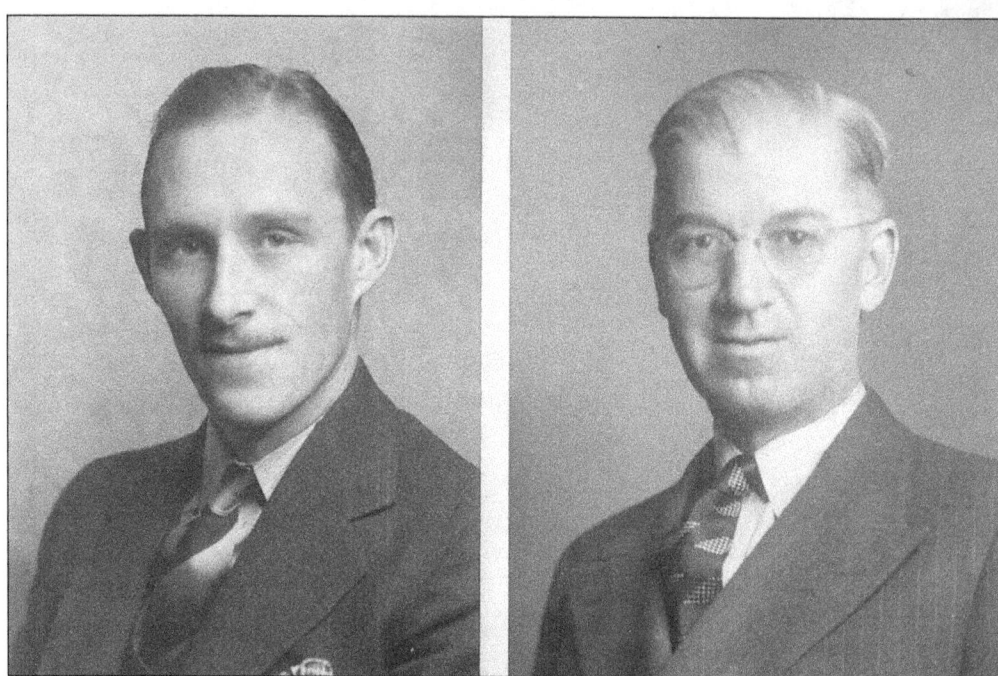

Dr. Matthew NeVertts (left) was a well-known physician in Frackville and had his office at 30 North Balliet Street. He served on the school board of Frackville High School with Mr. Flannery (right). This picture was taken February 19, 1940.

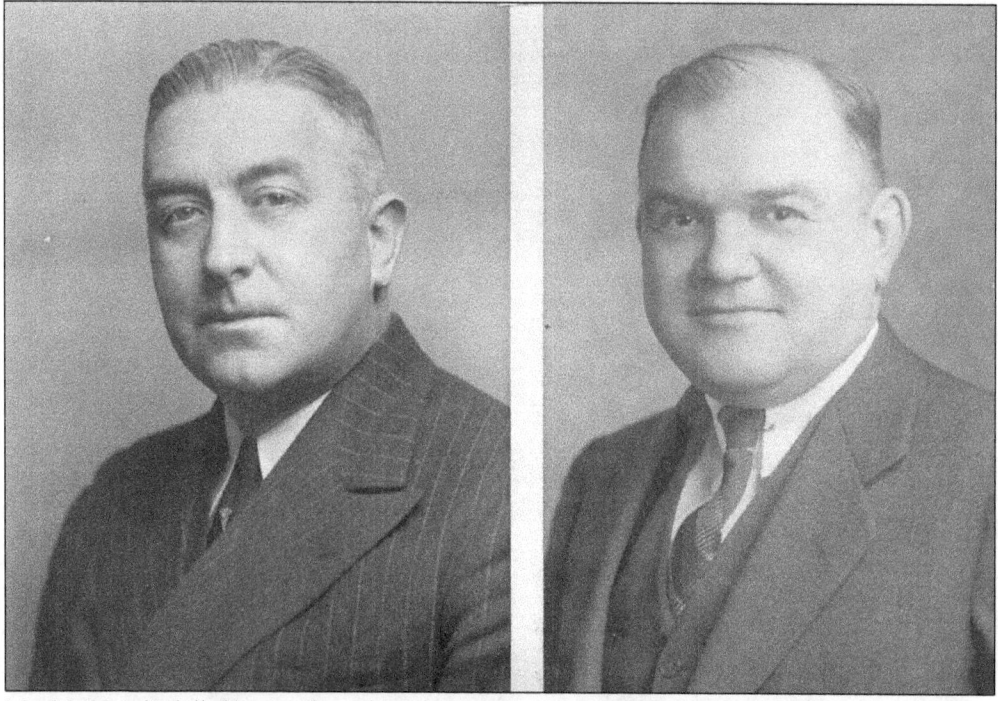

Mr. J.J. Hamford (left) served on the school board of Frackville High School with the school dentist, Dr. Howard Smith (right). Dr. Smith lived on the corner of South Nice and West Frack Streets. This picture was taken February 19, 1940.

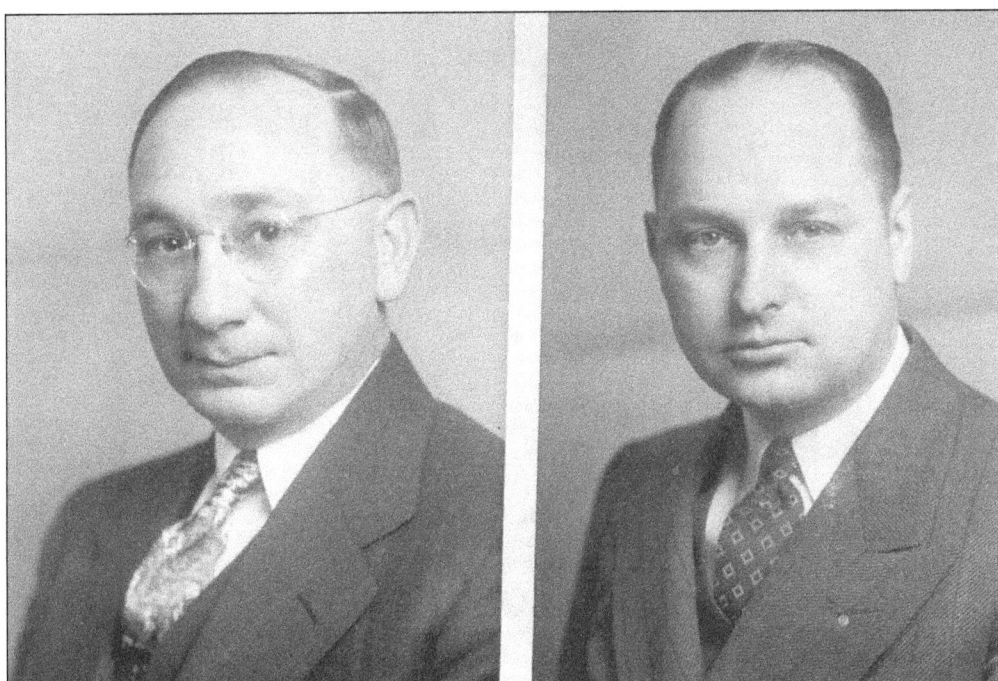

Mr. Guy Bowe (left) was the owner of Bowe's Garage on the corner of South Second and West Oak Streets. He served on the school board with Clarence D. Swade (right), who was the owner of Swade's Restaurant, a popular gathering place for Frackville residents. This picture was taken February 19, 1940.

William Dewey served on the school board for many years and was also the postmaster from 1939 to 1943. The following is a list of postmasters:

1875–1884	Mrs. Lenora Frack Meredith
1885–1886	Henry H. Brownmiller
1887–1890	Joseph Scheaffer
1891–1894	Edward W. Bateman
1895–1899	Joseph Scheaffer (reappointed)
1899–1915	Calvin Boyd Philips
1915–1919	John P. Durkin
1919–1924	Fred Wagner
1924–1932	Thomas W. Watkins
1932–1934	Edward Monroe
1934–1939	Charles O'Donnell
1939–1943	William F. Dewey
1944–1946	John J. Becker
1946–1972	Anthony Cickavage
1973–1983	Stanley Bulcavage
1983–1987	Thomas J. Zelinsky
1989–	Joseph W. McDonald Jr.

There were several officers in charge between appointed postmasters.

Sarah A. McCool, a Pottsville schoolteacher, was the first person in our area to write the history of Schuylkill County. She wrote a weekly series for the *Shenandoah Evening Herald* from February 8, 1874, to November 27, 1875, entitled, "Schuylkill County Historic Gleanings." She was born October 14, 1833, and died February 10, 1906. Frackville is listed in Chapter 34 of the series.

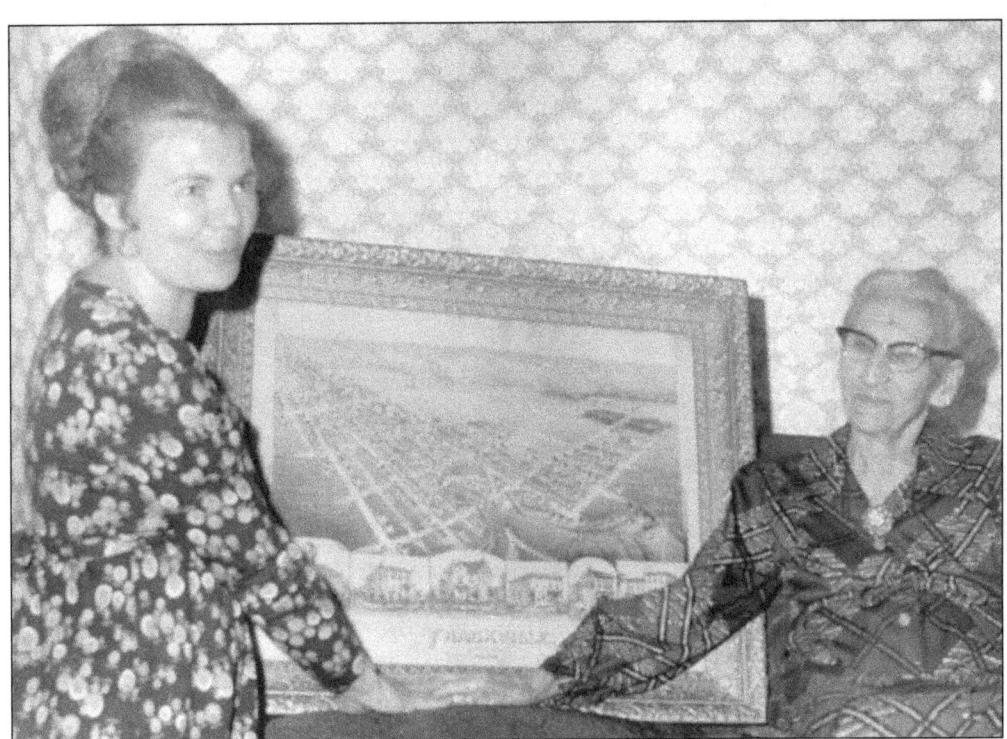

Mary Ann Giba (left) shows an 1889 artist's rendering of Frackville to her great-aunt, Mrs. Pauline Shadel, who celebrated her 97th birthday in 1973. This was one of many pictures displayed at the Old Tymers Nite of Fun and Frolic held in 1973.

Mrs. Sallie Swartz, 96, was the oldest resident born in Frackville who was still residing there during the centennial in 1976. She was honored in a parade during the centennial festivities.

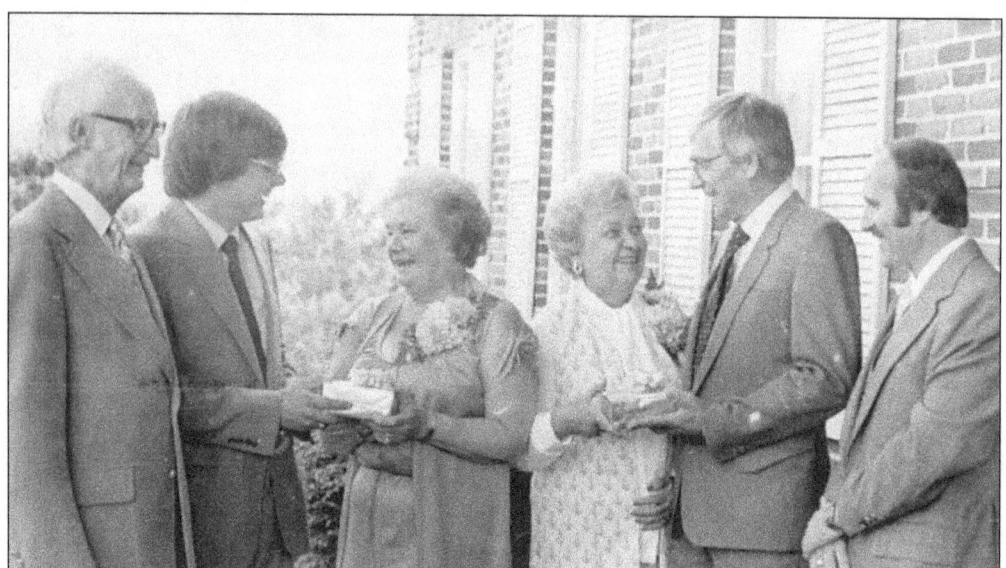

The Model Garment Company of Frackville honored two retirees at a dinner held at the Fountain Springs Country Club. Pictured are, from left to right, Willard Long (general manager), Anthony Baran (president), Mary Slovick (an honored guest retiring after 24 years of service), Lottie Jaskierski (retiring after 29 years of service), Walter Baran (guest speaker), and Wayne Robbins (assistant manager).

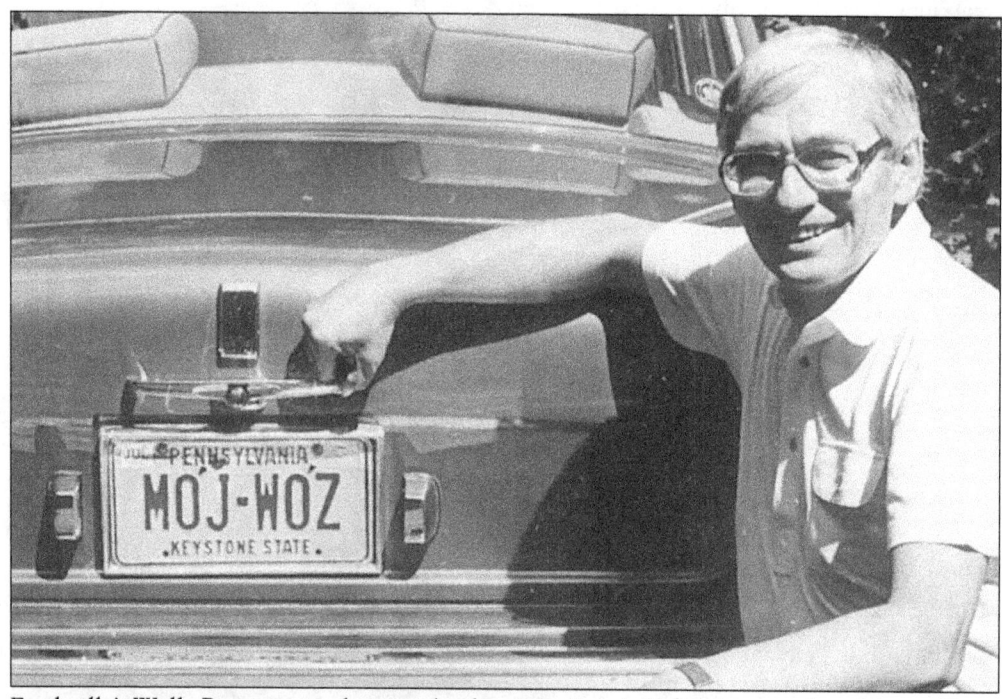

Frackville's Wally Baran owns what may be the nation's only Polish license plate. It's an official tag that identifies Wally's Rolls Royce as "My Wagon."

James Nahas, seen in his office in the Lincoln Building, was mayor of Frackville from 1974 to 1980. As the newly elected district magistrate, he was sworn in on January 4, 1982, but died eleven days later on January 15, 1982.

FRACKVILLE MAYORS
(Title was Chief Burgess to 1961)

Year	Name	Year	Name
1876	D.P. Haupt	1900-02	H.P. Price
1877	Joseph Beatty	1903	John Madara
1878-79	D.P. Haupt	1904-13	Samuel Steinbach
1880	P. Zimmerman	1914-17	H.E. Madara
1881	Jacob Rauch	1918-20	Ray Burchill
1882	John M. Thomas	1920-21	H.E. Madara
1883-84	J.B. Nice	1922-25	Harry Wood
1885-86	Frederick Sanner	1926-50	George Miller
1887	Thomas Irvin	1950-53	James Amour
1888	Robert Coxon	1954-61	William J. Miller
1889	Jeremiah Foulk	1962-67	Andrew Yesalusky
1890	Daniel J. Kiefer	1967-69	Walter Stepenaski
1891	William W. Wertz	1970-73	Metro Karlitskie
1892	James Kelly	1974-80	James Nahas
1893-95	E.J. Douden	1981-93	Raymond Tomko
1895-96	George W. Wagner	1994-97	Charles Brayford
1897-00	Reuben Wagner	1998-	Thomas Hombosky

First Borough Manager-Daniel Guers July 1994-December 26, 1997

This is a list of Frackville's mayors from 1876 to 1998.

Sgt. Albert G. Gricoski graduated from the FBI Academy, Quantico, Virginia, in October 1977. Active in many organizations such as the Knights of Columbus, Frackville Elks, and the Frackville Little League, he also served as chairman for many fund-raising projects.

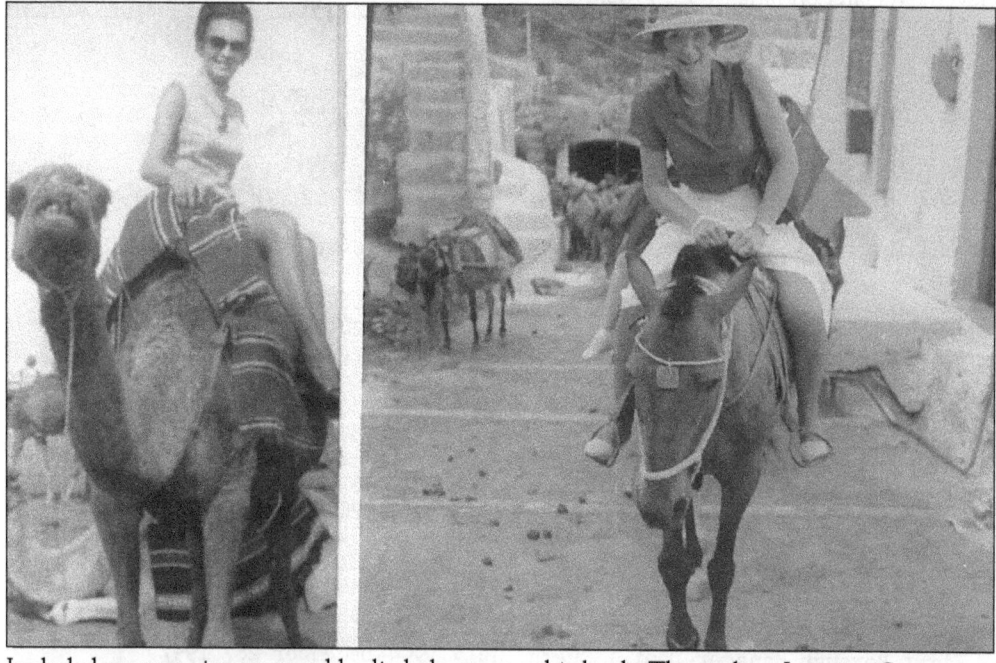

Included are two pictures to add a little humor to this book. The author, Lorraine Stanton, is shown (left) posing on a camel in Africa in 1970 and (right) riding a mule up 1,000 feet to the top of Santorini, Greece, in 1982. Today, at 73, she rides only cars, buses, and planes.

Two

BUSINESSES

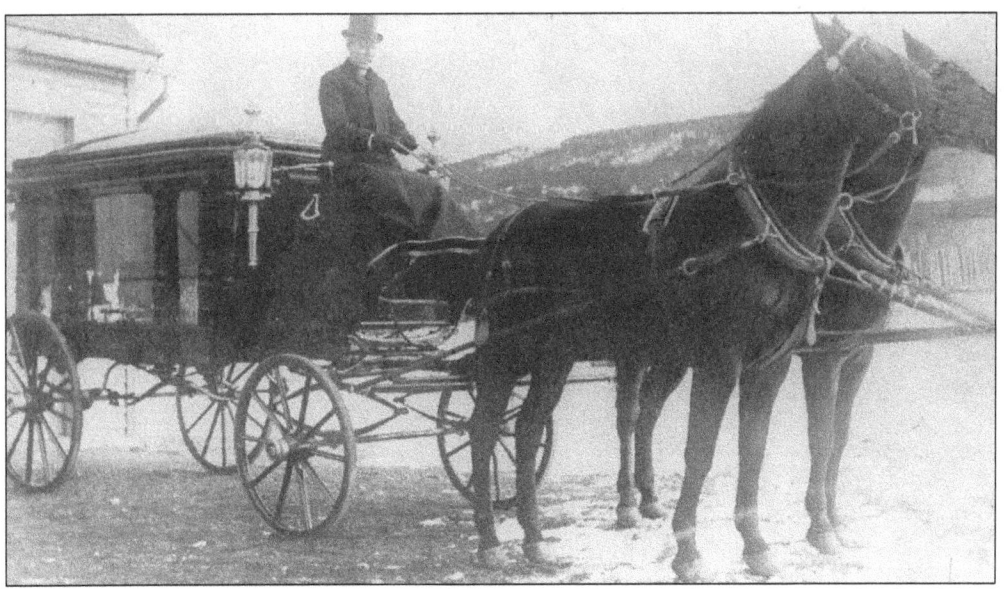

Pictured is the 1919 horse-drawn hearse of the Burke Funeral Home in Ashland. Edward J. Burke moved to Frackville in 1937 and built his residence and funeral home at 217 South Lehigh Avenue, where he conducted his business until his retirement on February 2, 1967, after 52 years as a funeral director. He was married to the former Beatrice Kane and he died April 14, 1967.

William Bellas, manager of the Frackville Manufacturing Company, posed with some of his fellow employees at the corner of West Spring and North Center Streets for the Welcome Day Parade held in Frackville in October 1919. The sign reads, "We manufactured 3,000,000

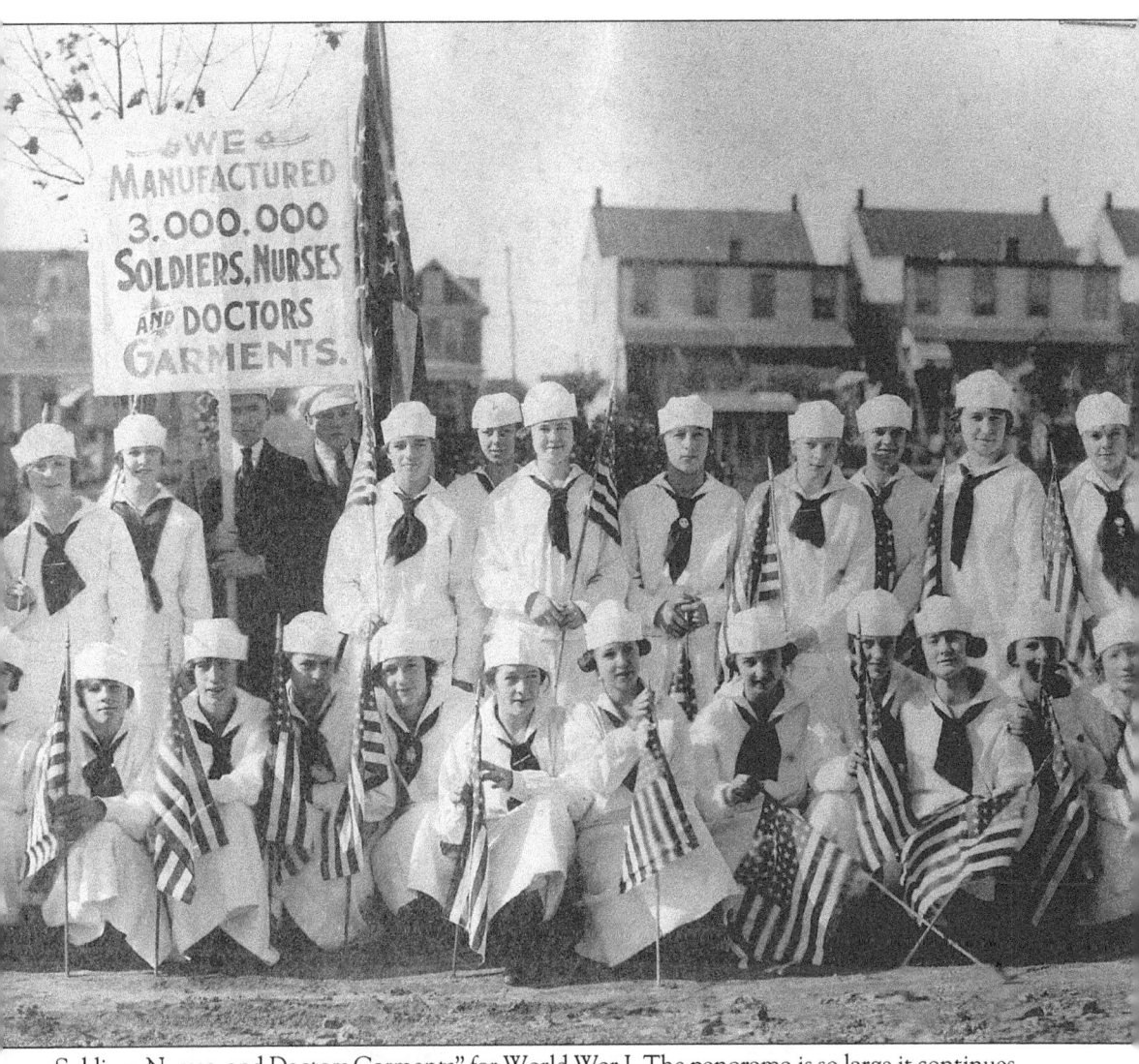

Soldiers, Nurses, and Doctors Garments" for World War I. The panorama is so large it continues on the following two pages

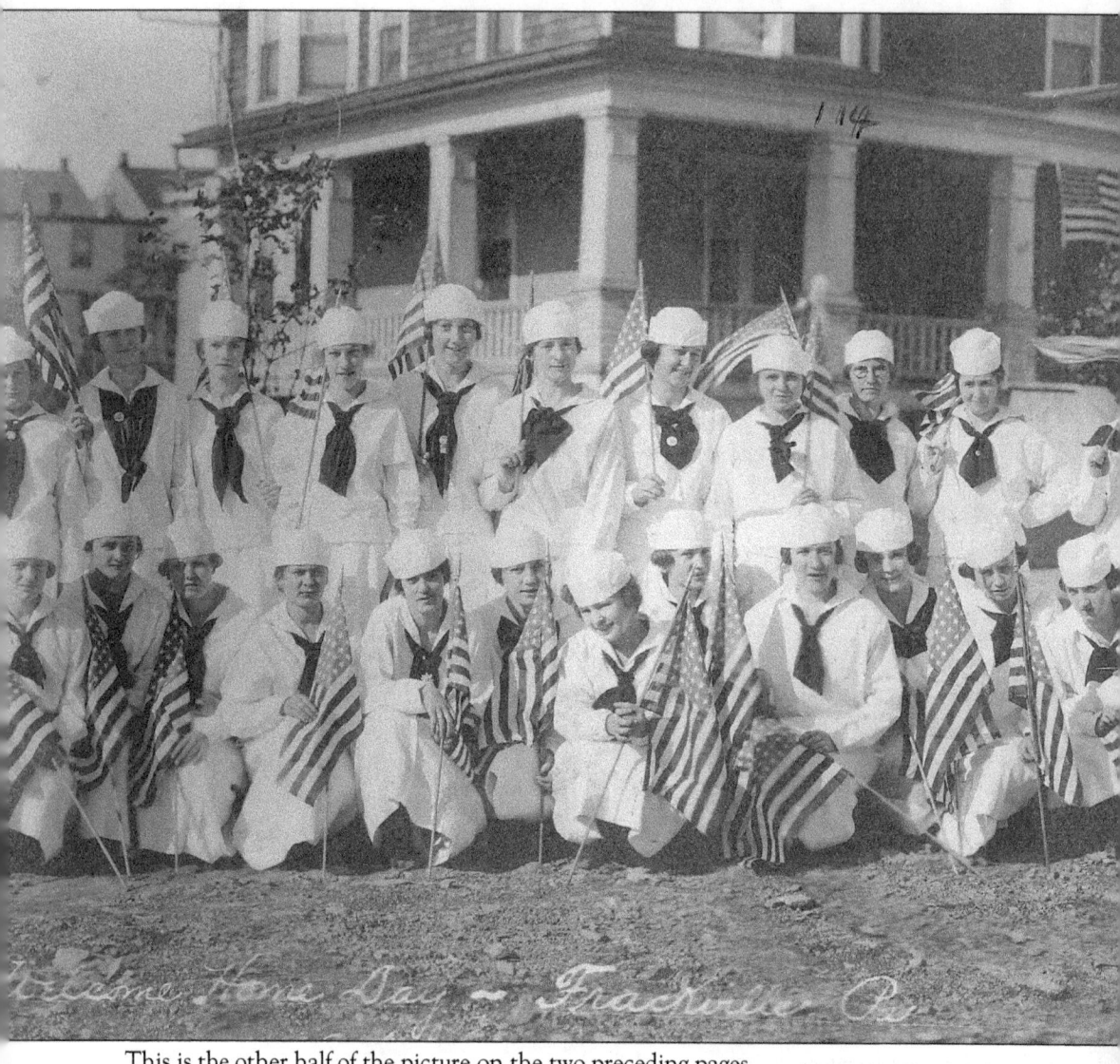

This is the other half of the picture on the two preceding pages.

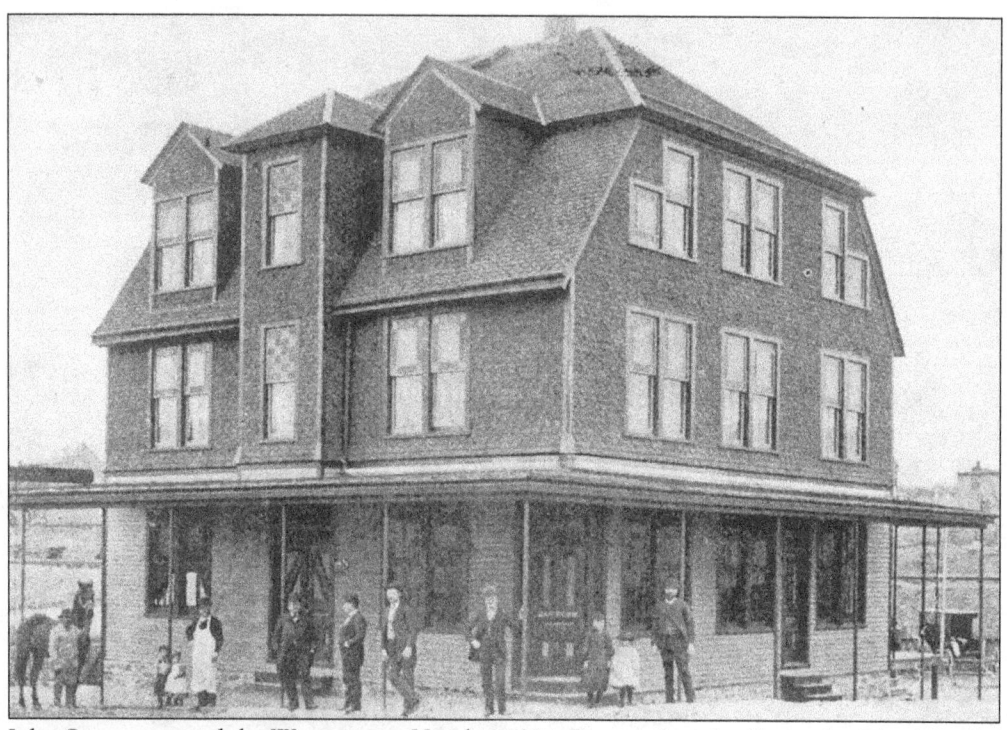

John Stone occupied the Westminster Hotel in 1904. Previously, it had been the Cloud Castle, operated by Charles Hillanbrand; later it was Joe Rice's Nite Club, Dengler's Nite Club, Paul's Inn, and Giorgios. Today it is Kasko's Catering.

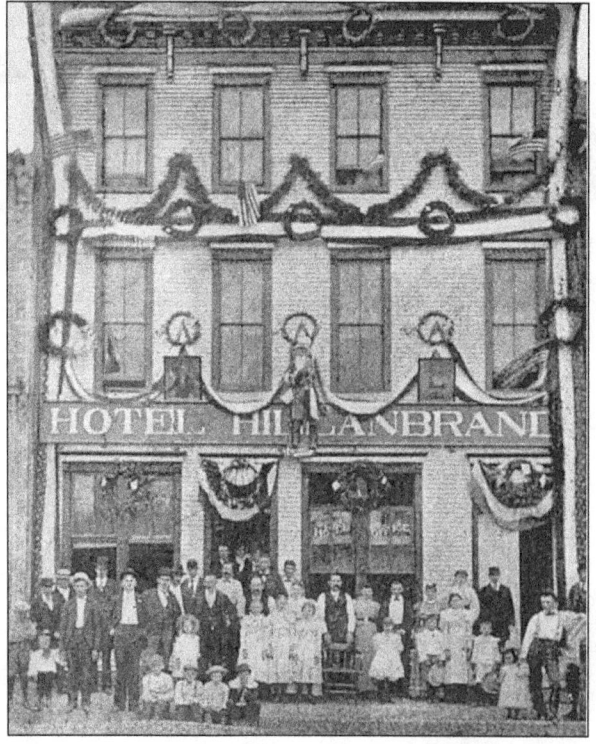

The Hotel Hillanbrand at 130 North Balliet Street was built in 1889 by Charles Hillanbrand. An 1889 news clipping reads, "The most enjoyable event of the season took place at the hotel of Charles Hillanbrand. Charley was not aware he was growing old. Wednesday was his birthday and his amicable wife did not forget it. She had all things ready for a surprise, and when the clock struck 9 o'clock the invited guests took his commodious house by storm. A supper with all the delicacies of the season was served, after which they all enjoyed themselves by dancing and singing. They adjourned by pulling Charley's ears 30 times and departed for their respective homes wishing him the return of many more."

This is an advertisement from September 10, 1927.

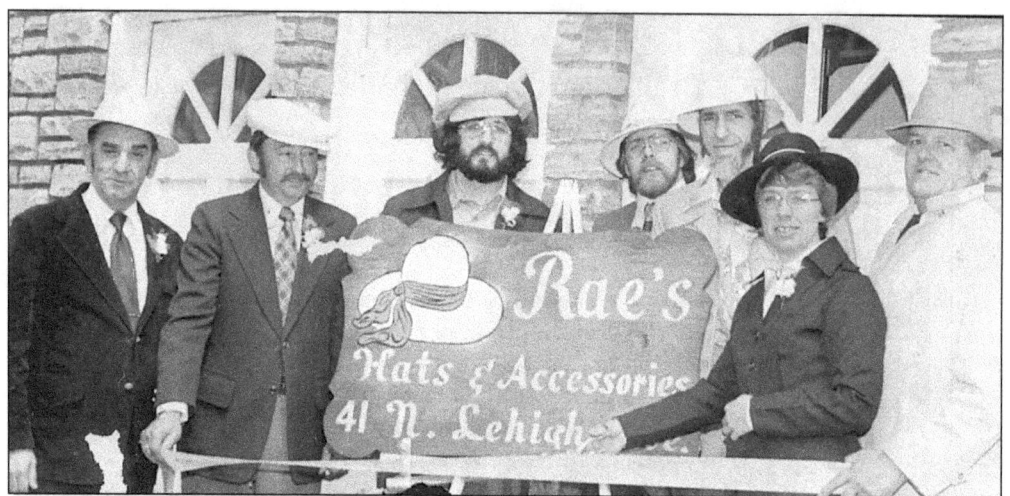

Pictured in April 1976 at the grand opening of Rae's Hats and Accessories Shop at 41 North Lehigh Avenue are, from left to right, Mayor James Nahas, Councilmen Joseph Probition and John Chuma, Randy Neyer, owners Ron and Rae Gilmore, and Edgar Herwick.

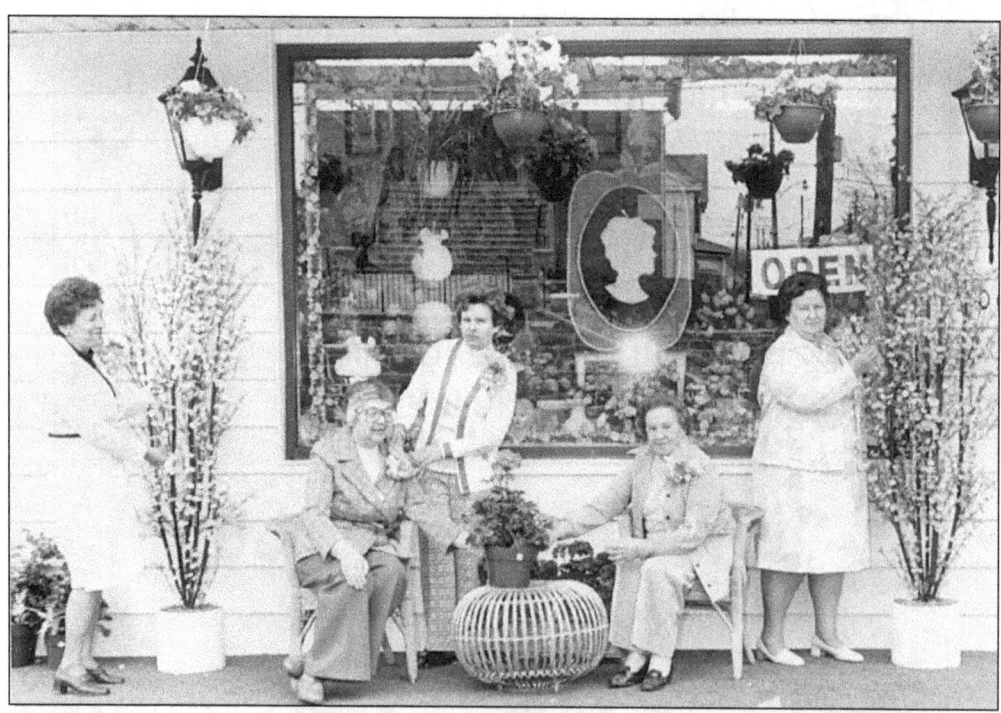

The grand opening of the Kitty and Dotty Flower Shop at 200 South Lehigh Avenue was in 1978. Pictured are, from left to right, Sue Remus, Mae Wolf, Terri Lane, Ann Seitzinger, and Zelma Shuey.

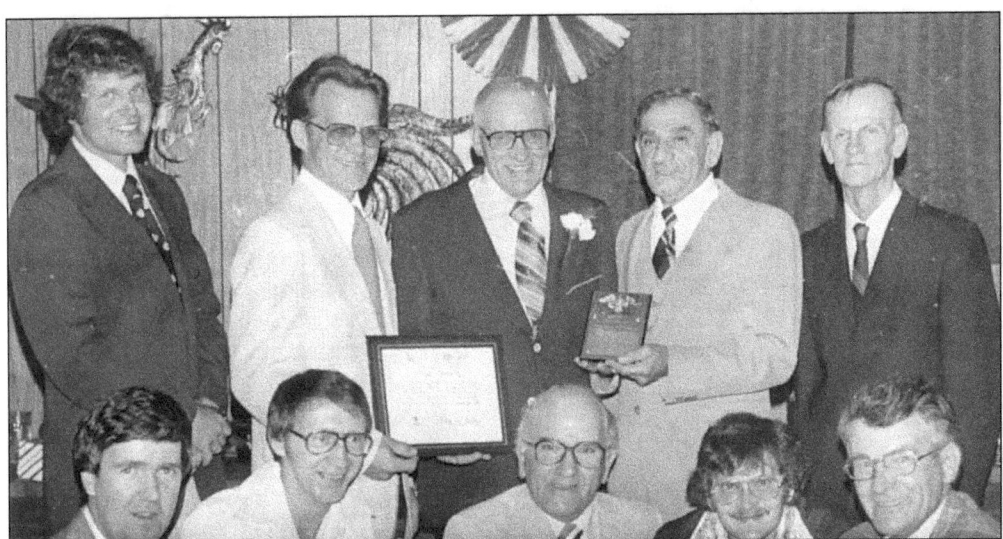

Carl J. Pyzowski (center rear), assistant Frackville postmaster, retired in May 1980 after 32 years of service. Honoring him, from left to right, are as follows: (front row) Joseph Coddington, Joseph S. Shagen, Michael Giba, Harry Schappell, and Michael Ryan; (back row) Walter Masinick, Postmaster Stanley J. Bulcavage, Pyzowski, Mayor James Nahas, and Leonard Rakowsky.

Anthony Cickavage, of Morea Road, was postmaster from April 1, 1946, to February 4, 1972. The U.S. Post Office in Frackville is located at 109 South Lehigh Avenue and was dedicated April 15, 1961. Here are the rates for first class mail:

Nov. 3, 1917, 3¢
July 1 1919, 2¢
July 6, 1932, 3¢
Aug. 1, 1958, 4¢
Jan. 7, 1963, 5¢
Jan. 7, 1968, 6¢
May 16, 1971, 8¢
Mar. 2, 1974, 10¢
Dec. 31, 1975, 13¢
May 29, 1978, 15¢
Mar. 22,, 1981, 18¢
Nov. 1, 1981, 20¢
Feb. 1, 1985, 22¢
Apr. 3, 1988, 25¢
Feb. 3, 1991, 29¢
Jan. 1, 1995, 32¢
Jan. 10, 1999, 33¢

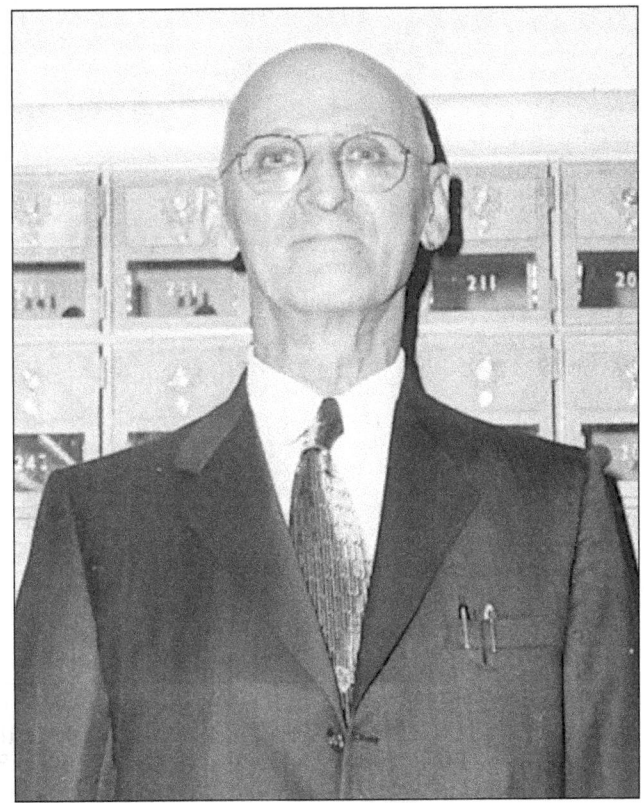

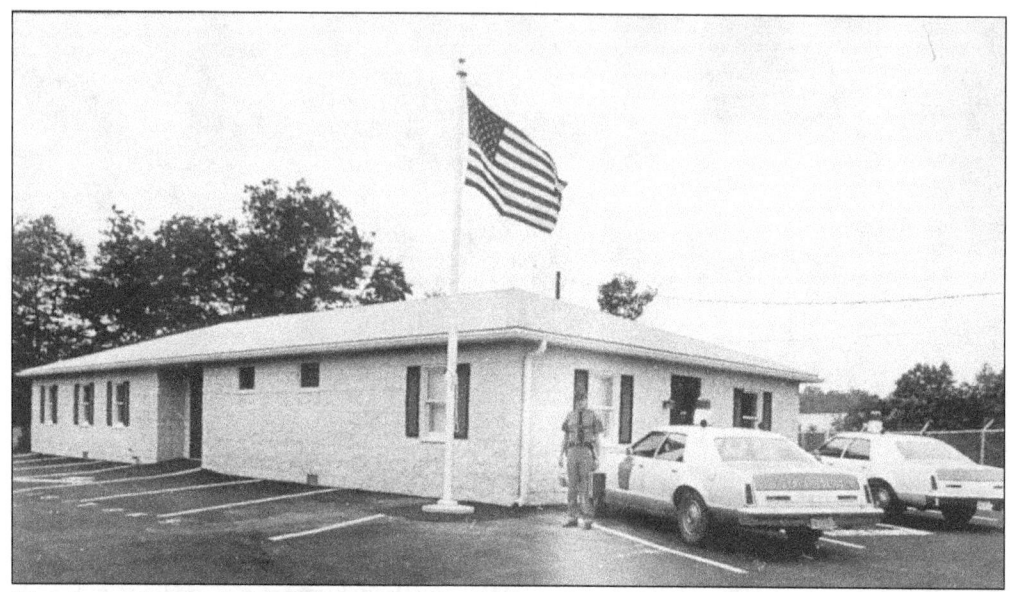

The Pennsylvania State Police Barracks, dedicated in October 1979, was located just off Interstate 81 and Route 61. It was built to the specifications of the state police by landowner Paul Caparell. In 1990, the state police moved to a new location on the Morea Road. Pictured here is Robert Gobla of Mountaintop.

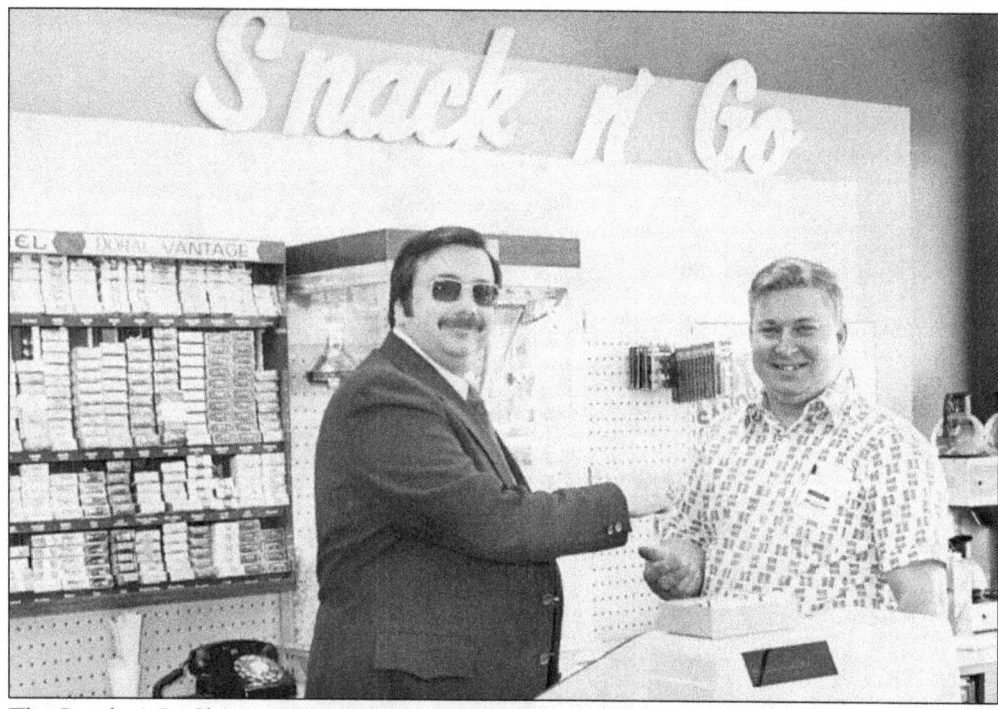

The Snack n' Go Shop at 155 South Lehigh Avenue opened in 1978. Robert Mertz (left) hands the keys to the new manager, Gerald Schuettler. This was the eighth store in the chain, and some of the employees at that time were Nicholas Babilya, Barbara Wysincavage, Mary Ellen Reilly, and Bonnie Heiler. It is now the Uni Mart Store.

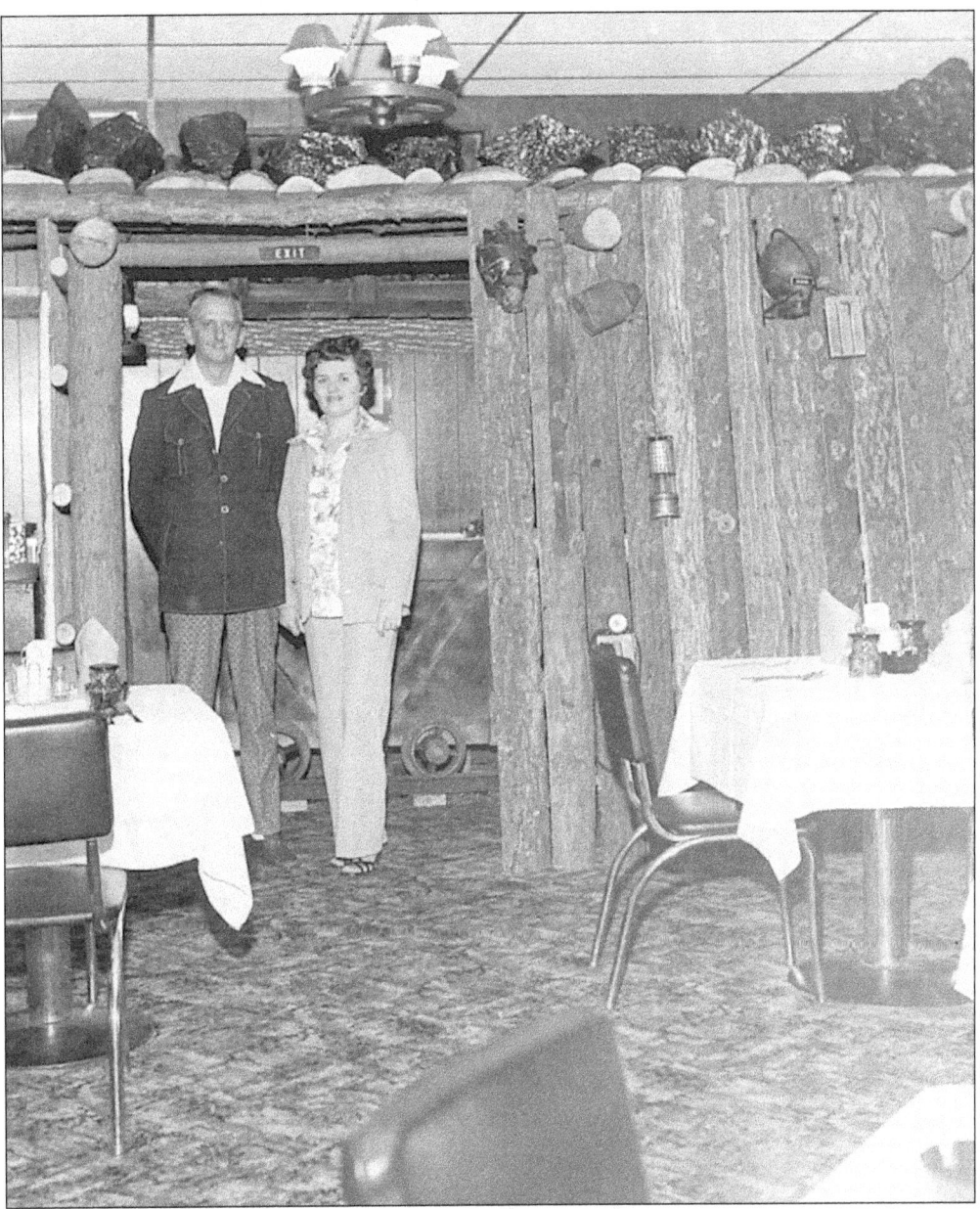

When Hank's Cafe was remodeled in 1977, an anthracite theme was used that included miners' hats, water bottles, lamps, picks, shovels, and other items of the deep mine era. Pictured at the door of a simulated mine chamber are owners Hank and Irene Roman.

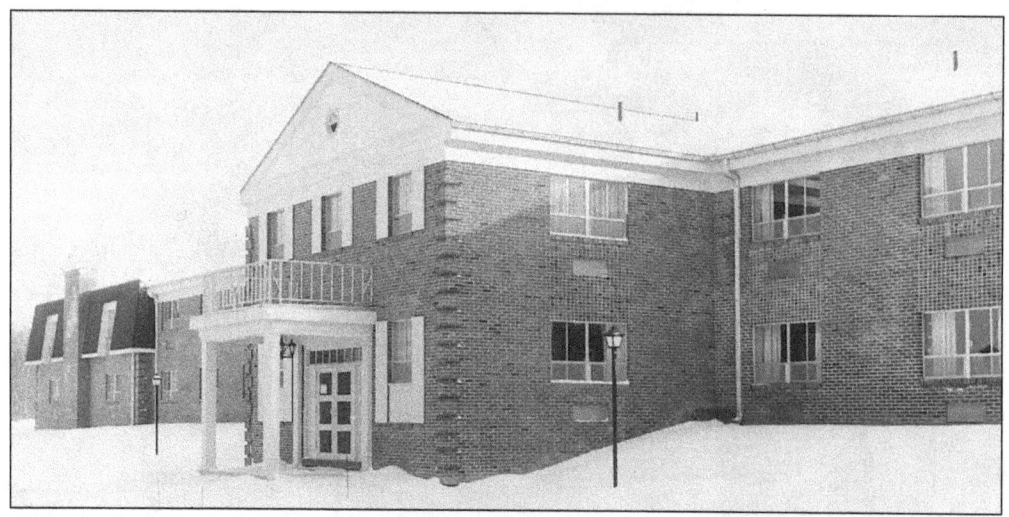

This picture shows the Broad Mountain Manor Nursing Home at 500 Laurel Street in the snowstorm of January 26, 1971. The nursing home is an extended care facility and is advertised as "Always Healthful—no smog, no air pollution, located in a forest, breathtaking view, and always quiet." It officially opened on October 1, 1970.

The Pennsylvania National Bank and Trust Company, at 255 South Lehigh Avenue, is shown here as it looked on January 29, 1971. The officers at that time were John H. Thomas, John J. Crane, Harry Lehrman, Paul Malinchock, Joseph J. Neds, and William L. Scharadin. An addition has since been added to the structure.

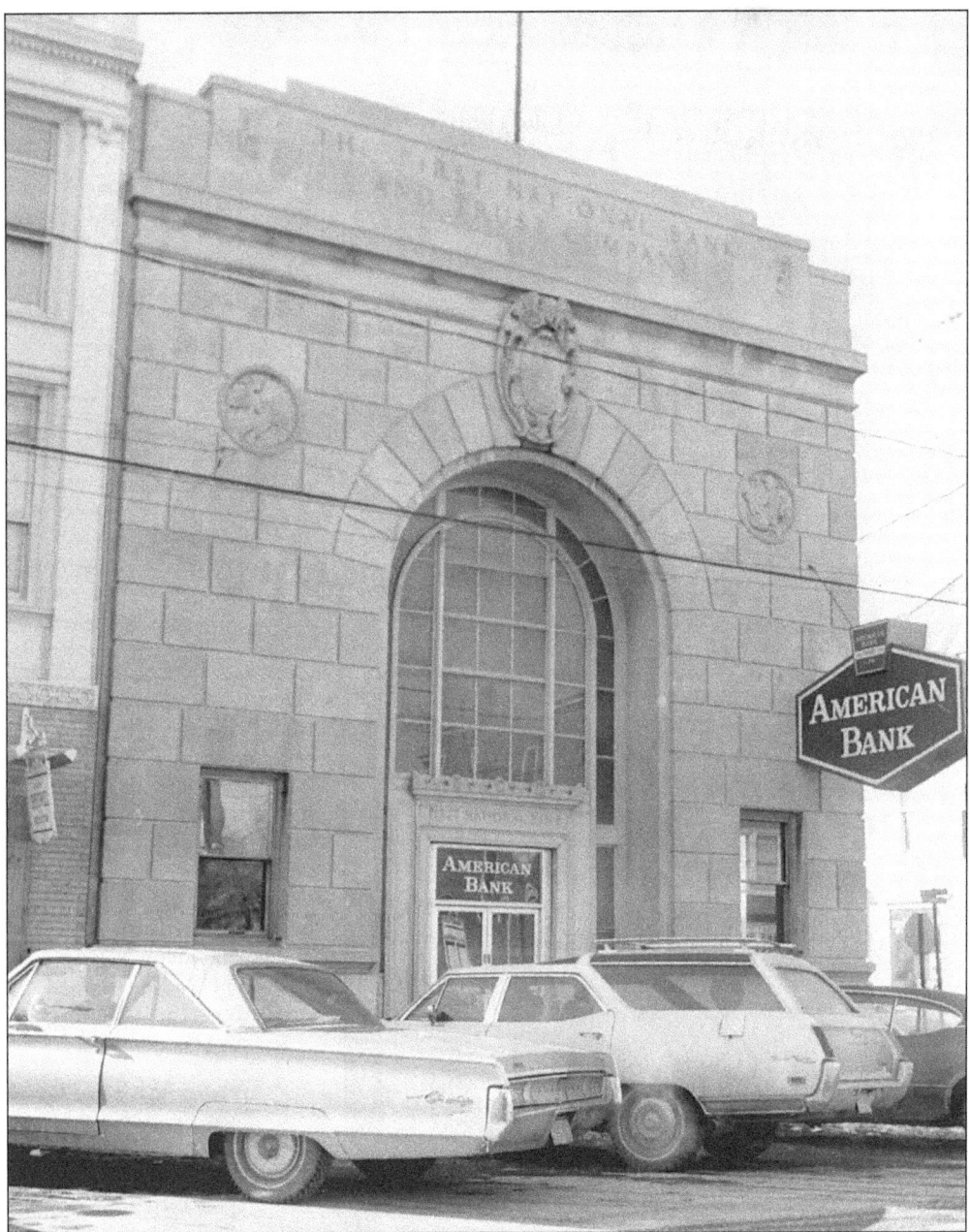

The First National Bank and Trust Company opened on February 7, 1934. In succeeding years, it was known as American Bank, Meridian Bank, CoreStates Bank in 1996, and First Union National Bank in 1998. At the time of this picture in 1977, the directors were Walter Baran, Harvey Cresswell, Felix DiCasimirro, John Domalakes, Paul D. Heck, Robert F. Hoppes, Victor Smith, Ben M. Stone, Joseph P. Swirsky, Russell Tatusko, and George H. Watkins.

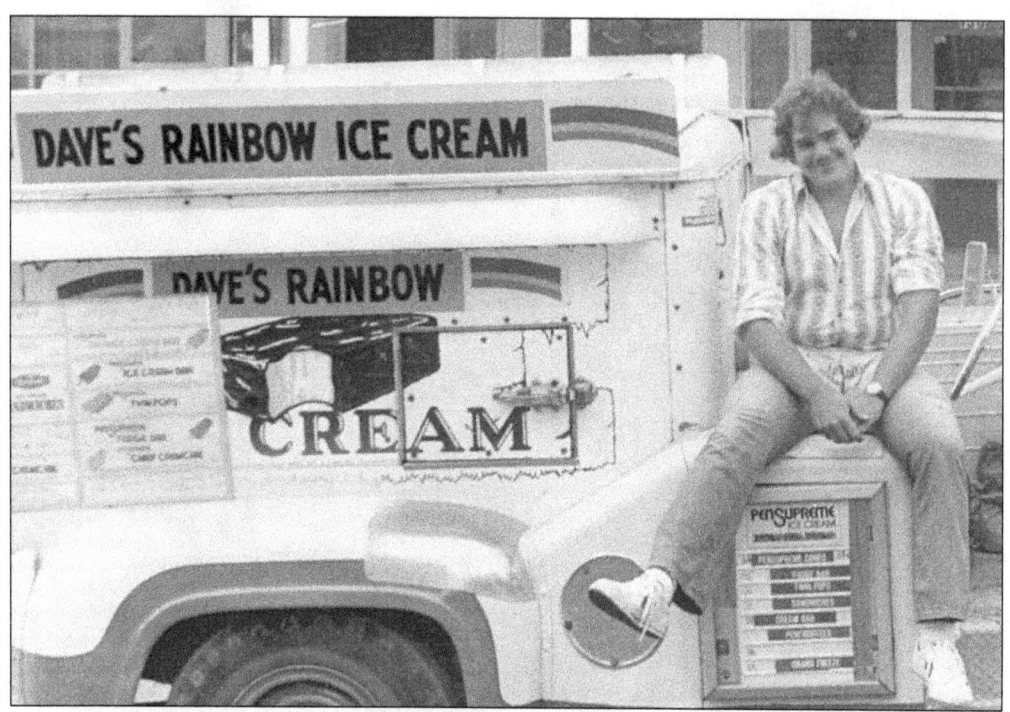

"Here Comes the Ice Cream Man," yelled Frackville children in July 1979. Dave Thomas, Frackville's teenage ice cream entrepreneur, sits on his truck, which could be seen blocks away. The white truck, sporting bright orange-and-red stripes and green wheels, was a sight to behold! Dave died on October 28, 1990.

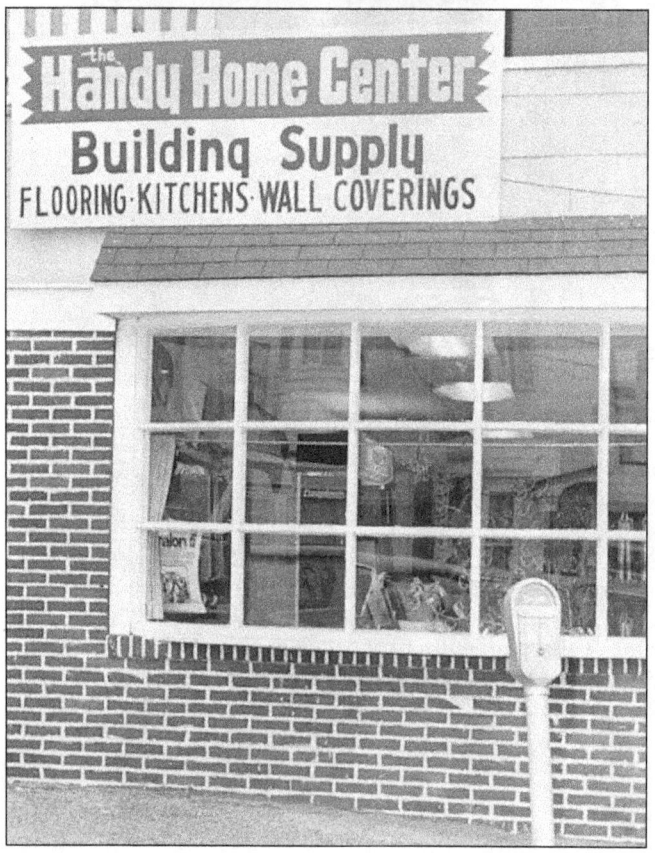

The Handy Home Center at 36 North Lehigh Avenue had its grand opening in July 1977. Selling various lines of Burlington carpet were Bob Walaconis (manager), Dennis Kitsock (salesman), and Joe Vanlinsky (stockboy).

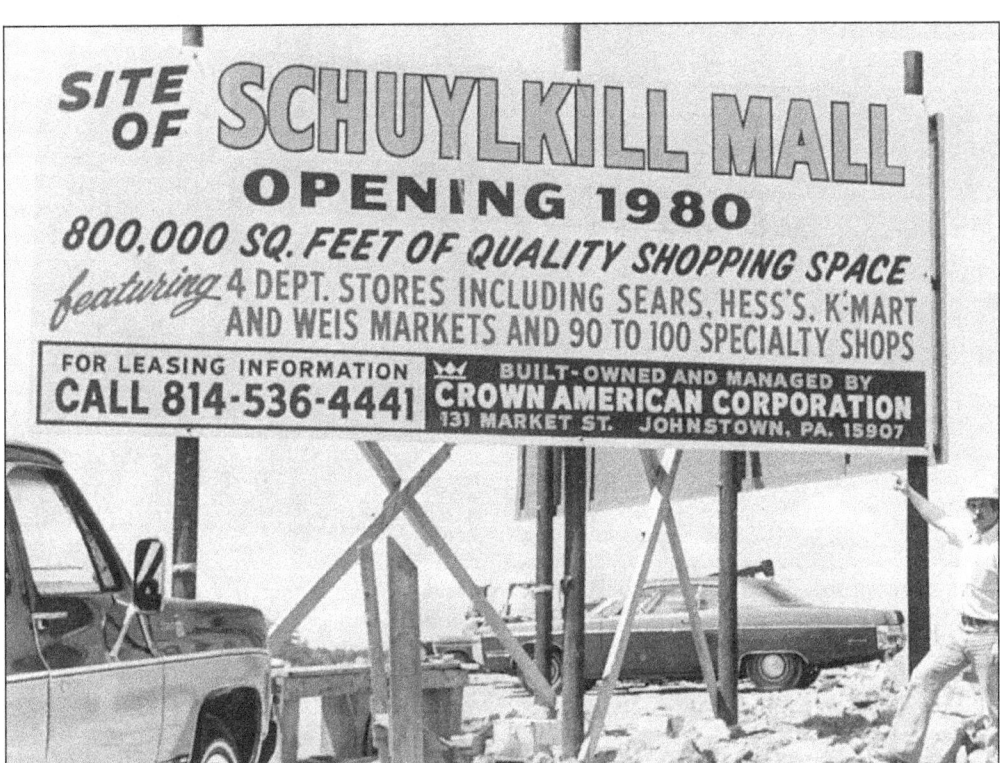

Construction on the Schuylkill Mall began in July 1979. This huge sign could be seen for miles from Interstate 81. The grand opening of the mall was October 9, 1980. Can you imagine life without it?

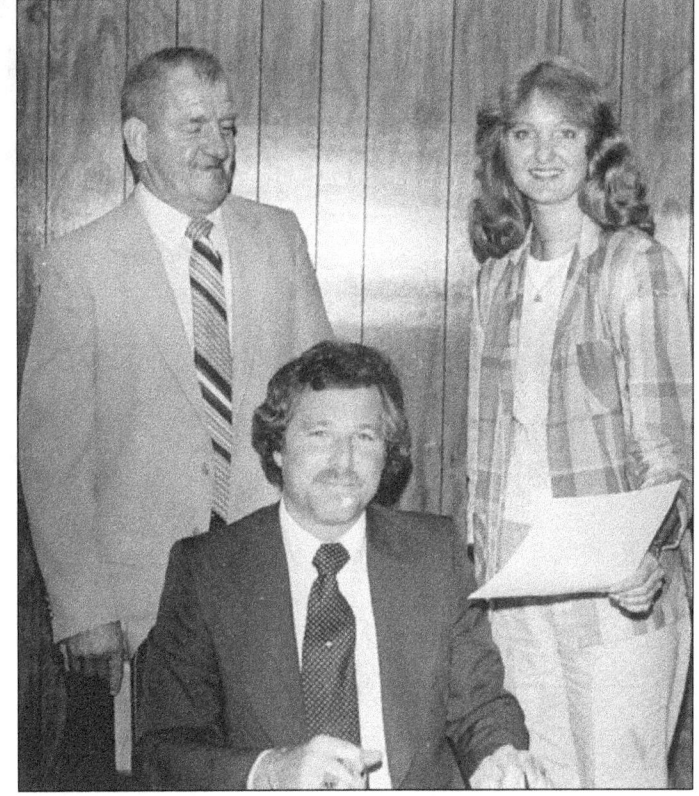

The Crown American Corporation, owner-developer of the Schuylkill Mall, announced the appointments of the mall's management staff. John Merinsky (foreman), David Siegel (manager), and Carol Zulewski (marketing director) are shown here in July 1980.

"The secret of success in business today is parking and any loss of meters is definitely going to hurt the merchants," stressed Leonard Wonderlick, a Frackville businessman. In July 1980, the newly installed parallel parking caused a controversy in the borough.

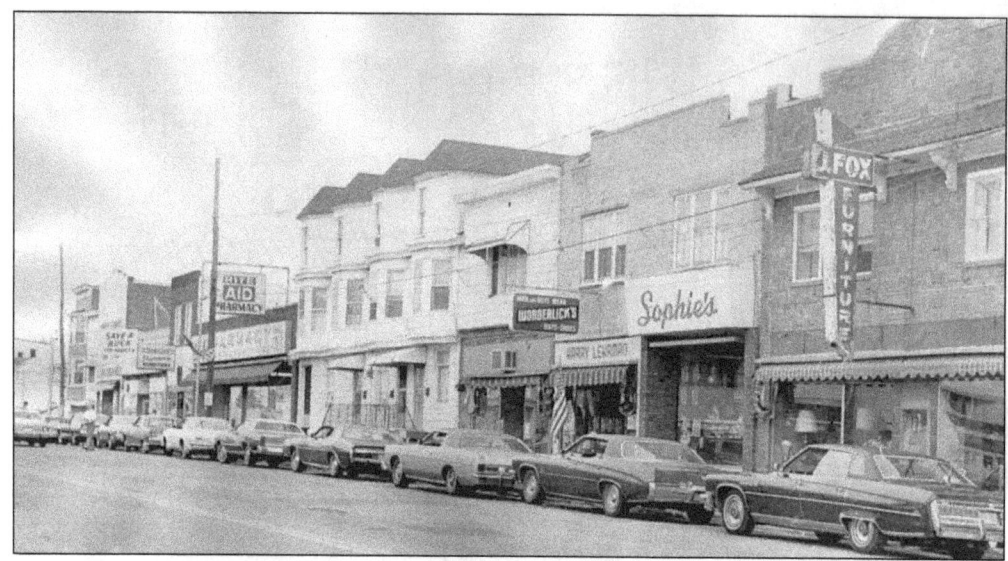

Sophie Yonalis (owner of Sophie's Gift's Shop), Leonard Wonderlick (owner of Wonderlick's Clothing Store) and Rhoda Klemow (owner of the Fox Furniture Store) show their displeasure at the removal of the old meters in order to make way for parallel parking in 1980.

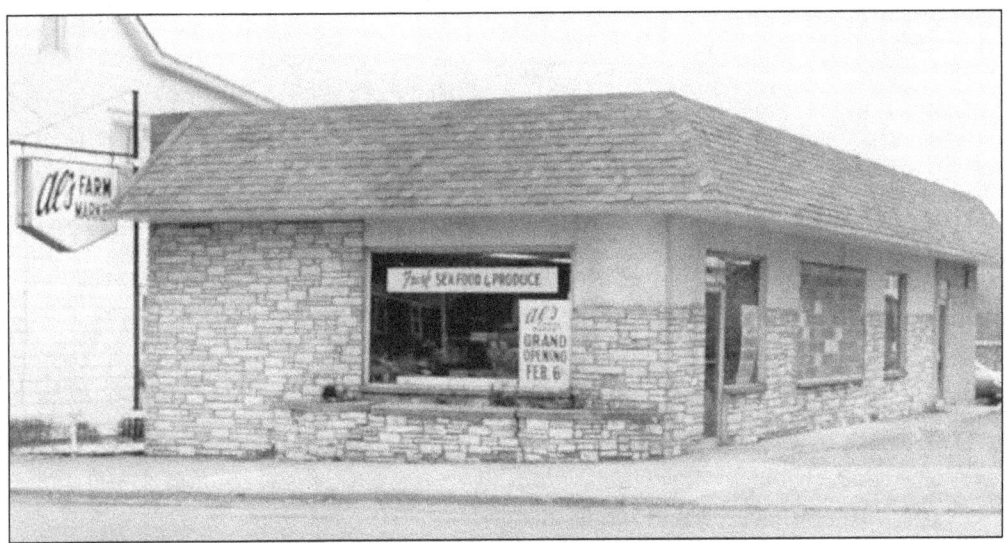

Al's Curbside Market at 112 North Lehigh Avenue was Frackville's newest business in March 1978. Ron Rader and Al Green were co-owners at that time.

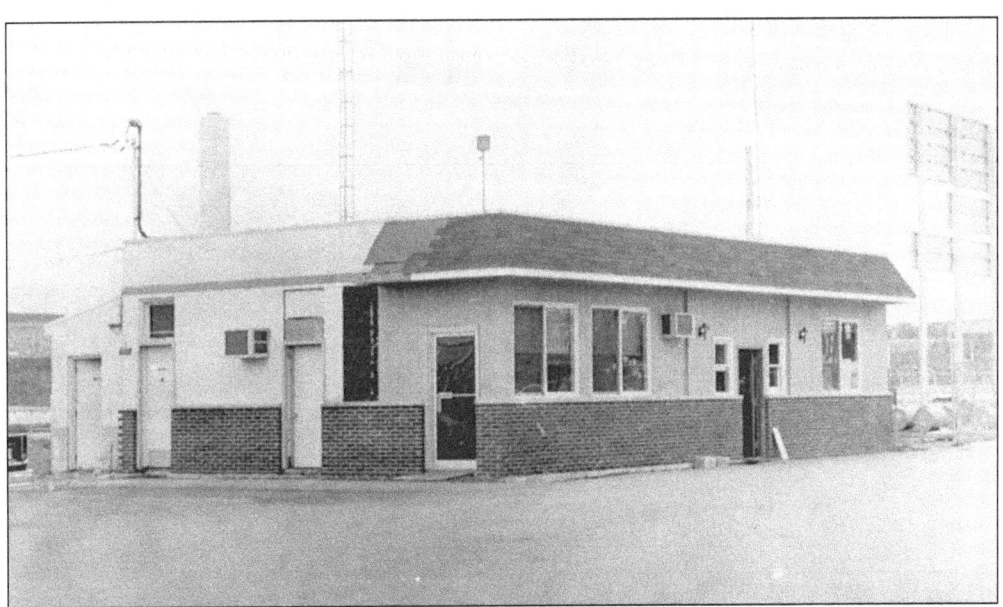

The Frackville Central Oil Company (now a Chevron service station) takes on a new look as the owners remodeled the structure in August 1980.

The Happy Times Nursery and Learning Center was located in the Bohard Building in May 1980. In September of that year a Montgomery Ward Catalog store located there. The building has since been demolished.

In October 1980, C.M. Offray and Son, a New York-based manufacturer of ribbons and narrow fabrics, started their company in the Pennsylvania Bedding Manufacturers Building at the Altamont section of town.

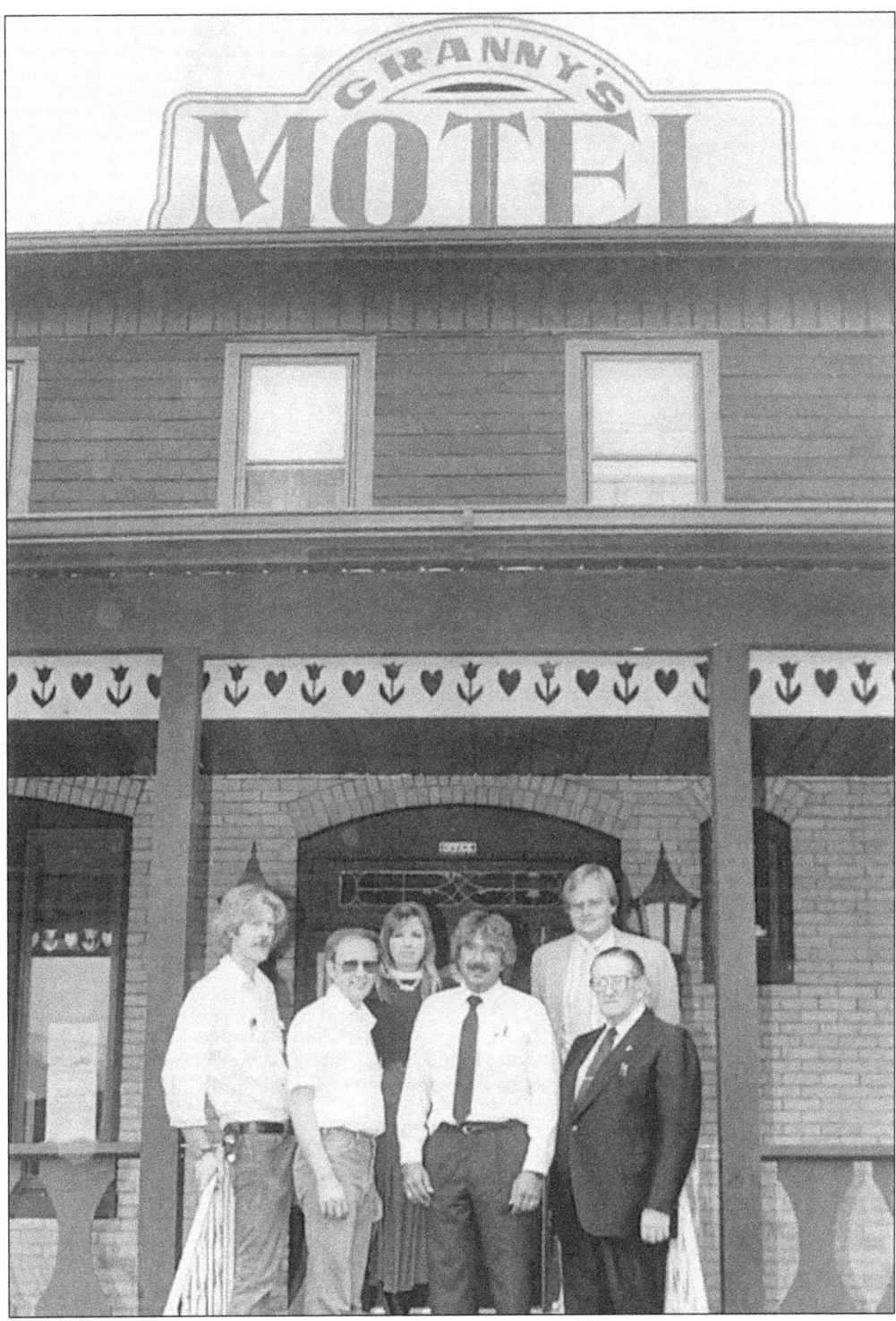

Standing in front of Granny's Motel and Restaurant in 1987 are, from left to right, as follows: (front) Bernie Pasker, owner Victor Prep, Leonard Trague, and William Griffins; (back) owner Eileen Prep and John Yanchulis.

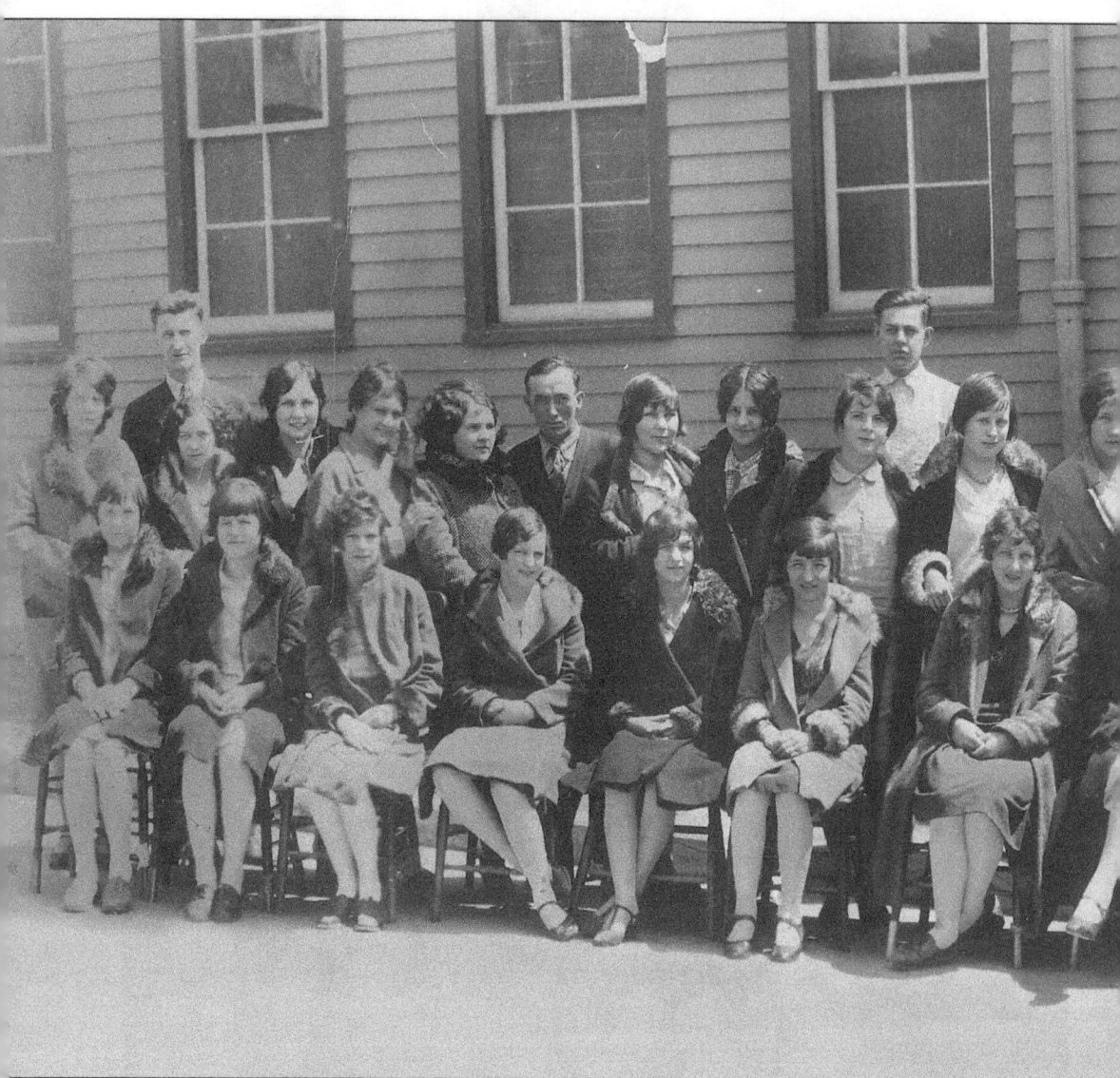
Manager William Bellas poses in front of the Frackville Manufacturing Company garment factory on West Oak Street between Lehigh and Balliet Streets. Later known as the Martin Dress Factory and then the Keystone Meat Company, it is now a vacant building. At one time,

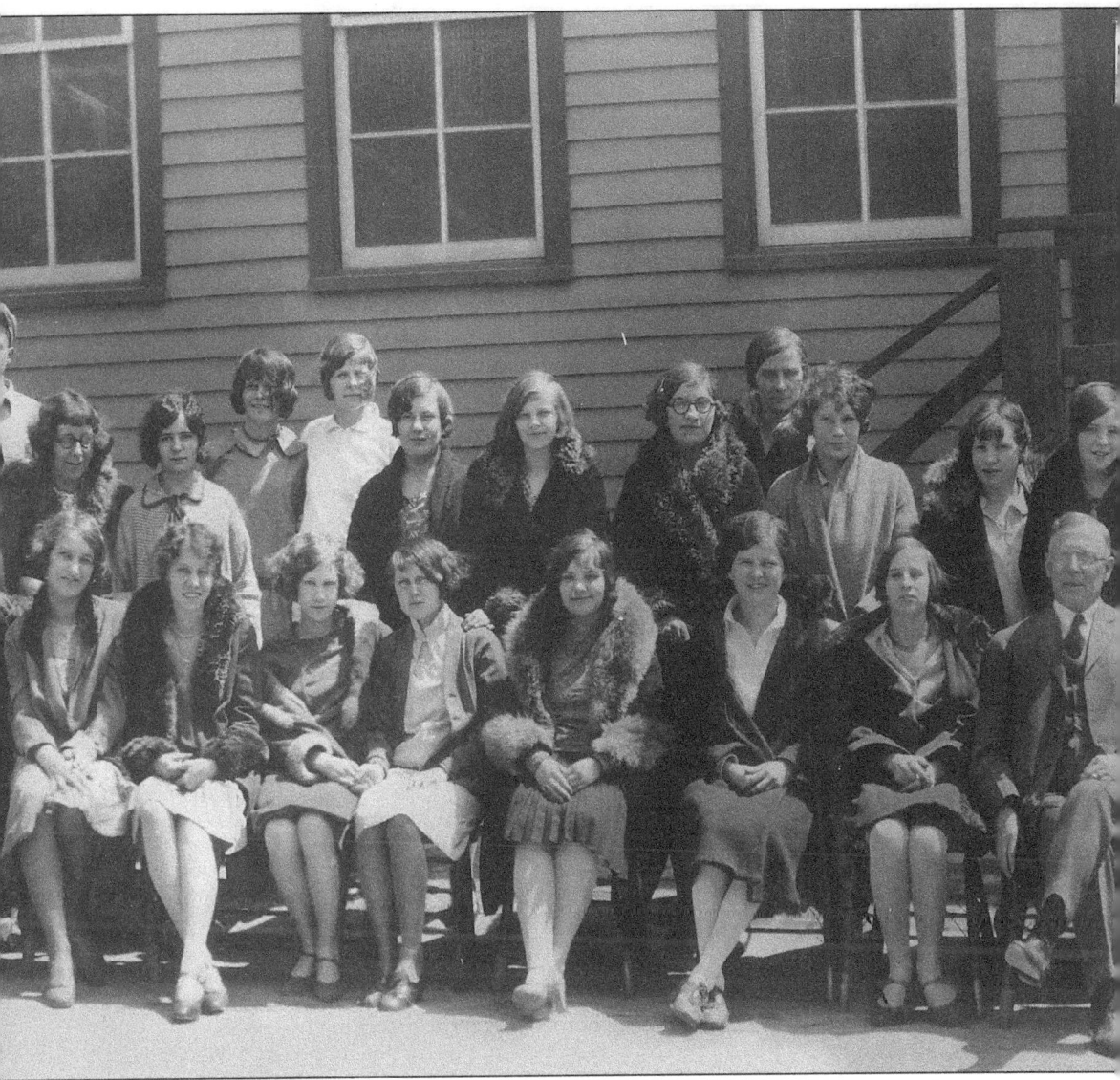

Frackville had several garment factories, which employed hundreds of women as production workers. When the coal mines closed, many women had to provide for their families. This panoramic view is so large it continues on the following two pages.

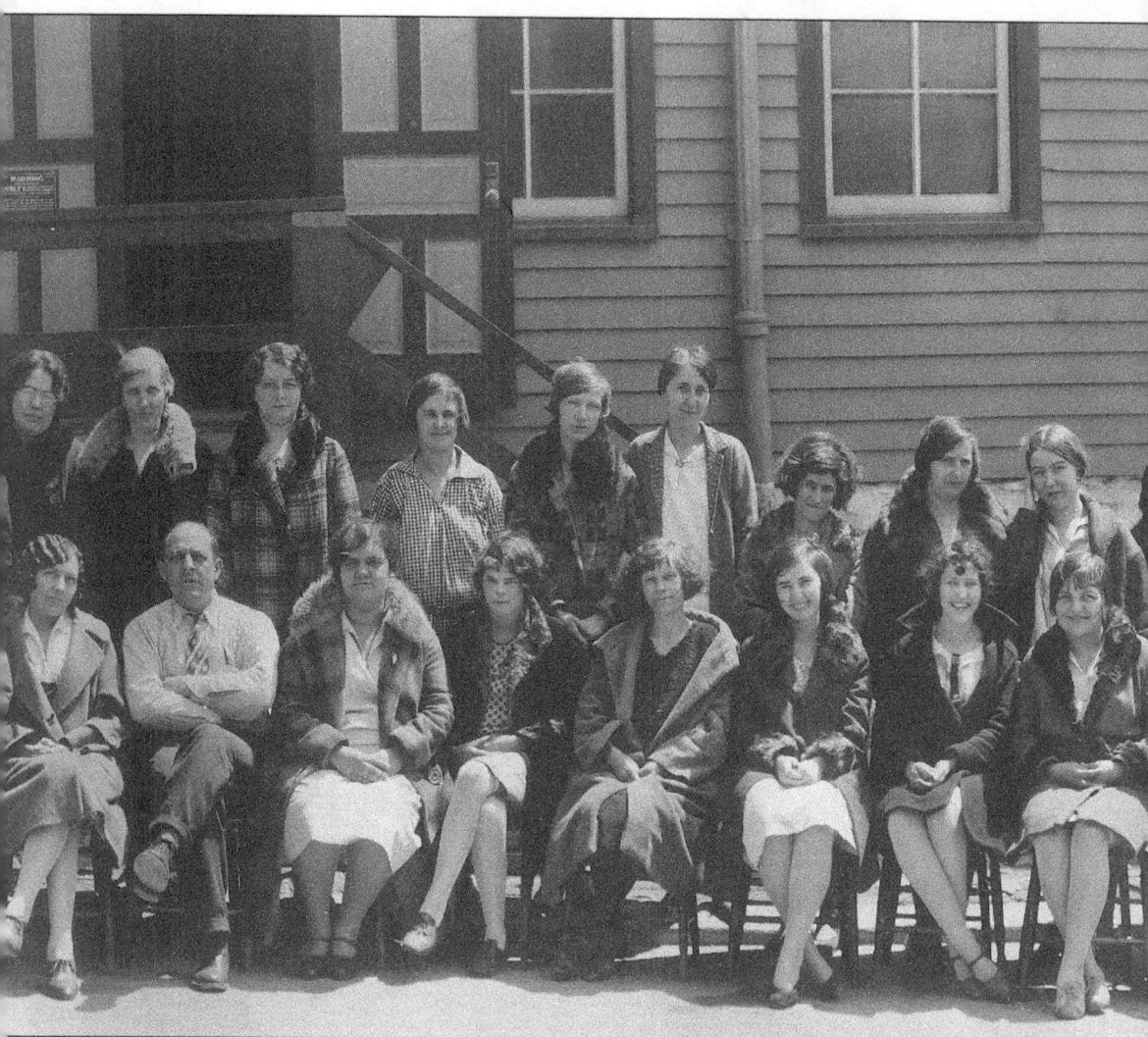

This is the other half of the panoramic photograph on the preceding two pages.

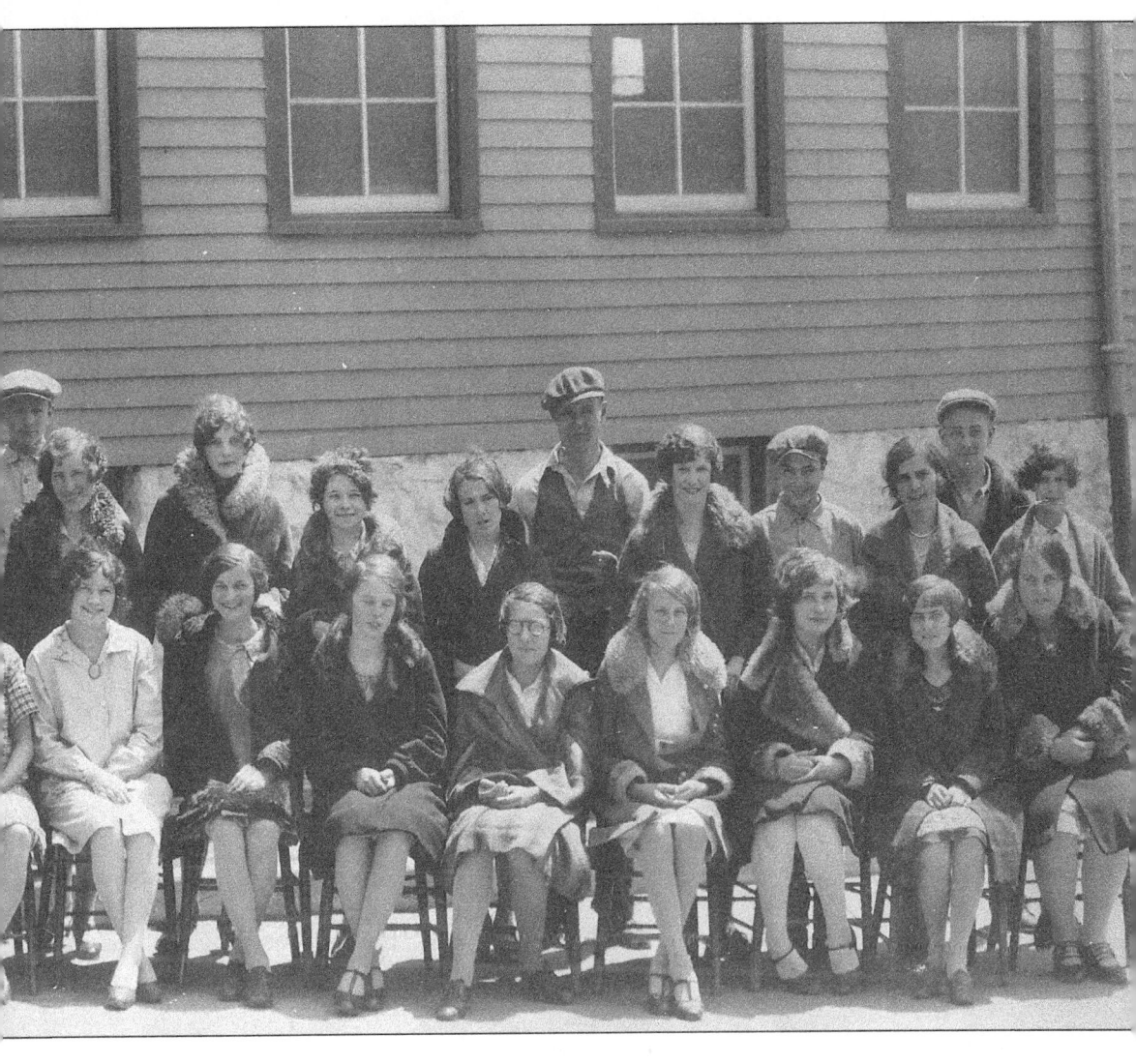

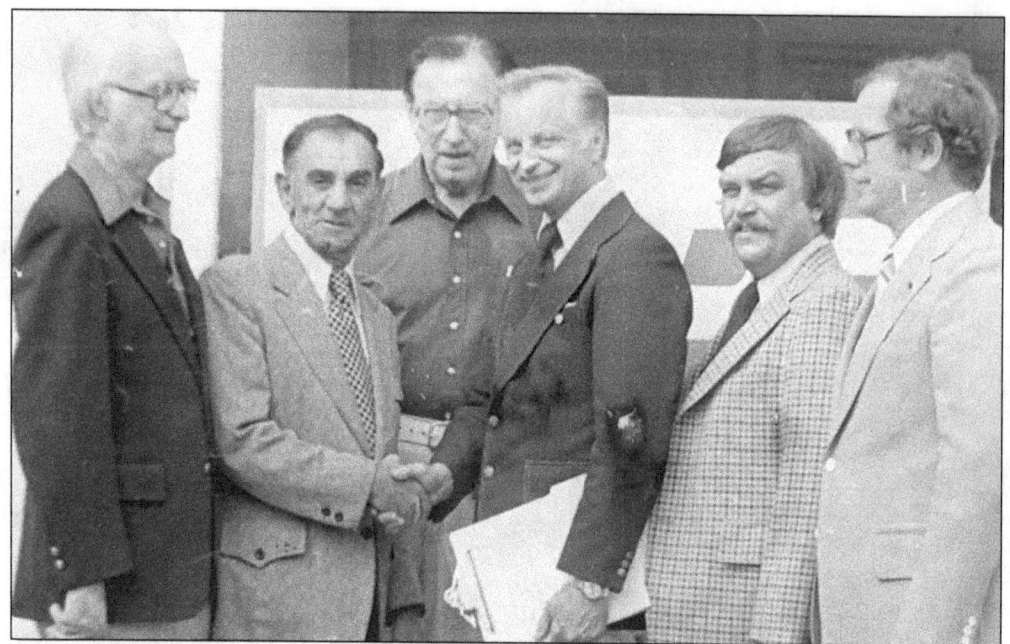
In 1980, the Shenandoah Job Service Office opened a branch in Frackville to handle all job services for the new Schuylkill Mall. Present for the opening day ceremonies were, from left to right, Willard Long, Mayor James Nahas, Leonard Kurlowicz, William Hendricks, Robert Kozak, and employment interviewer Dewaine Lutz.

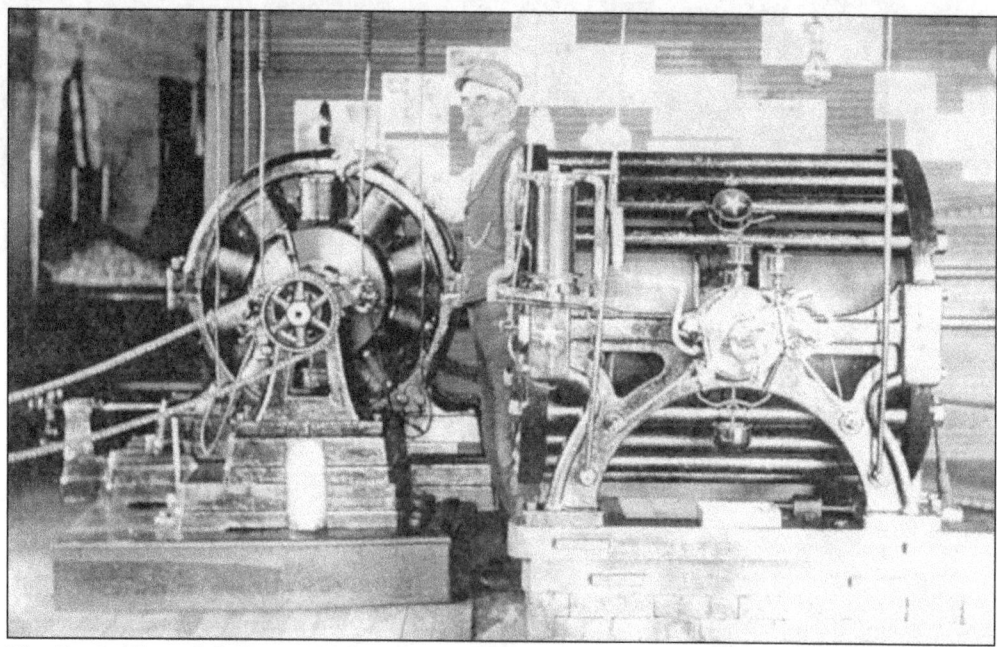
The Frackville and Gilberton Light, Heat and Power Company was incorporated on August 25, 1890, and became the first company to supply electricity to the borough of Frackville. In 1894, the company extended its services to the borough of Gilberton and then to Girardville. This photo from the Bevan family shows Thomas Vaughn at the Electric Power House in Frackville in the early years.

Three

ORGANIZATIONS

The Meredith Cornet Band of Frackville was organized by the Meredith brothers, John, Joseph, James, Samuel, and Asa. They were the sons of Lenora Frack and John Meredith and the grandsons of the founder of Frackville, Daniel Frack. This band was well known in the county and is shown in a parade at Mt. Carmel on June 12, 1913.

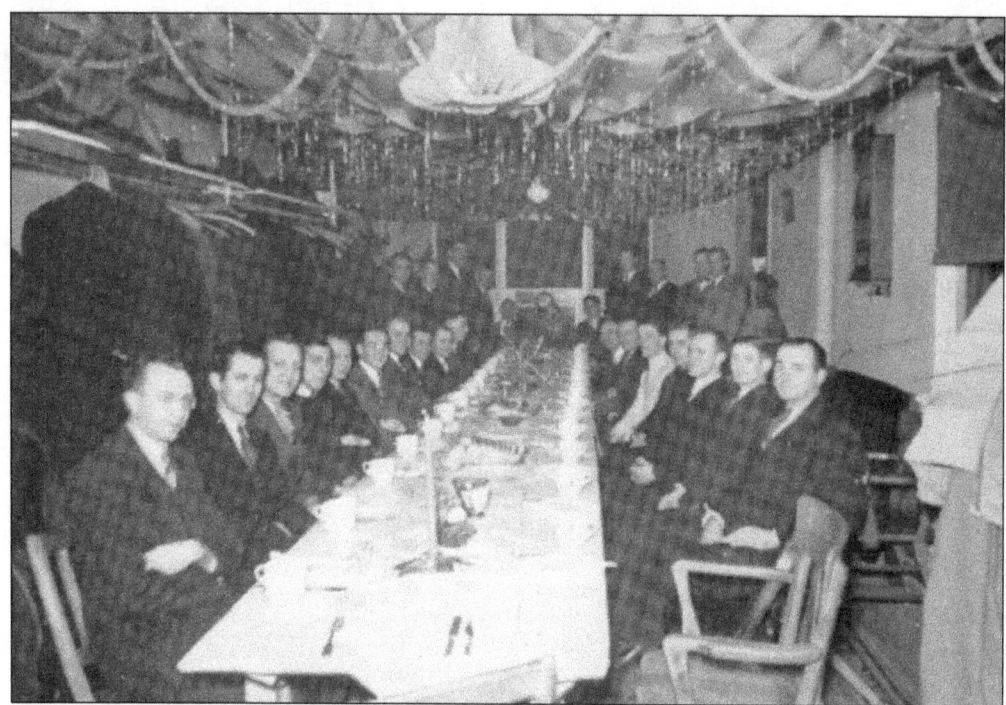

The Criterion Club of town met at 14–16 West Frack Street, the present location of the Law Building. Some of the members were Edgar Thomas, Kenneth Fry, George Wagner, Mr. Brocius, Luther Phillips, Walter Heim, Charles Hostler, Claire Hostler, Leroy Shirey, Walter Eisenhower, Robert Rogers, Jack Williams, Harry Turnbull, Red James, Harry Snyder, and Robert Hall.

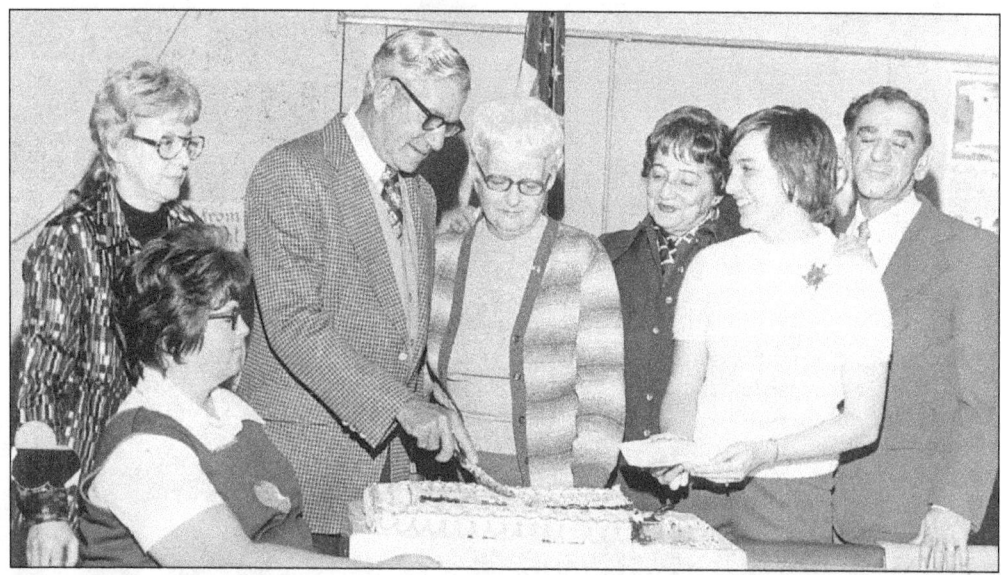

The Frackville Library celebrated its 35th birthday in 1974. Pictured are the following, from left to right: (seated) librarian Velma Sippie; (standing) Gertrude Schoor, John Lindenmuth (cutting cake), Barbara Grabey, Ruth Abeloff, Suzanne Domalakes, and Mayor James Nahas.

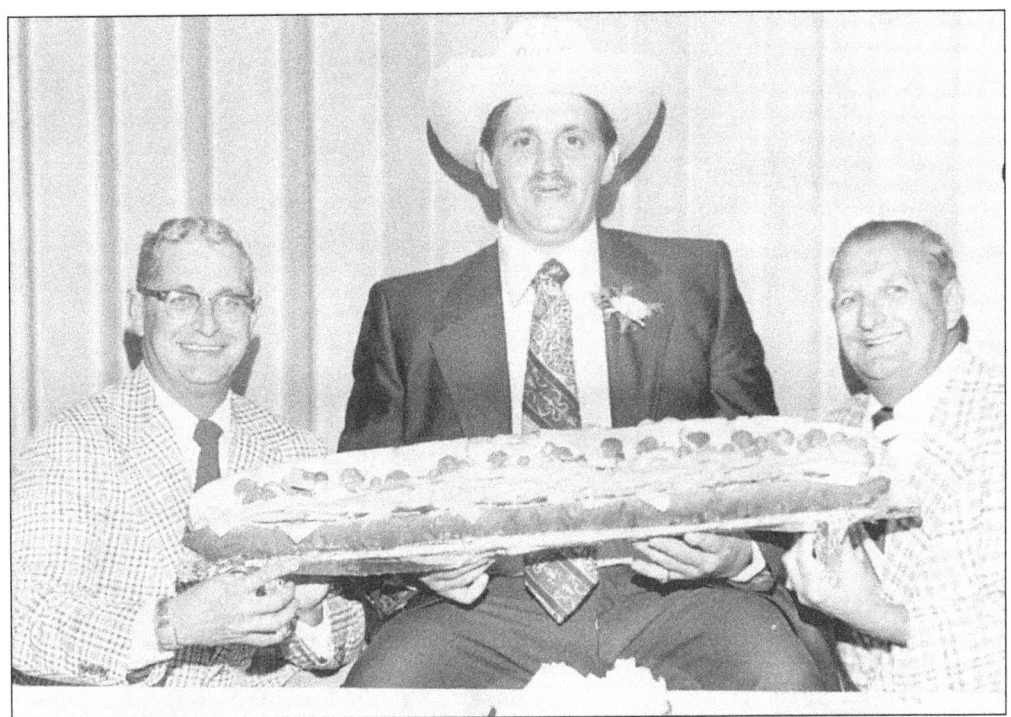

Raymond "Duke" Tomko (center) was honored as Elk of the Year in 1975. He was presented with this king-sized hoagie and ten-gallon hat from several of his Elk brothers. Duke was the mayor of Frackville from 1981 to 1993 and was the Exalted Ruler of Elks Lodge #1533 in 1998. Pictured are, from left to right, Troy Lindenmuth, Duke Tomko, and Eddie Lycoff.

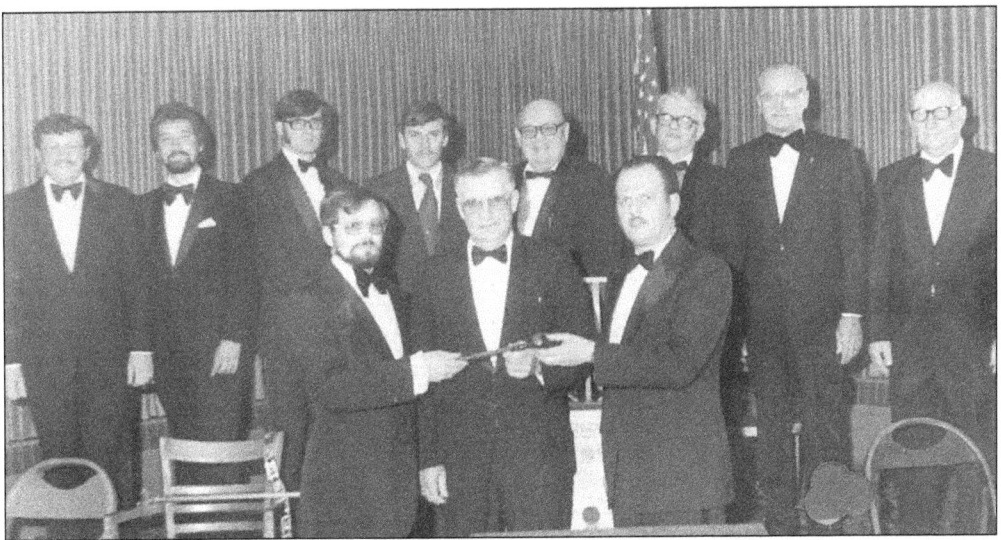

The Elks Lodge holds the installation of officers each April. Pictured from left to right are as follows: (front row) Donald Dillman (Exalted Ruler from 1976 to 1977), Woods Etherington (Exalted Ruler from 1972 to 1973), and Ronald Klemkosky (Exalted Ruler from 1975 to 1976); (back row) Joseph Meade, Dennis Kitsock, Bernard Brutto, Thomas Hinkle, Harold Bowe, Peter Becker, Claude Buchanan, and George Ebert.

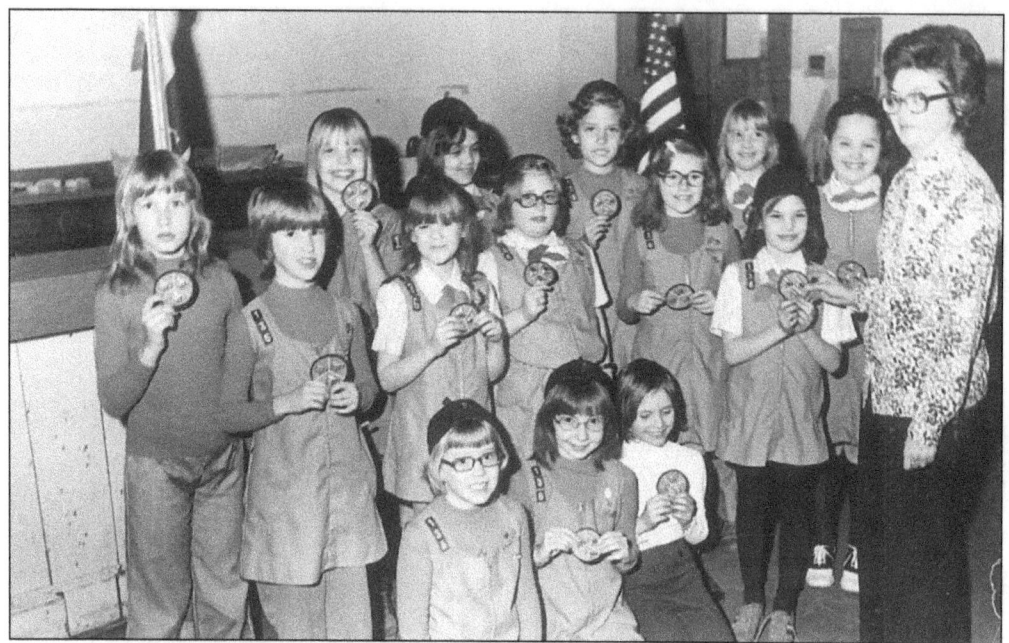

These brownies of Frackville Troop 136 distinguished themselves by being the first to receive the Brownie Patch for completing all the requirements to the Brownie Be's: Be a discoverer, Be a friendmaker, and Be a ready helper. Each "Be" had three divisions, including arts, home, and outdoors, making a total of nine requirements each girl had to attain. In this 1976 picture, from left to right, are the following: (kneeling) Lori Berg, Lisa Wiskerski, and Christina Trakes; (middle row) Marie Mastella, Cindy Hampton, Denise Reilly, Monica Ziegmont, and Joanna Payne; (back row) Janet Lazusky, Karen Boxter, Candice Lapp, Judy Lizewski, Joan Kastroba, Denise Damiter, and leader Mrs. Joanne Lazusky.

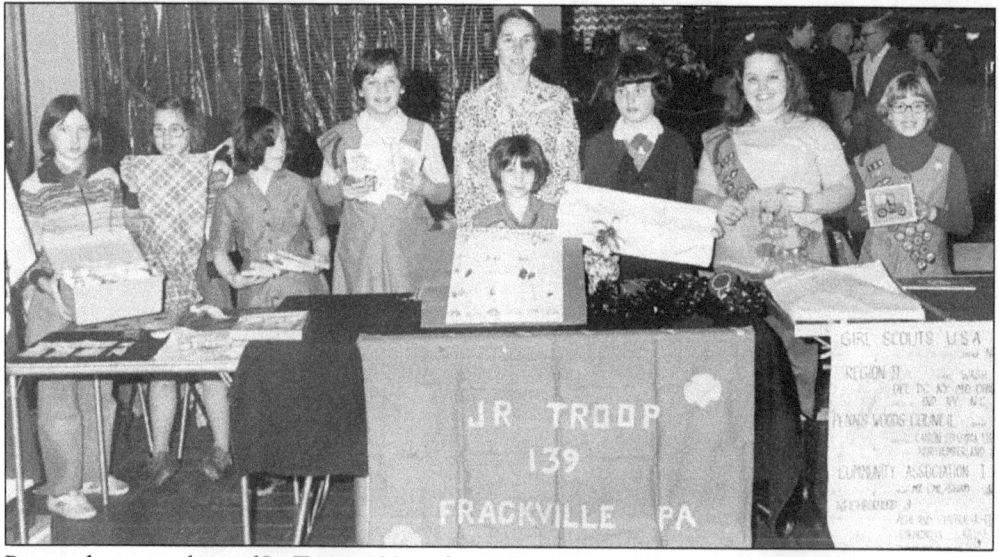

Pictured are members of Jr. Troop 139 at the 1979 Girl Scout Day at the Fairlane Village Mall showing their needle craft and sewing requirements. Shown are, from left to right, Kim Paletski, Colleen Paletski, Lisa Paletski, Michelle Selinko, leader Carol Ziegmont, Lisa Bainbridge, Barbara Bricker, Monica Ziegmont, and Lori Berg.

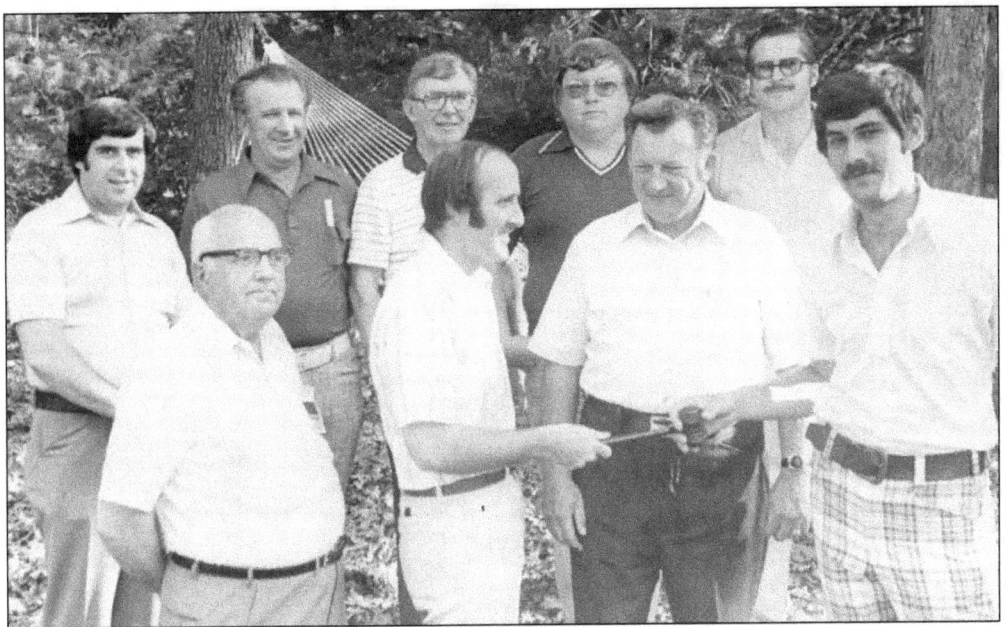

The Lions Club held their annual installation of officers at Baran's Grove in 1978. Pictured, from left to right, are the following: (front row) Andrew Bender (treasurer), Wayne Robbins (president), Ron Hinderliter (installing officer), and Michael Anthony (retiring president); (back row) Thomas Sullivan (second vice president), Carl Gerlott (lion tamer), Nick Tatusko (tail twister), John Niedzwiecki (first vice president), and Joseph Alshon (secretary).

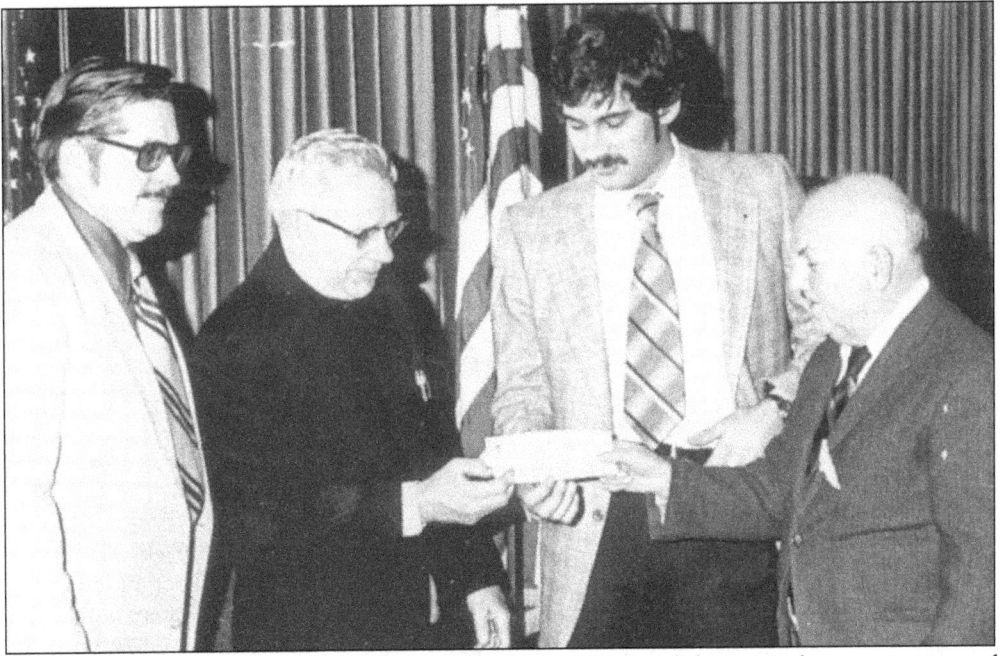

The Frackville Library has been the recipient of many financial donations by organizations of Frackville. The Lion Club's donation of $500 to the library fund in 1979 was presented by, from left to right, Joseph Alshon (secretary) Rev. Joseph Rapczynski (library treasurer), Michael Anthony (president of Lions), and Andrew Bender (treasurer).

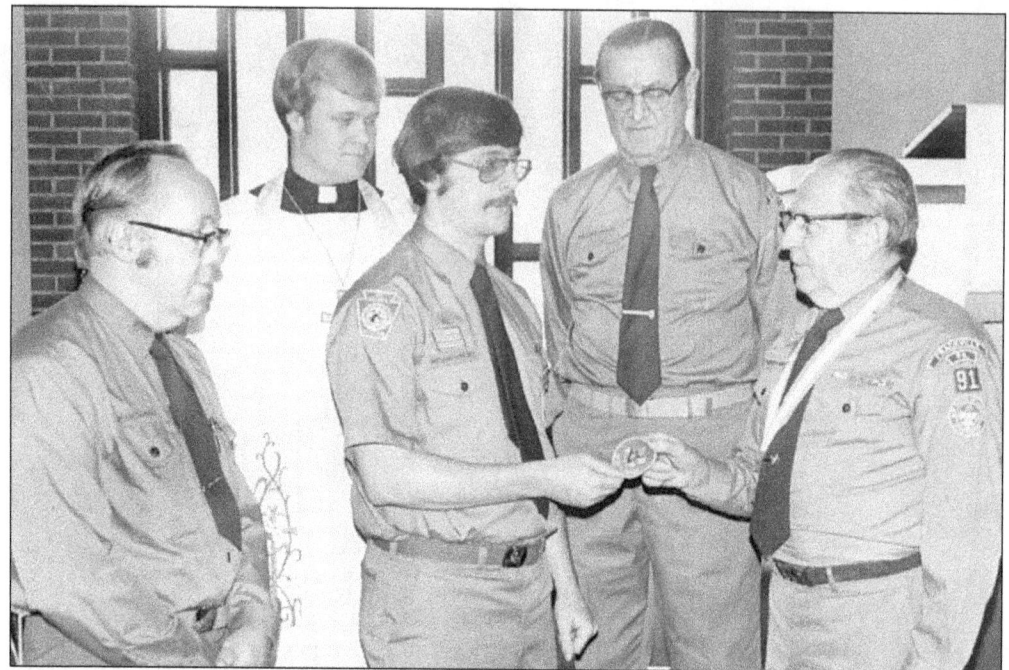

This photograph shows the change of scoutmasters for Troop 91 as Walter "Scotty" Bradbury ends his scouting career. Pictured are, from left to right, Ben Filer, Rev. Richard Harris (pastor of St. Peter's UCC Church), Ron James (new scoutmaster), Alex Koropchak (troop chairman), and Scotty Bradbury (retiring after 50 years).

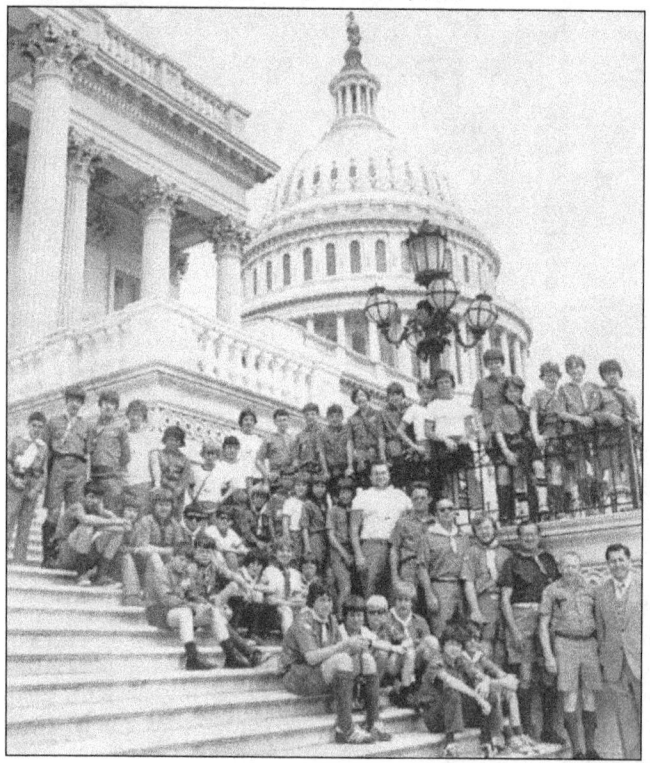

Members of Frackville Boy Scout Troop 91 are shown on the steps of the Capitol with Congressman Gus Yatron in July 1976. They enjoyed a week-long historical tour of Washington, D.C., and its vicinity.

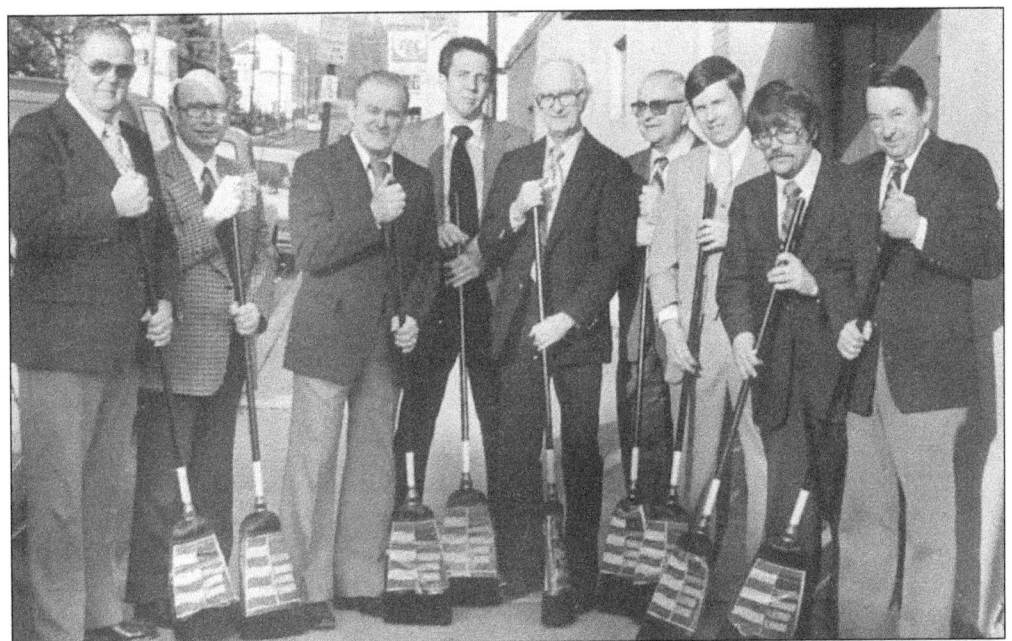

Frackville Rotarians hoped for a clean sweep in their 1980 broom sale. Rotarians pictured are, from left to right, Ken Sturm, Nick Corsi, Joe Swirsky, Ron Nice, Willard Long, Frank Zalskus, Toby Shimer, John Fields, and Joseph Probition.

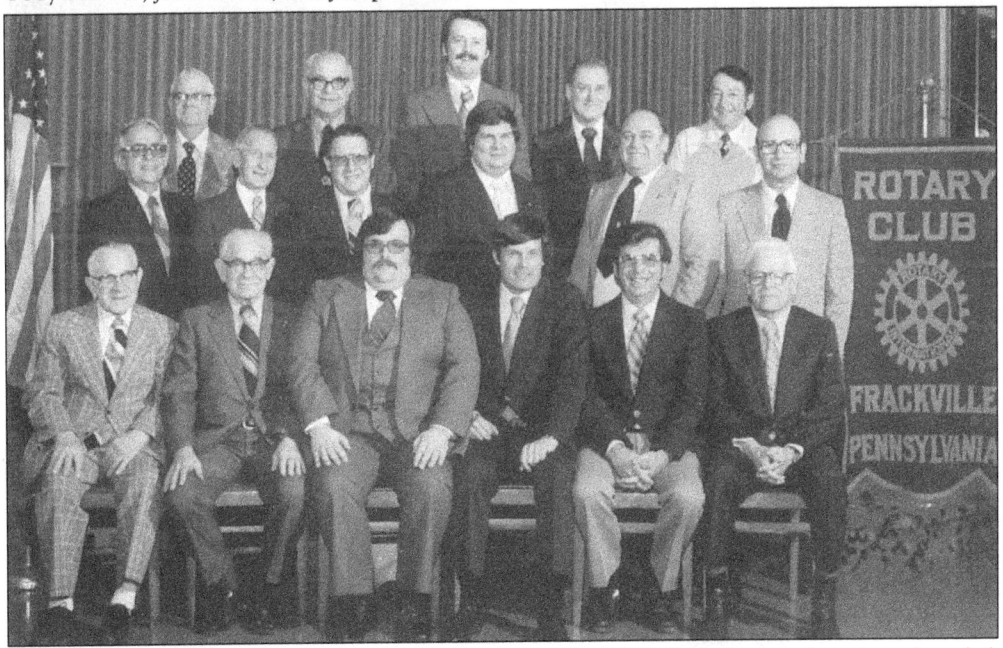

The Rotary held its 50th year golden anniversary in May 1978. Members at that time, from left to right, were as follows: (front row) Victor Smith, Harry Lehrman, John Fields (president), Toby Shimer (vice president), Daniel West (secretary), and Robert Hoppes (treasurer); (middle row) Paul Malinchock, William Kellett, Joseph Recla, John Domalakes, Harvey Cresswell, and Nicholas Corsi; (back row) Walter Mengel, Frank Zaylskus, Charles Miller, Joseph Swirsky, and Joseph Probition.

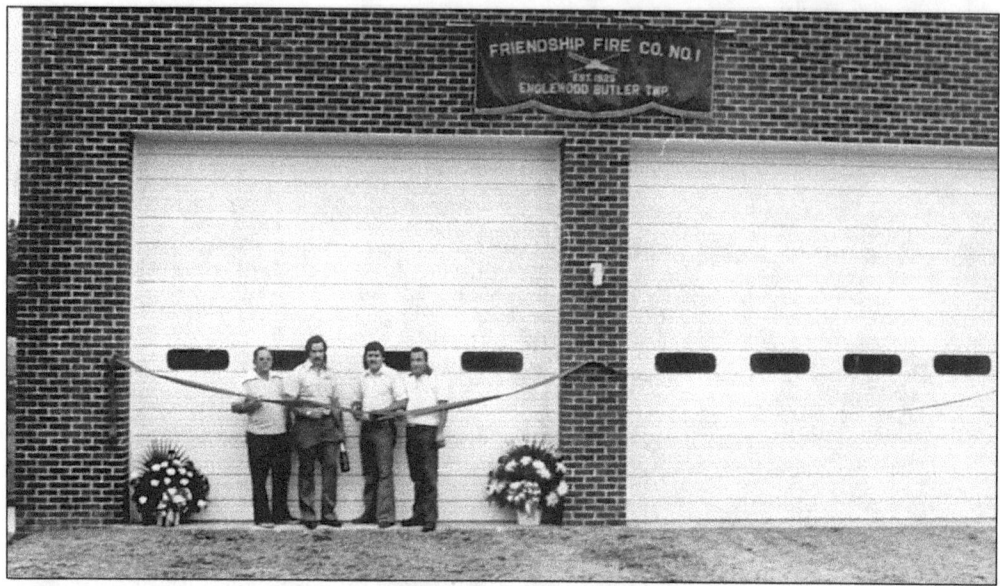

Ribbon cutting ceremonies were held in 1979 at the Friendship Fire Company's new building addition at Englewood. Pictured are, from left to right, Jack Blickley, Fire Chief Wayne Frantz (president), Anthony Vebrosky, and Alex Prock.

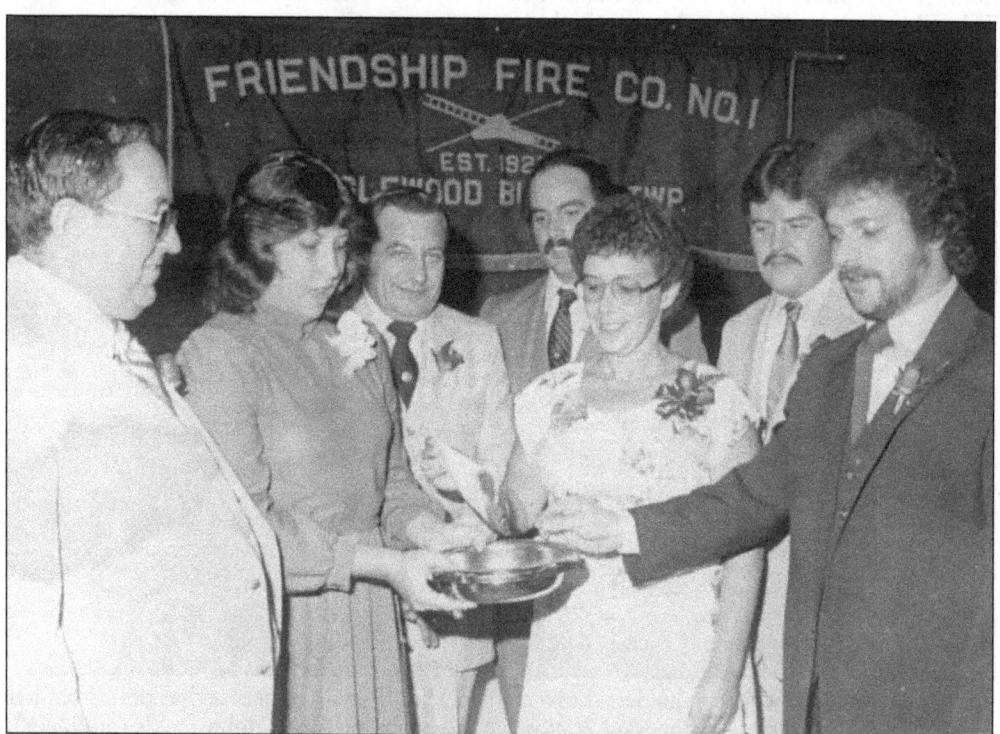

It was a great day for the officers and members of the Friendship Fire Company of Englewood with the ceremonial burning of the mortgage during a banquet and program at the firehouse in 1982. Taking part in the ceremony were, from left to right, Jack Blickley, Cindy Damiter, Alex Prock Sr., Wayne Frantz, Doris Roberts, Anthony Vebrosky, and Alex Prock (president).

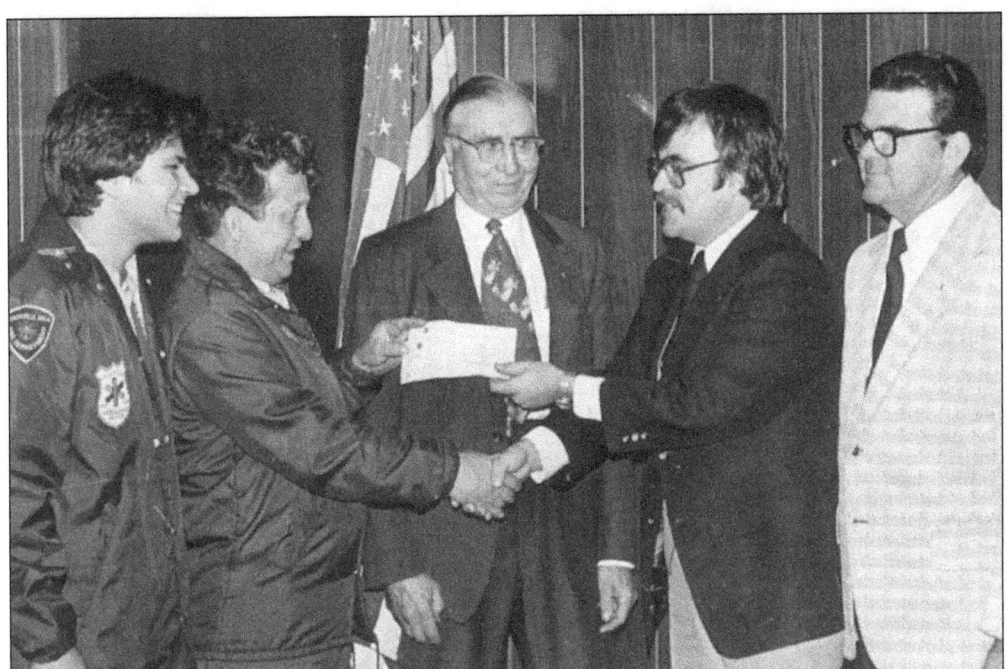

In 1979 the Frackville Knights of Columbus put some teeth in the Goodwill "Jaws of Life" fund by presenting a check for $500 and an additional $50 as their annual contribution to the ambulance association. Pictured are, from left to right, Arthur Kaplan, David Dillman, Peter Kowker (KofC treasurer), John Fields (grand knight), and Francis Heine (financial secretary).

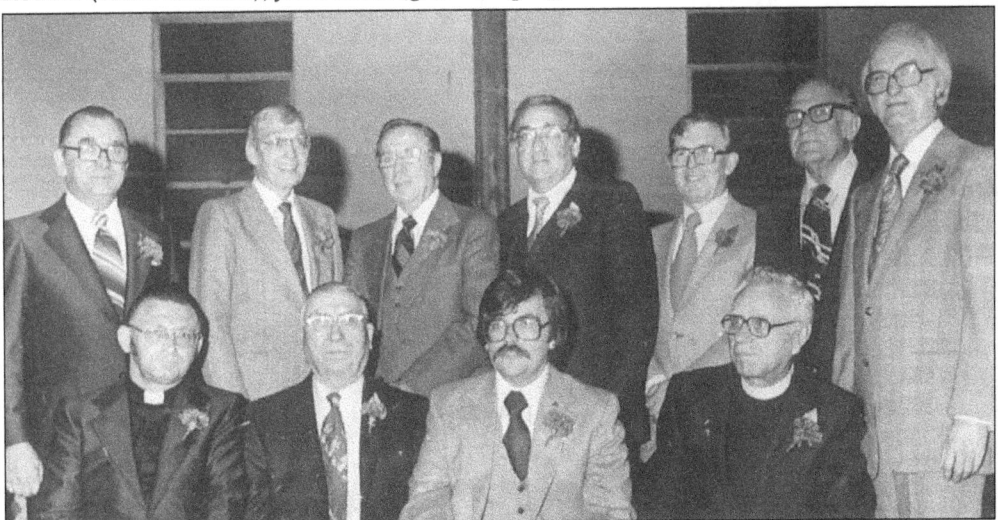

Wally Baran has been "roasted" so many times he's no longer rare—but well done! In 1979, the Knights of Columbus roasted him, and some of the comments were, "He's so religious, he wears stained-glass spectacles! His antique cars are so old, they don't use antique plates—they use uppers and lowers! He's so conservative that if he was at the Last Supper, he'd ask for separate checks! When he was in the hospital, the only get well card he received was from the Blue Cross!" Pictured, from left to right, are as follows: (front row) Rev. Al Bartkus, Peter Kowker, John Fields, and Rev. Joseph Rapczynski; (back row) Eli Hancher, Wally Baran, Judge John Lavelle, Arnold Delin, Nick Tatusko, Joseph Drasdis, and Willard Long.

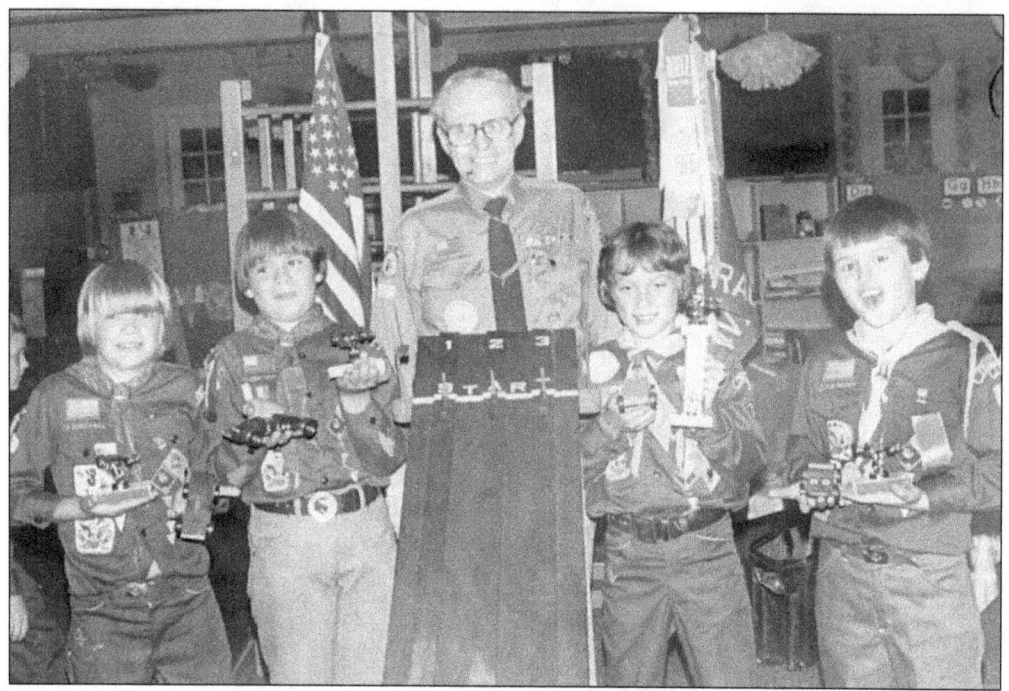

Frackville Cub Pack 790 held its annual Pinewood Derby in 1979, and the winners posing with Cubmaster Robert Berg (center) were, from left to right, Robbie Wertz, Jack Lazusky, Ronald Antalosky, and Sherwood Robbins.

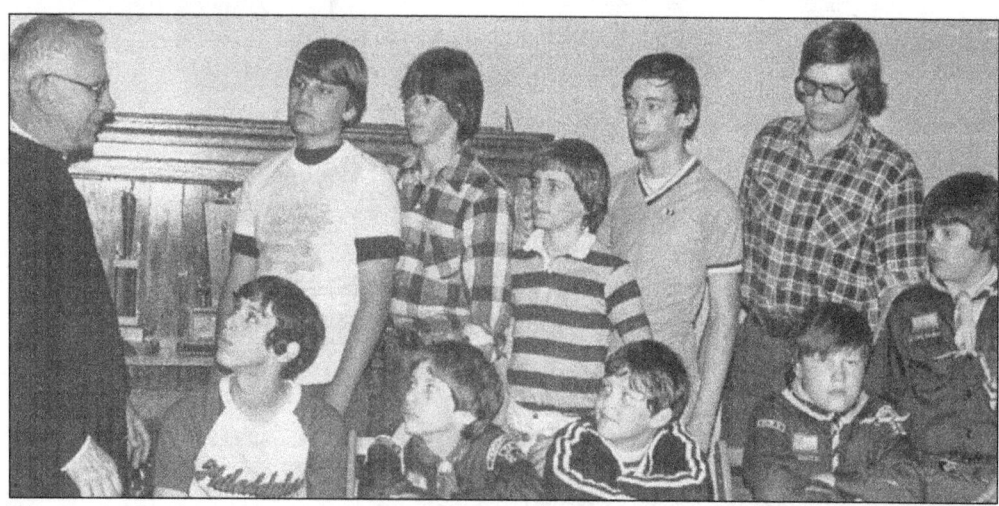

The Frackville Troop 789 scouts were advertising for a scoutleader in 1979. Pictured with Rev. Joseph Rapczynski (left) are the following, from left to right: (front row) Richard Kenton, Scott Gergal, Paul Burda, Derek Yankiewicz, and John Budwash; (back row) David Gricoski, Gary Burda, Steve and Tom Dellock, and assistant Joe Kaledas.

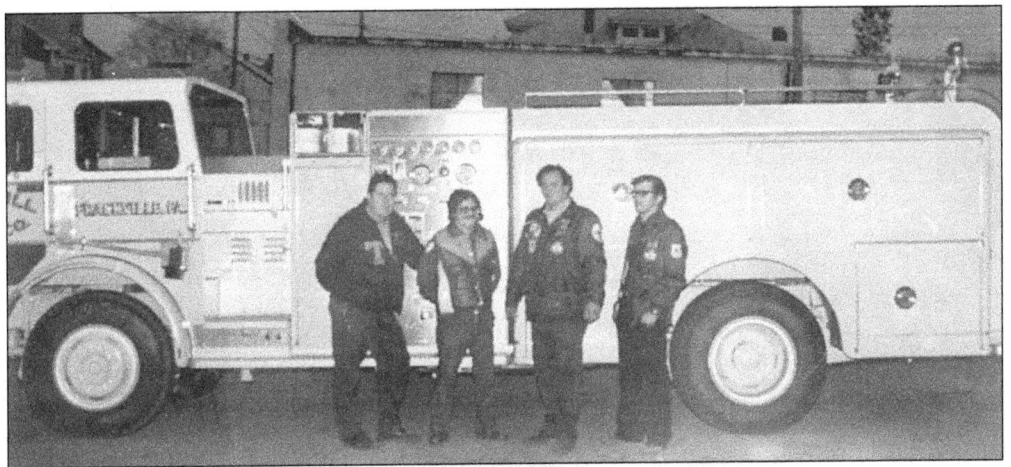

This 1980 Hahn 1,000-gallon pumper was delivered to the Goodwill Hose Company in 1979. Pictured with the new truck are, from left to right, James Gervel (driver), Albert Dillman (first assistant), Robert Thomas (fire chief), and Richard O'Donnell (assistant fire chief).

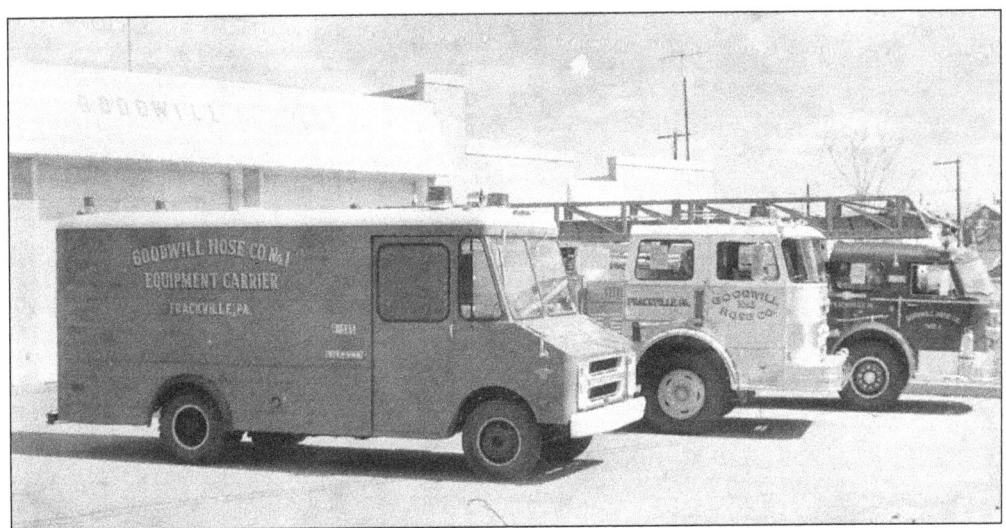

The Goodwill Hose Company was organized in October 1910 and incorporated November 15, 1910. They received their charter on December 19, 1910, and are still active in the community. This 1980 picture shows the equipment carrier and fire trucks parked in front of the Goodwill Hose Company on South Balliet Street.

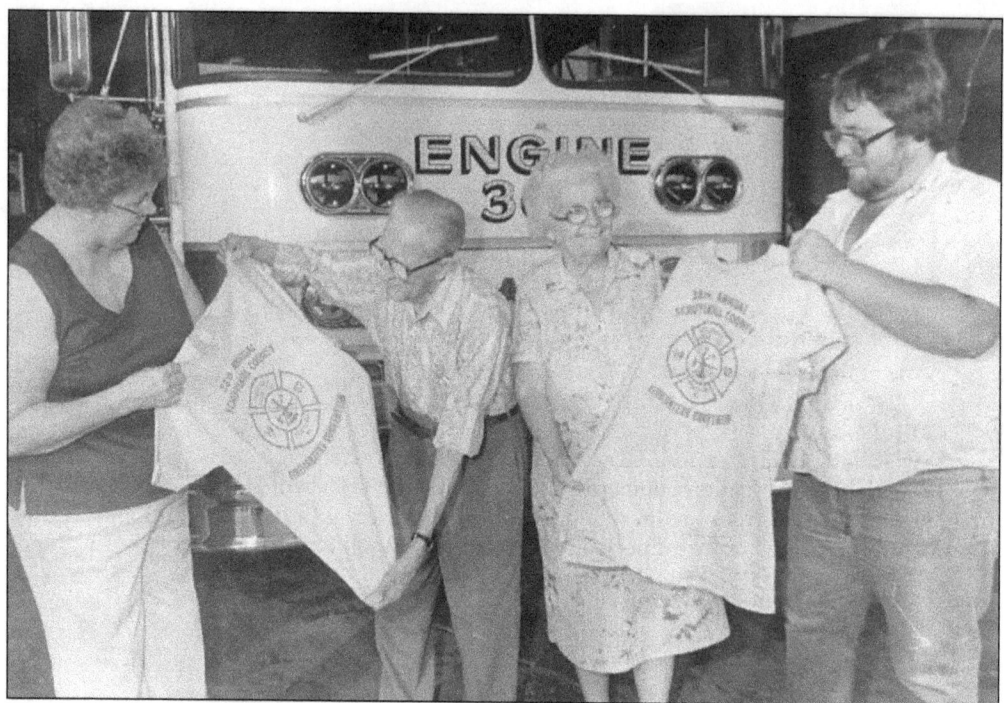

The Six County Firemen Convention was held in 1982, and one of the fund-raising projects was selling convention shirts. Shown displaying shirts are, from left to right, Jean Lipshaw, Joel Felsburg, Ethel Leiby, and Joseph Rubright.

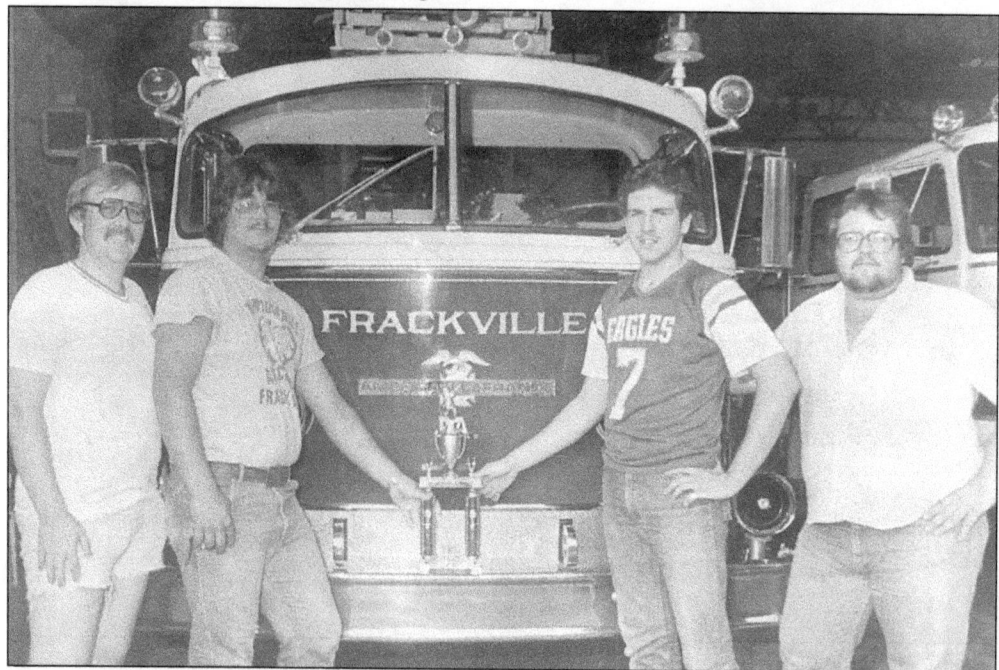

The Goodwill Hose Company received this trophy in 1982 for their 1974 LaFrance ladder truck. Pictured with the prize-winning vehicle are, from left to right, Michael Swartz, Edward Lizewski, Steven Malinchock, and Joseph Rubright.

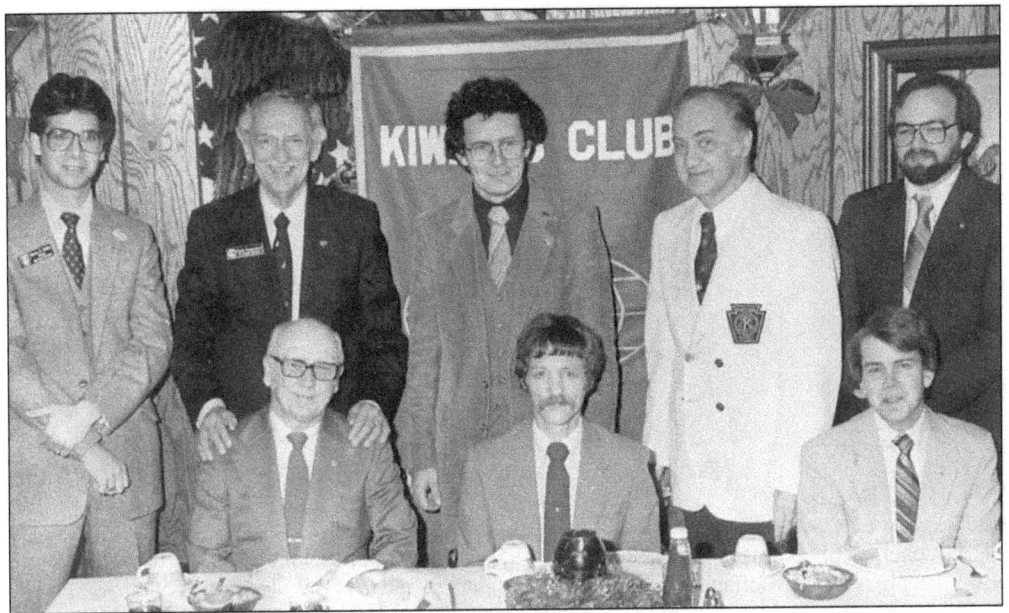

The officers of the Kiwanis Club in 1982 were from left to right, as follows: (seated) William Dunleavy, Richard Fletcher, and Steven Owens; (standing) Bruce Kelley, Claude Sweppenhiser (Pennsylvania district governor), David Bowen (president of Frackville Kiwanis), Al Foltin (Pottsville organizer), and Jack Biddle (president of Pottsville Kiwanis).

The Frackville Catholic Daughter officers in 1979 were, from left to right, as follows: (front row) Dorothy Rader, Lenore Yashin, Dorothy Solinsky, Ann Bendrick, Joyce Torpey, and Jean Tomalavage; (back row) server Paul Smiley, Regina Tyson, Judith Smiley, Rev. Joseph Rapczynski, Rev. William Conley, Rev. Al Bartkus, server Joseph Bluge, Helen Mengel, and Jean O'Boyle.

St. Michael's Holy Name Society officers in 1980 were the following, from left to right: (front row) Joseph Snitzer, Michael Wardigo, John Tacelosky, and George Shimko; (back row) Pastor Msgr. Joseph Batza, Alex Koropchak, Michael Cooper, Michael Pavlishin, John Fields, and Michael Kupcho.

The 1979 Borough Council was installed with the following members, from left to right: (seated) Mayor James Nahas, Donald Dillman, John Chuma, and Manny Lightstone; (standing) John Domalakes, Raymond Tomko, David Boyer, Michael Denchak, and Frank Mirocke.

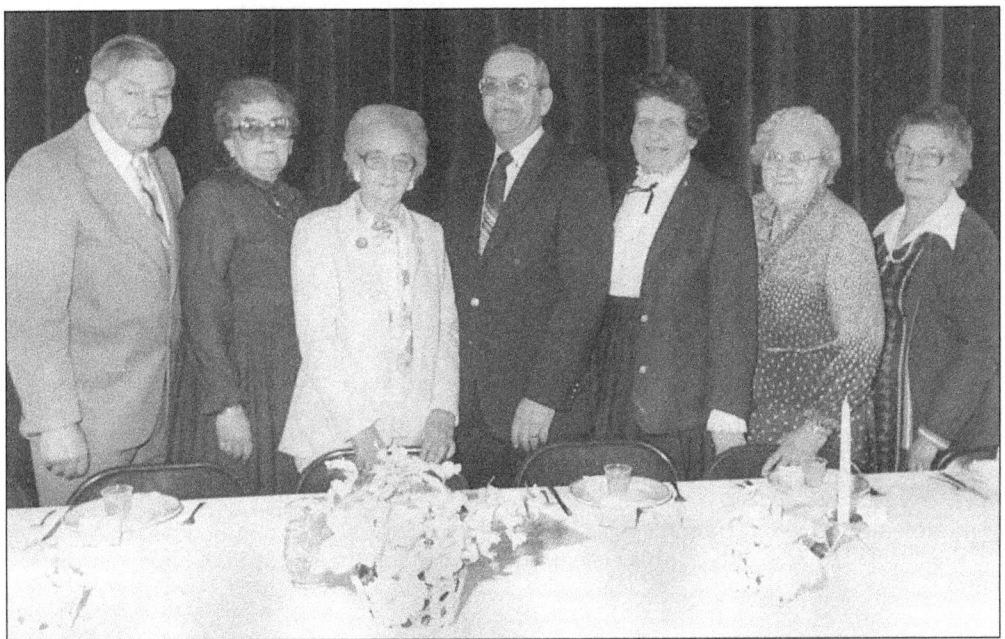

The Frackville Seniors held their 19th anniversary banquet at the Annunciation BVM Hall in May 1984. Officers installed were, from left to right, Joseph Grabuskie (trustee), Lucille Klock (recording secretary), Helen Baney (vice president), Grant Klock (president), Ann Yatcilla (financial secretary), Mary Kuschick (trustee), and Helen Dower (trustee).

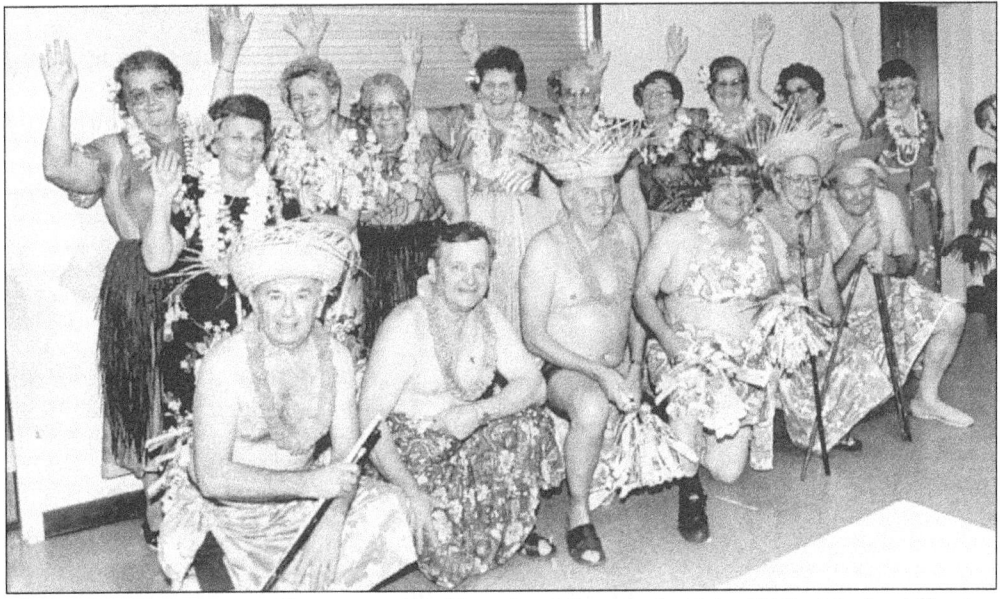

The senior citizens are still enjoying life. Hawaiian Nite was held in 1986 with the following participants, from left to right: (kneeling) Harry Smith, Michael Homa, Morris Puls, Frank Mazur, Walter Evans, and Joseph Grabuskie; (standing) Faye Mazur, Esther Smith, Liz Puls, Eva Homa, Ann Yatcilla, Aldona Tragus, Helen Smilanich, Mary Pascavage, Sophie Osenbach, and Esther Evans.

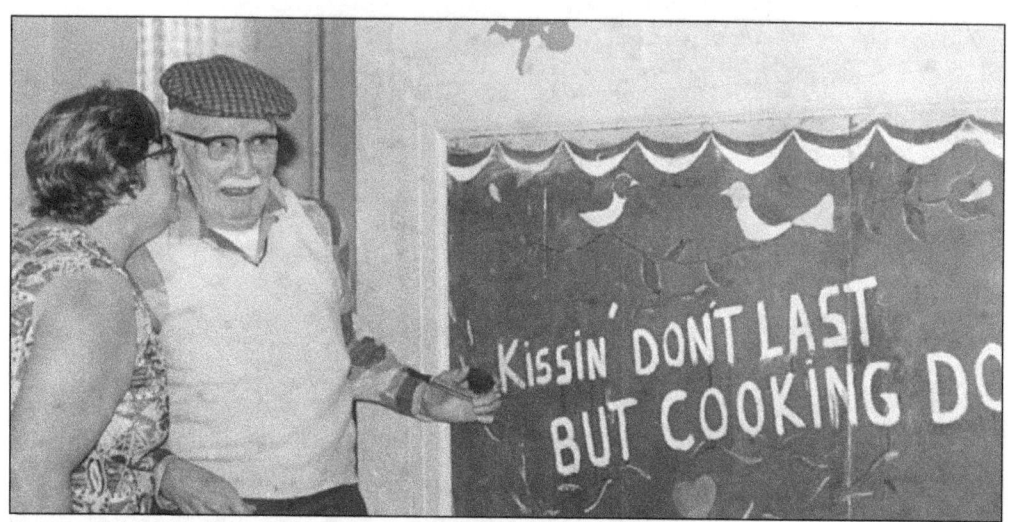

Jean Lipshaw, recreation coordinator of the seniors in 1980, gives Ralph Berkheiser, 82, a kiss on the cheek, but he points out his views to the message on the blackboard. Here is a song for seniors:

<div style="text-align:center">

BATTLE HYMN OF AGING
(tune of Battle Hymn of the Republic)

</div>

We reach the age of sixty-five,
Our golden years are here,
They tell us that the age begins
A happy new career,
For now our Uncle Sam becomes
Our permanent cashier
As we go marching on. (Chorus)

Our social security
From Harrisburg is sent,
We buy a little bit of food and
Maybe pay the rent,
And after that we're stony broke
And left without a cent
But we go bravely on. (Chorus)

We don't know how we make it
As we live from day to day,
With income fixed, and prices up,
There is always more to pay,
So minding our arthritis,
Let's get on our knees and pray
That we'll go bravely on. (Chorus)

And first of all, let's thank the Lord
That we are still alive,
The dreams we have may still come true
When we are ninety-five,
So, please dear Lord, give us the
Strength our troubles to survive
As we go bravely on. (Chorus)

<div style="text-align:center">

Chorus:
Glory, Glory Hallelujah,
Glory, Glory Hallelujah,
Glory Glory Hallelujah,
As we go bravely on.

</div>

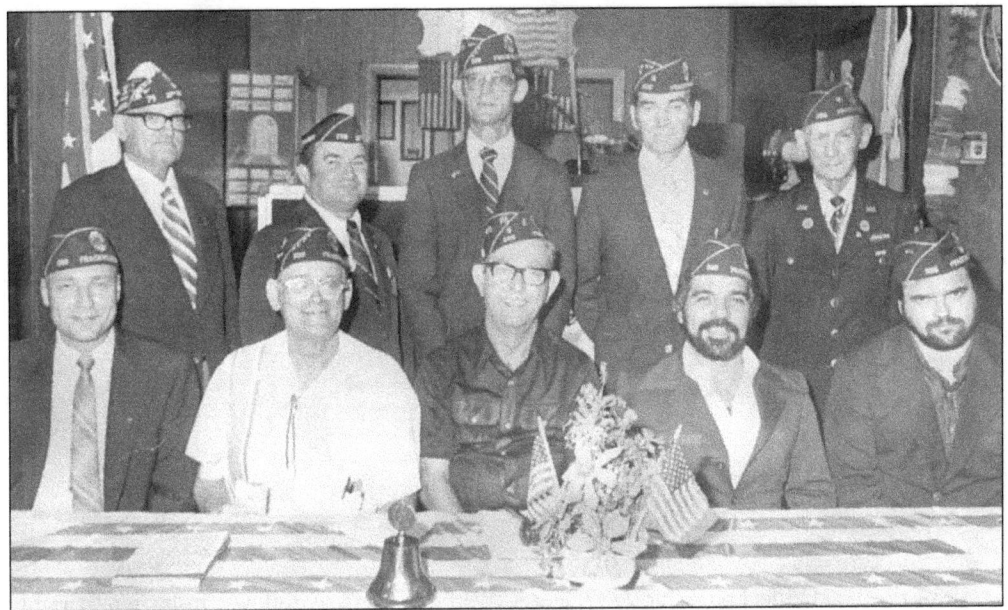

The Frackville American Legion Post 398 held its installation of officers for the 1983–84 term. Pictured from left to right are as follows: (seated) Jerry Marks, Steven Kaliher, William Lindenmuth, Robert Griffiths, and Randy Derricott; (back) George Nefos, Jim Arner, Ron Pasker, Ray Andershonis, and Andy Smerick.

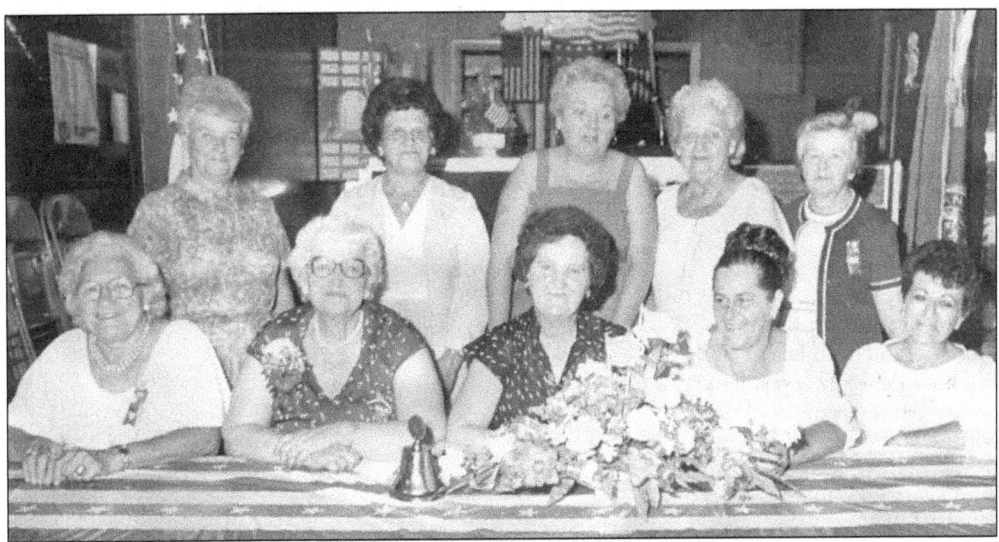

The 1983–84 Ladies Auxiliary officers were, from left to right, as follows: (seated) Margaret Zelonis, Bessie Ditzler, Mary Skiptunas, Marion Watson, and Elsie Docherty; (standing) Genevieve Kaliher, Caroline Irvin, Frances Slotcavage, Lottie Jaskierski, and Helen Aponick.

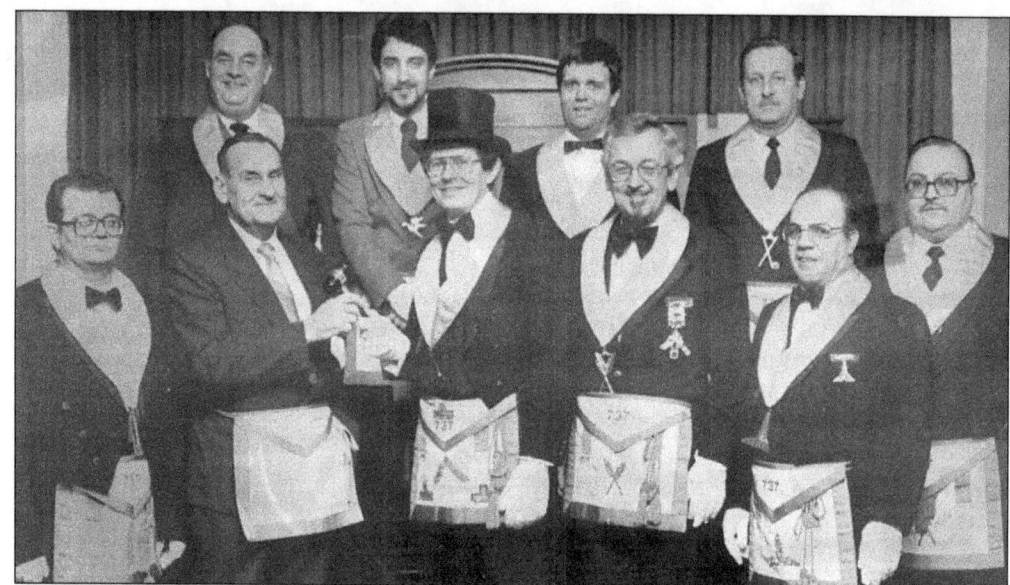

In 1987 the Frackville Lodge No. 737, F&AM officers were as follows, from left to right: (front row) Fred Boychalk, Al Roper, David Bowen, Tony Kurdilla, Hugh Beddow, and John Zemansky; (back row) James Straub, James Lerch, Dale Schimpf, and Harry Price.

The Jaycees held a 100 Years of Progress poster contest in 1975. Pictured are, from left to right, Michael Paulonis (president), Sandy Basara (winner of the contest), and Robert Wagner (director). After more than ten years of involvement in worthwhile community projects, the Jaycees, unable to reach a minimum of 20 members, were forced to disband in 1982.

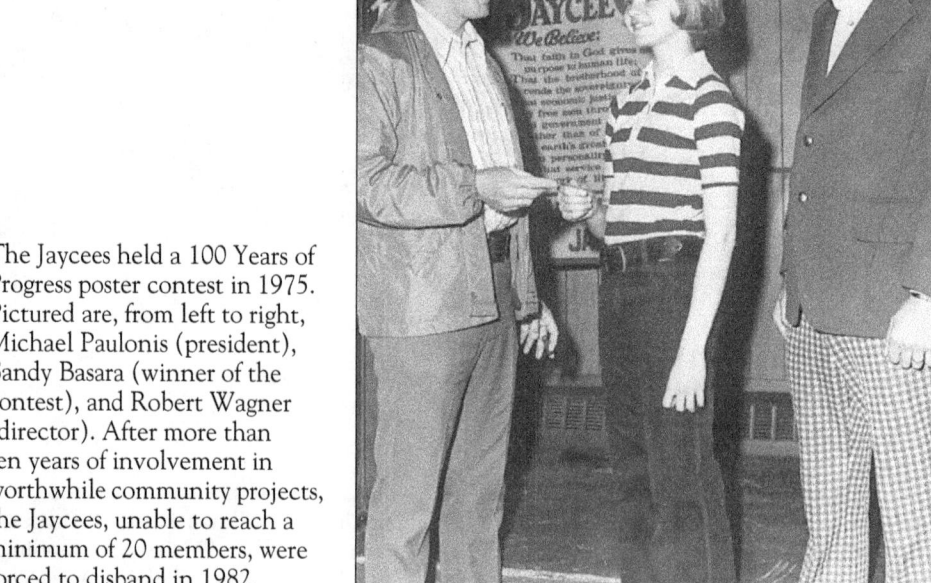

Four

EVENTS

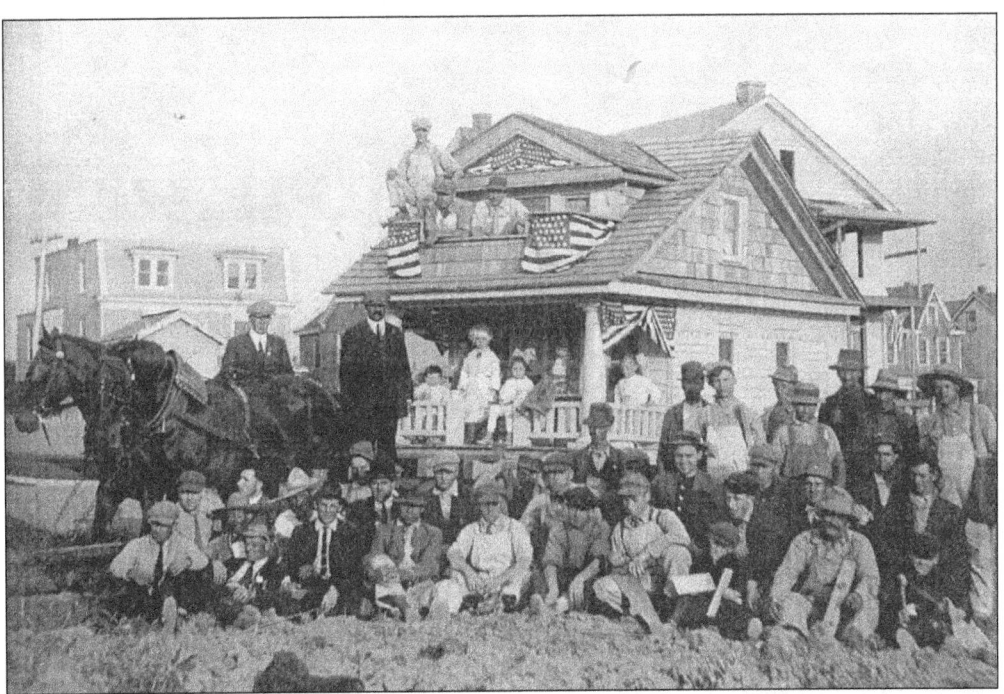

The Old Home Week Parade was held in September 1914. This news clipping explains the picture given to me by the Bevan family: "For the best appearing float, the prize of $35 was awarded to contractor William J. Evitts, who had a small bungalow, about fifteen feet square, a miniature of the Grant bungalow on Washington Street, in line. This piece of work was constructed during the past week. Twenty carpenters were employed on the work, as it was perfect in every detail. Miss Lois Reick, attired as an old woman and Clarence Berkheiser as her husband, were seated on the front porch, while there were fully ten grown persons in the interior."

The Goodwill Hose Company participated in many parades throughout the state. Many male residents were members of this organization, shown pictured at a parade in Mt. Carmel on June 12, 1913.

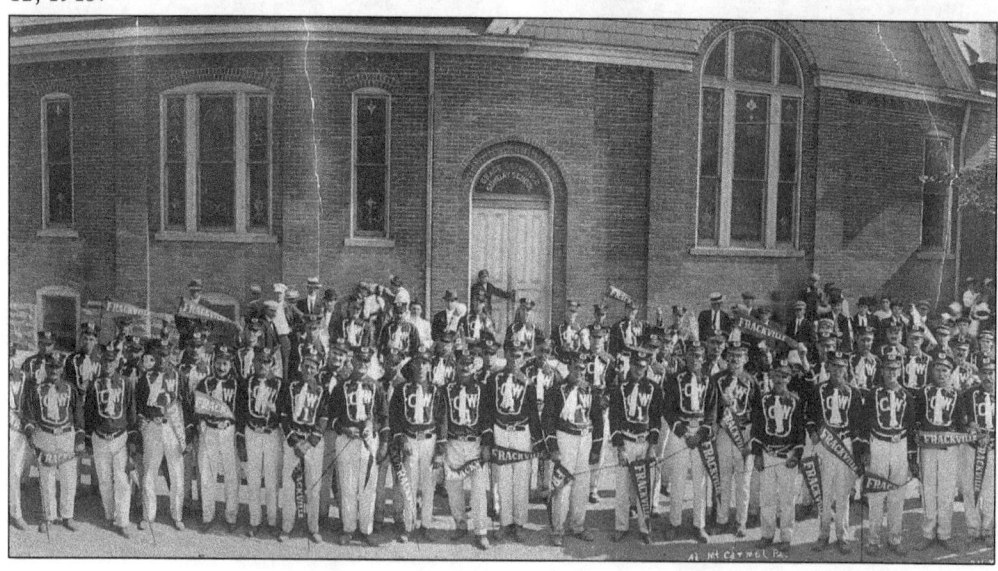

Frackville holds annual Halloween parades for the children of the town. This 1973 picture shows the "Odd Couple" being bothered by Bugs Bunny as they stroll the town streets. Pictured are, from left to right, Darlene Church, Nicholas Donchak, Michael Tenaglia, Bobbie Jo O'Connell, and Patty O'Connell.

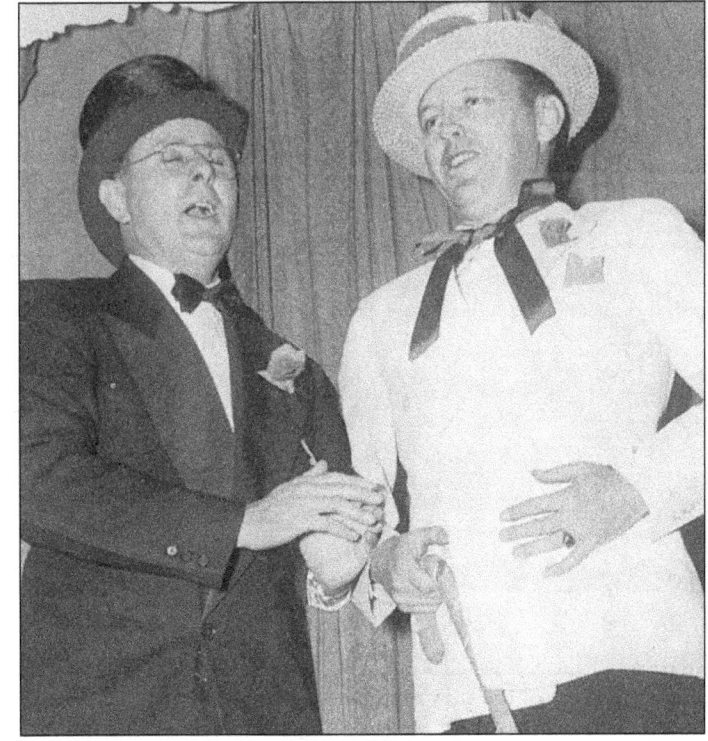

St. Patty's Day minstrels were an old tradition in the coal regions. Two of the old pros in the annual St. Joseph's Minstrels were Jake Kleman (left) and Joseph Purcell performing a duet, "Gallagher and Sheehan," in the 1950s.

Many men organized clubs for the centennial in 1976. Here is Bill's Sports at 64 North Nice Street. Its members, from left to right, included the following: (front row) William Kirelawich, Maurice McDonald, Harry Waters, James Gaughan, Frank Yashin, Bob Kurdy, Ray Kostick, Bill Cickavage, Joe Davis, and Tom Kapusnik; (middle row) John Koropchak, Bill Harbest, Sam Bender, P. Slivinsky, James Nahas, Bob Dintamin, Bill Zalonis, Bob Ziegler, Harold Hocking, and Don Rafferty; (back row) Bob Zimmerman, Tony Kustinavage, Ed Sklaris, Bill Hayek, Tom Green, Bob Hall, unknown, Paul Koropchak, Joe Huth, Jack Dixon, Ricky Kirelawich, John Brecker, Ron Jones, John Rosella, Michael Kowalick, John Tiejero, Frank Maniotka, Jack Antalosky, Mitch Dziczek, and Russ Cunningham.

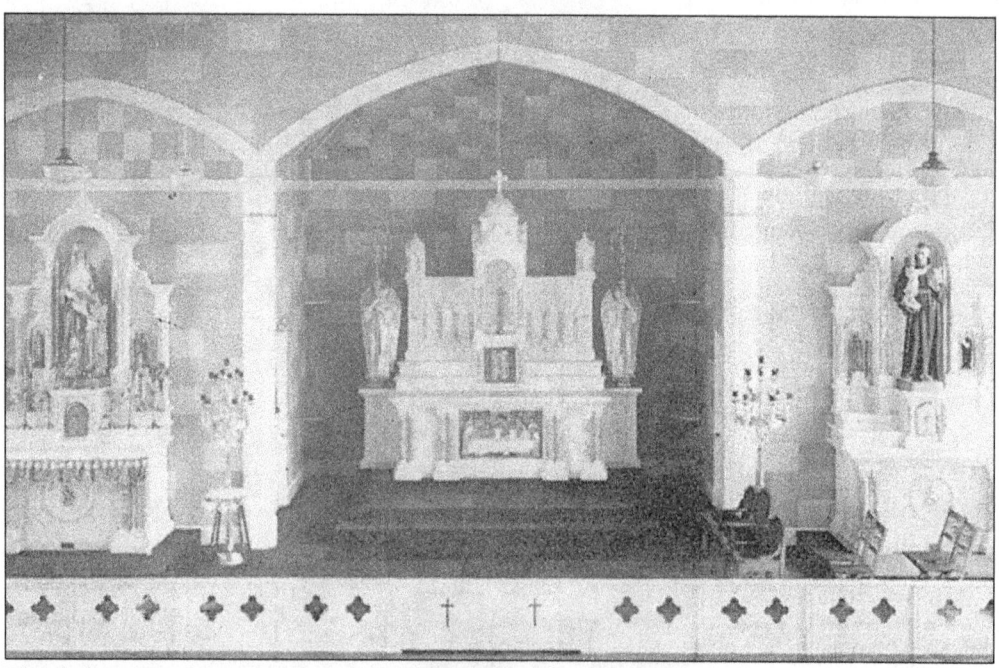

The dedication of the new main altar of St. Ann's Church, located at Spring and Line Streets, was held on July 14, 1940. Rev. Stanley J. Garstka was pastor at that time.

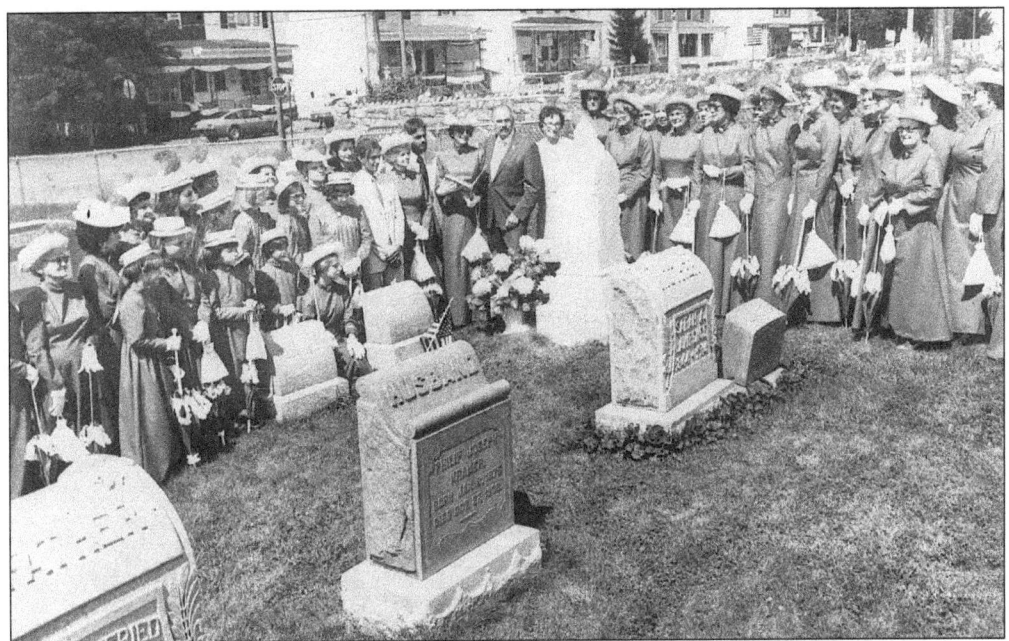

During the Frackville Centennial in August 1976, a memorial service was held at the Frack family graveside by the Polish Star Belles. Prayers were said, a eulogy was given, and a basket of flowers was placed at the grave.

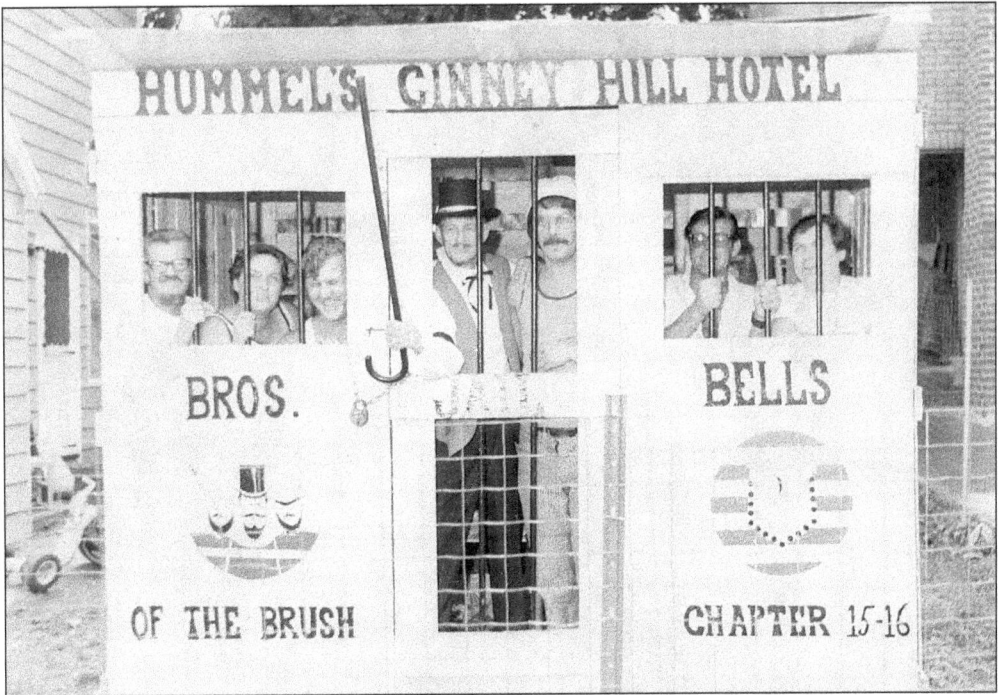

Residents who violated the "Centennial Laws" during the centennial were placed in the Centennial Jail. All residents were asked to wear some visible centennial apparel (such as hats, ties, or centennial buttons). Men were not allowed to shave, and women had to wear the official garter. Pictured are violators at Hummels Ginney Hill Jail on North Balliet Street.

This special bicentennial creation decorates the wall of the Frackville Senior Center Building on East Frack Street. It was made by Eagle Scout Joseph Alshon (right) and presented to Senior President Edith Troxell (left) during the organization's anniversary dinner in April 1976. Michael Onuskanich (center) was scoutmaster of Troop 89.

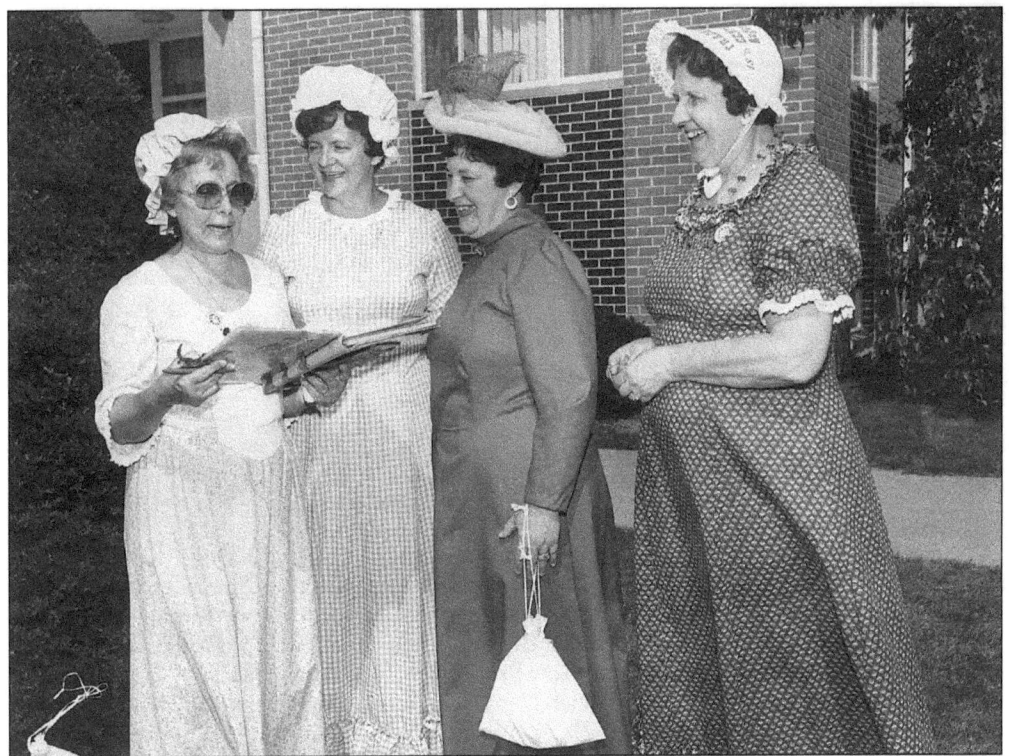

The Polish Star Belles held a Garden Party at St. Ann's Grove for the honored guests of the Frack and Meredith families who returned to Frackville for the centennial festivities in 1976. Looking at the guest book are, from left to right, Helen Mengel, Marie Robbins, Peggy Zamonsky, and Ann Yatcilla.

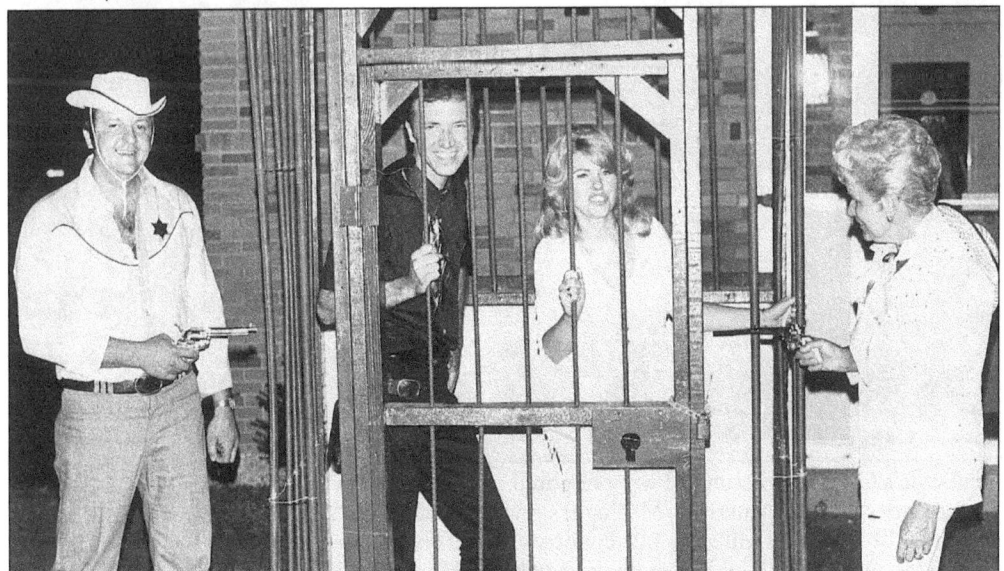

Western Nite was held at the Frackville Elks Lodge in July 1977. Locked in the hoosegow are John "Dead Eye" Seasock and Lynn "Cowpoke Lil" Stewart, the featured singer. The sheriff is Joseph "Slow Draw" Roman, and the jail keeper is Stella "Side Saddle" Ryder.

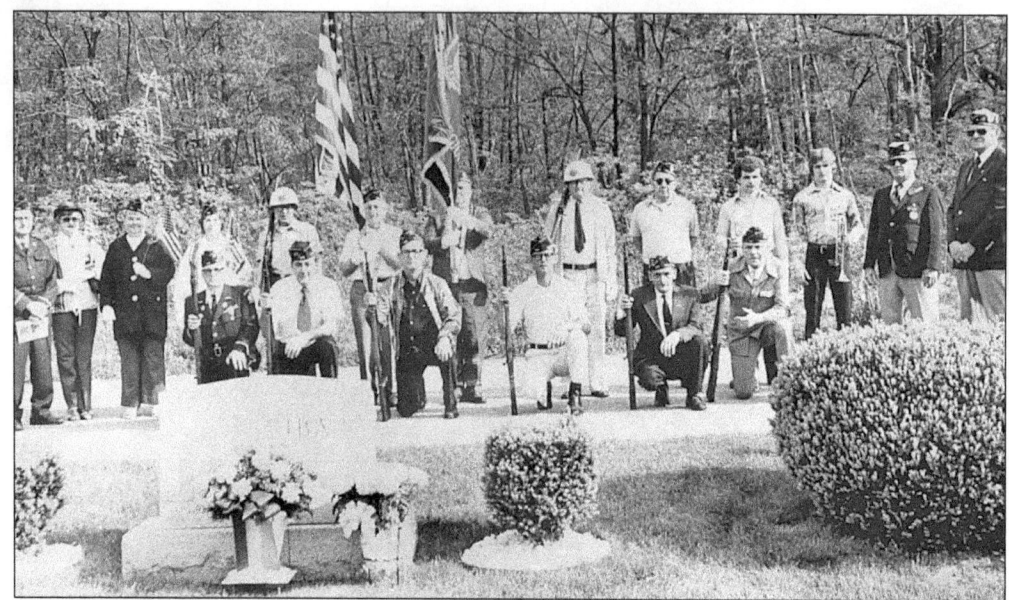

Each Memorial Day the American Legion holds services in all of the cemeteries in town in honor of veterans. The 1978 rites included the following, from left to right: (kneeling) Nick Boychak, Ted Neary, Bill Lindenmuth, Ron Pasker, Joe Tophoney, and Tony Gilbert; (back row) Joe Mastauskas, Catherine Karpovich, Jenny Kalaher, Alma Wagner, Dave Urban, Joe Engle, Bernard Dougert, Hap Hahn, Oscar Wagner, Ron Andrews, Jeff Andrews, George Semanchik, and Bill Bendrick.

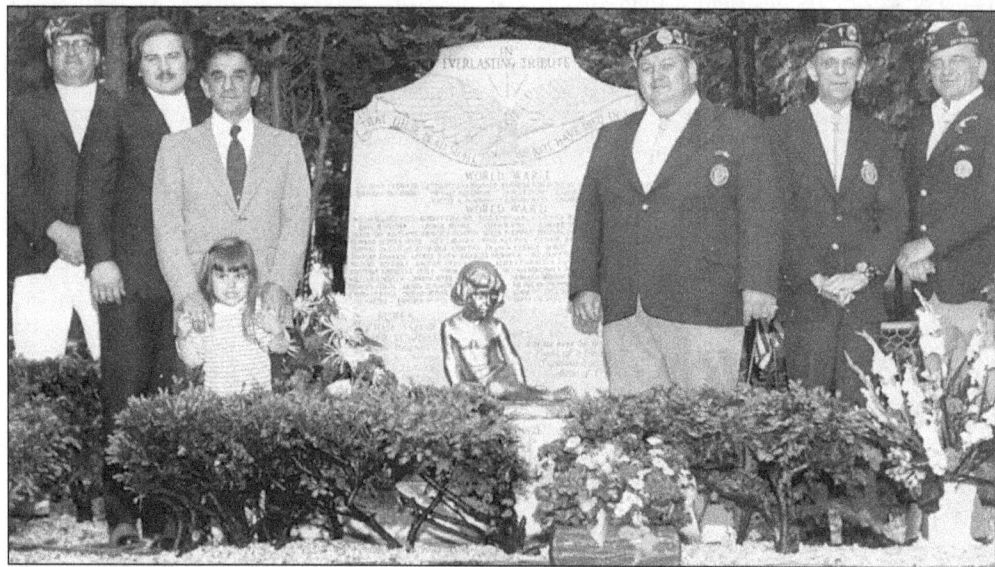

Frackville's Gold Star Memorial was presented to the town by the Frackville Council No. 828 Junior Order United American Mechanics on Armistice Day 1947. It contains all the names of Frackville residents killed in our country's wars. The statue in front of the memorial was donated in memory of Paul Berger by the Frackville High School Class of 1944. The dedication ceremonies were sponsored by American Legion Post 398. Pictured in 1975 are, from left to right, John Navitsky, Jack Zaylskus, Mayor James Nahas and daughter, Mr. Weremedic, unknown, and George Semanchik.

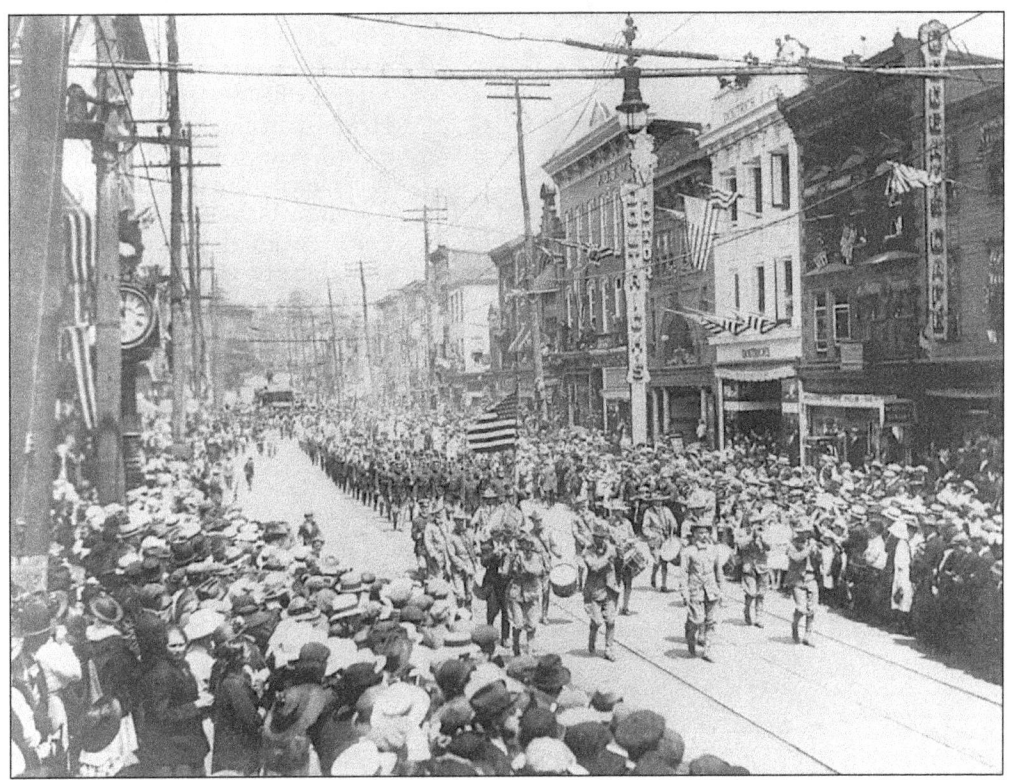

All Schuylkill County veterans participated in the victory parade held in Pottsville on September 1, 1919. Many of the soldiers were miners, and this was their song.

The Battlefields of France

I'm proud to say that I'm from PA, where the mining boys are loyal,
Where they cut that coal in that manly hole, so deep beneath the soil.
They're familiar with the powder smoke, for gas they have no fear,
And among the bravest of the brave are the miners who volunteered.
They love the flag of liberty, the red, the white and blue;
They love the miners' union, and to it will stick true.
Their leaders are all honest men, John Mitchell, Hayes and White,
And in nineteen-two they showed the world how the mining boys could fight.

Then hurrah for President Wilson; he is honest, loyal and shrewd
And the miners are all with him for whatever he may do.
Some laid their picks and shovels down and threw away their lamps;
They are fighting for Democracy on the battlefields of France.

—George Korson, in *Minstrels of the Mine Patch*.

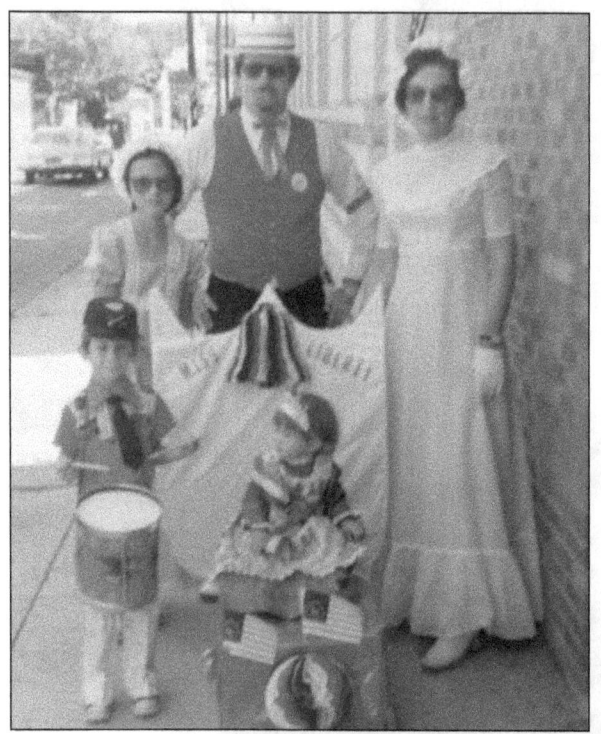

The Centennial Baby Parade was held on August 21, 1976, at Frackville Memorial Park. Hundreds of children participated, and all were given small trophies to commemorate the centennial festivities. Pictured are Marc Janov (with the drum), Jessica Janov (Miss Liberty, in the wagon), Joe and Margaret Ann Maley, and Lorraine Stanton (author of the "Old Frackville Tales" series).

The Frackville Elks 1533 Players performed at the annual Elks Ladies Installation held in April 1976. Shown are the following, from left to right: (kneeling) Linda Dillman and April Wytovich; (standing) Madge Kerrigan, Judy Kovach, Bernice Bohard, and Dolores Wasilewski.

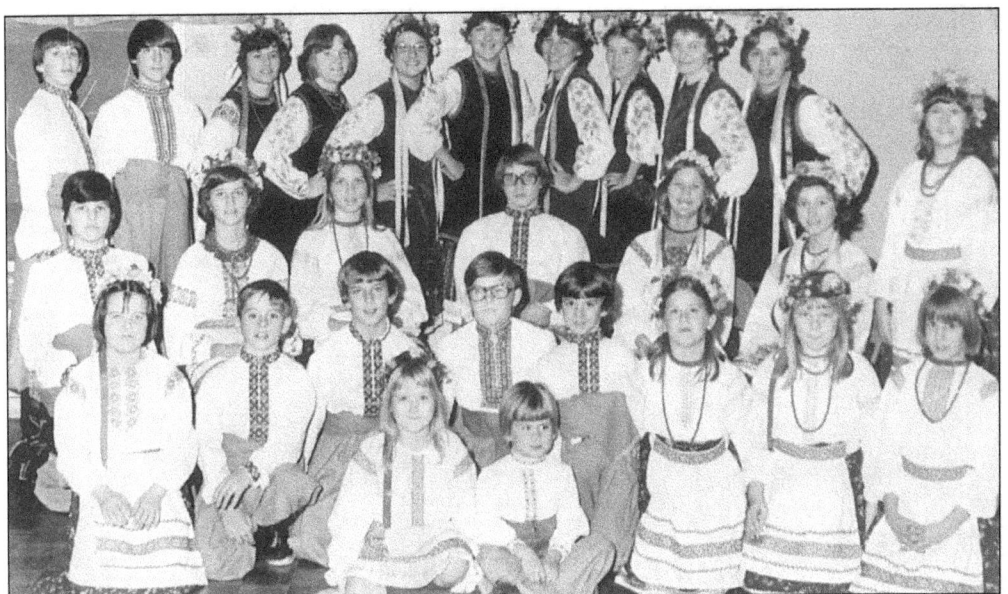

St. Michael's Ukrainian dancers have performed all over the country. Pictured from left to right are as follows: (front) Nicole Damiter and Daniel Bane; (front row) Valerie Mohutsky, John Chowansky, Ronald Bane, Michael Mohutsky, Jeff Hancher, Lori Bane, Brenda Damiter, and Kathy Yeager; (middle row) Ralph Mohutsky, Donna Hancher, Denise Damiter, David Rynn, Stasia Peleschak, Angie Kaliher, and Rose Kaliher; (back row) Paul Hancher, Mark Peleschak, Marie Hancher, Melissa Mohutsky, Rose Peleschak, Chris Kaliher, Sue Peleschak, Karen Evans, Kalina Spotts, and Michelle Halupa.

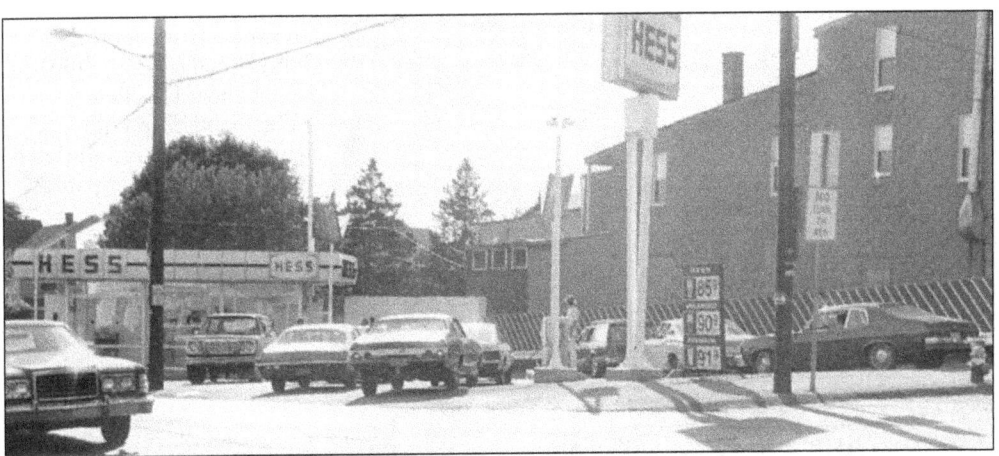

Remember the gas shortage of July 1979? Hess Service Station at the corner of Oak Street and Lehigh Avenue did a tremendous business as cars lined up waiting their turn to fill up. The prices are evident on the sign at right.

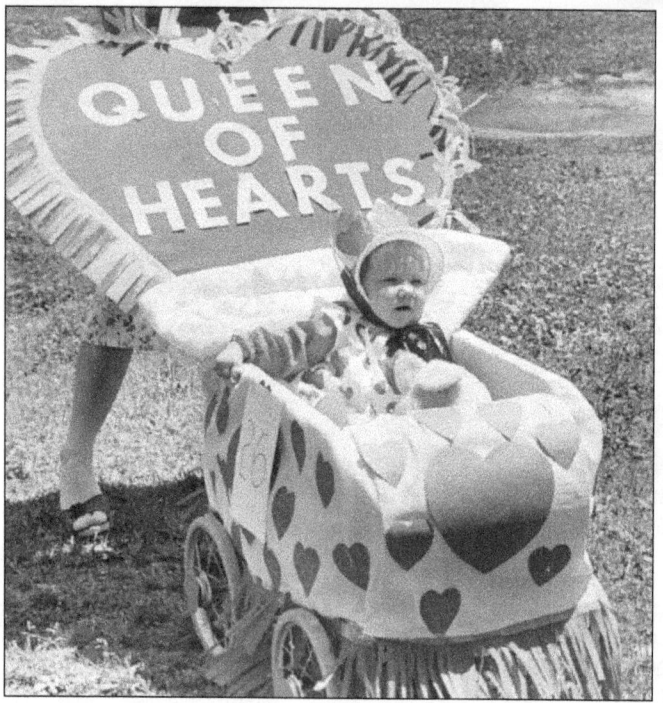

An old-fashioned Fourth of July celebration was held in Memorial Park in June 1980. The baby parade is always a big event, with trophies and prizes given to winning entrants. Three-month-old John Douglas Frantz (top) sleeps aboard his float, "The Good Ship Lollipop," while Sheila Gradwell (left) enjoyed playing her part as the "Queen of Hearts."

Catholic School Week is an annual event proclaimed by the mayor of the town. Pictured in 1980 are from left to right, John Petrus (student at St. Joseph's), Rev. William Conley (pastor of St. Joseph's), Sister David (principal of St. Joseph's), Mayor James Nahas, Sister Stephen Marie (principal of Annunciation BVM), Rev. Al Bartkus (pastor of BVM), and student Sharon Wascavage.

The Catholic School Week Poster Contest in 1982, "Spread the Good News," had several winners. From left to right are as follows: (front row) Josh Paulonis, Michael Canavan, Carrie Little, and Christine Bardzak; (back row) Shannon Gaverick, Donald Navit, Paula Cahill, and Michael Meskunas.

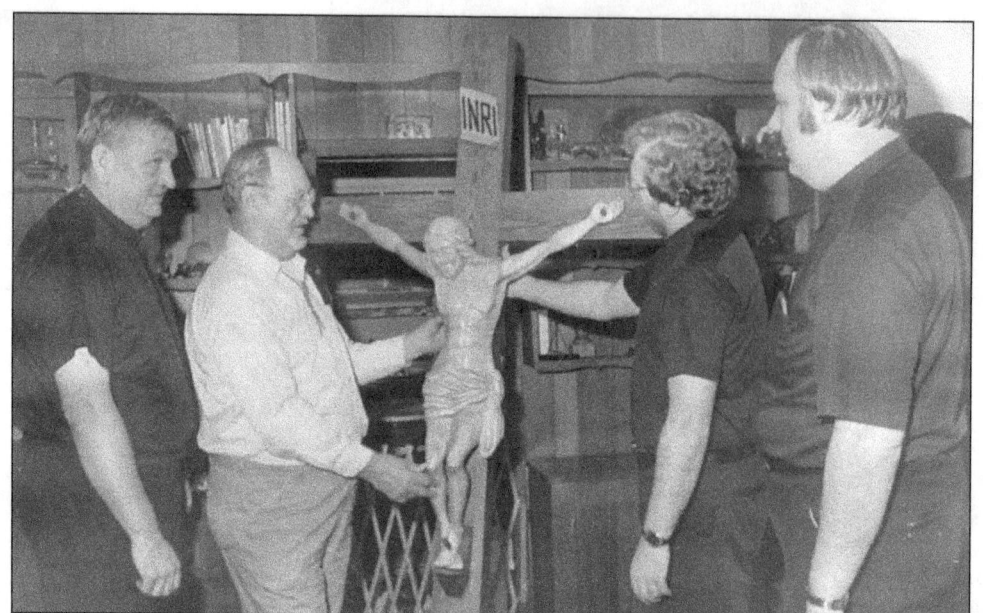

Woodcarver Henry Pascavage has carved religious items for churches throughout the area. Pictured are, from left to right, Rev. Edward Tomczyk and Henry Pascavage of Frackville, and Rev. Czeslaw Kuliczkowski and Rev. Thaddeus Dymkowski from St. Mary's Polish National Church of Duryea.

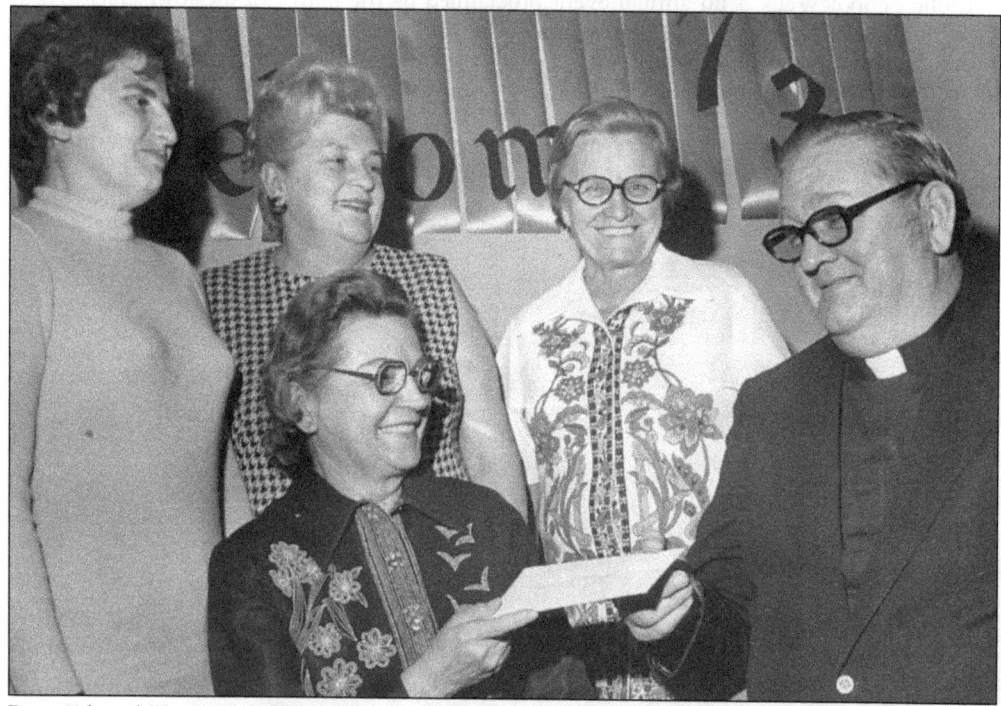

Rev. Edward Tomczyk of St. John's Polish National Church celebrated his 20th anniversary in 1973. Presenting a gift of appreciation are, from left to right, as follows: (seated) Helen Dower and Rev. Tomczyk; (standing) Louise Gursky, Valeria Golba, and Lottie Snokus. Pastor Tomczyk died on April 18, 1999.

Nature's paintbrush created this picturesque scene at the Charles Everett residence at Oak and Center Streets in 1979.

The 50th anniversary of Rev. Joseph Rapczynski of St. Ann's Church was celebrated in 1984. Shown are, from left to right, Eli Hancher (chairman), Frank Trakes (toastmaster), Dorothy Wabo (president of the Union of Polish Women Group 34), and Rev. Joseph Rapczynski.

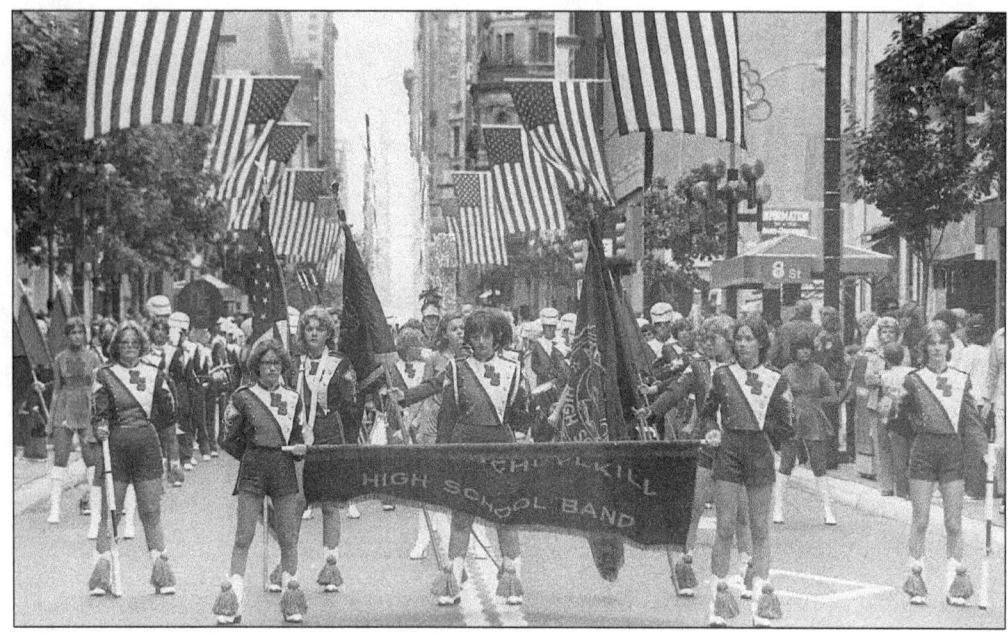

We are proud of our North Schuylkill High School Band, shown here in 1978 parading in Philadelphia.

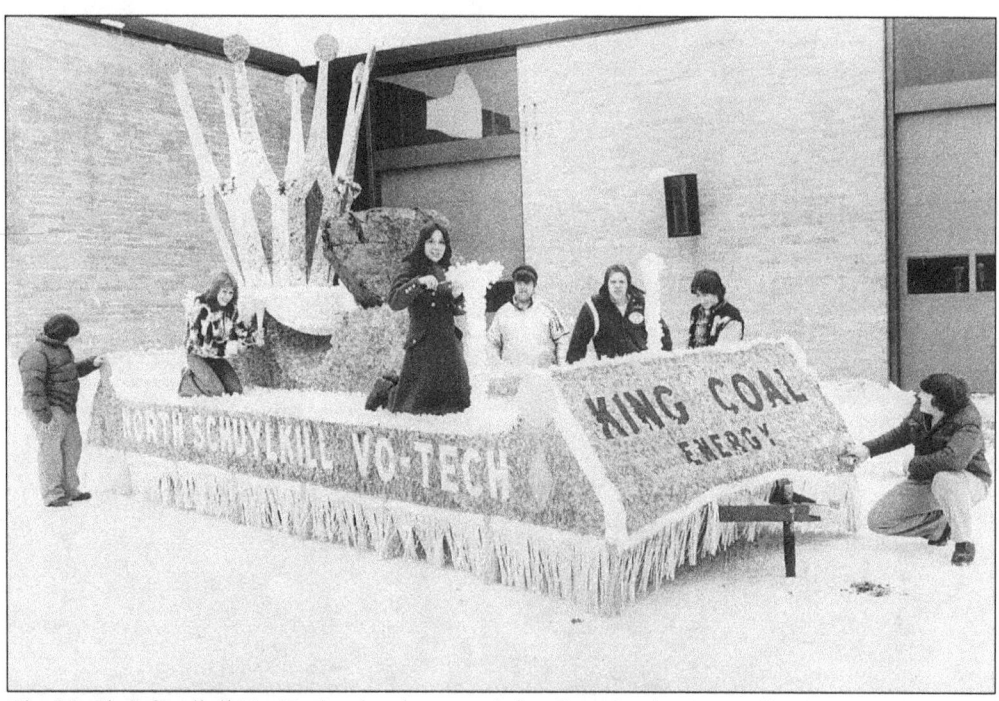

The North Schuylkill Vo-Tech schools created this float for the Pottsville Winter Carnival in 1979. Pictured are, from left to right, William McMullin, Princesses Judy Klinger and Shelly Ann Kimmel, Curtis Merkel, John Hughes, Tom Filiziani, and Bill Blickley.

In 1982, the Rainbow Assembly Iroquois #148 Installation took place at St. Peter's United Church of Christ. Pictured are the following, from left to right: (seated) Christine Harris; (standing) Stephanie Keim, Cindy Hampton, Kristine Swartz, and Kim Maurer.

The 1984 graduating class of St. Peter's United Church of Christ vacation school are, from left to right, as follows: (seated) Lisa Barlow, Mark Barnett, Gabrielle Martin, Wendy Frew, Joey Tertel, and Melodi Whylie; (middle row) Michael Lord, Jill Morgan, David Whylie, Mark Frew, Hilary Barnett, and Kristy Frantz; (back row) Bobby Giba, Tricia Oakum, Barbara Filer, Paula Bane, and Johann Filer.

The 1943 faculty of Frackville High School, from left to right, are as follows: (front row) Miss Marion Eisenhower (music), Miss Verdilla Rubright (physical education), Mrs. Ellen W. Webb (languages), Miss Elvira J. James (commercial), Mrs. Constance P. Balche (commercial) Mr. Charles Drumm (principal), Miss Pauline Fennelly (mathematics), Miss Alice Morgan (social studies), Phyllis Hicks Fellows (mathematics), and Miss Jean Liddicoat (home economics); (middle row) Mr. Thomas V. Morgan (science); Mrs. David White (home economics), Miss Myrtle Purnell (history), Miss Verna Hampton (commercial), Mary Swartz (secretary), Miss May Jones (English), and Mr. Walter Lash (commercial); (back row) Mr. George Grabey (civics), Mr. Robert Hall (science), Mr. Joseph Pilconis (physical education), Mr. Charles Miller (English), Mr. Charles Dunkelberger (biology), Mr. Roy Wertz (mathematics), Mr. Chester Timmins (English), and Mr. Charles Wagner (Latin).

Five

RECREATION

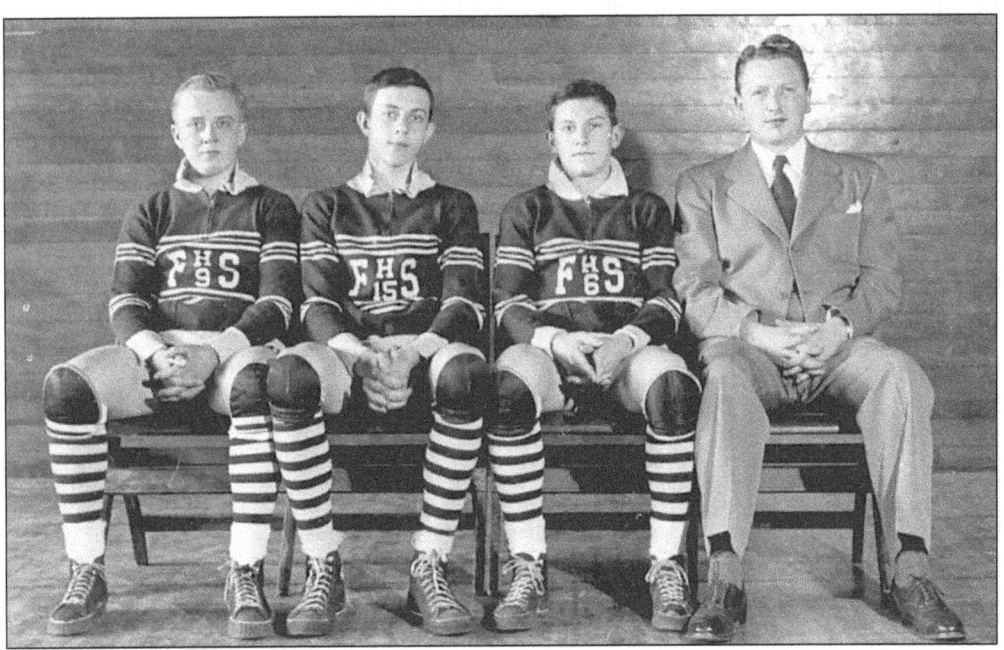

The 1943–44 jayvee basketball team had several outstanding players. Pictured here are, from left to right, Adolph Roland, Joseph Cudding, Jack Klock, and Charles "Daw" Miller. Miller was coach of the Frackville Jayvees for many years before becoming varsity coach. The three players went on to become outstanding players in varsity competition.

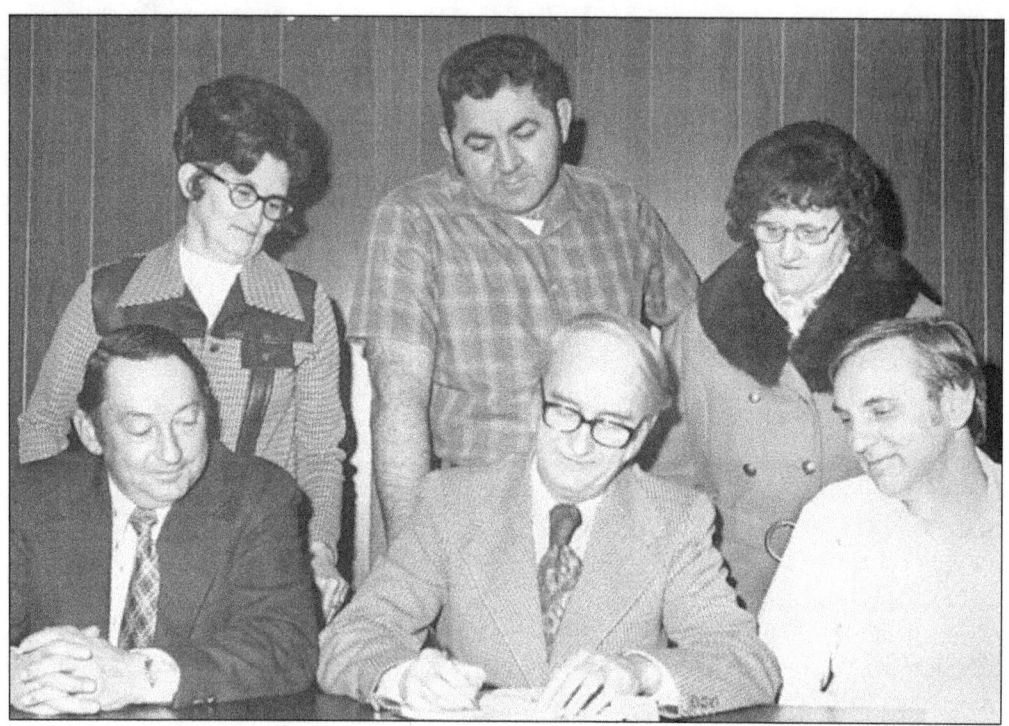

The 1975 Borough Recreation Board consisted of the following, from left to right: (seated) Joseph Probition (council president), Willard Long (board president), and Joseph Bluge; (top) Rosemary Truskowsky, Anthony Kostinavage, and Leah Robbins.

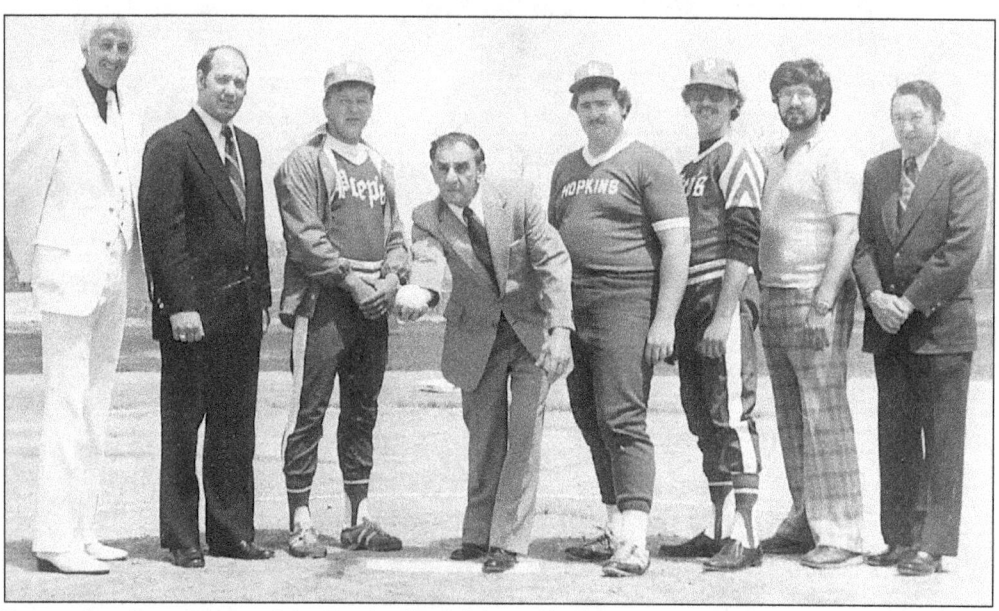

Pictured at the opening of the Frackville Adult Softball League in 1979 are, from left to right, Joseph Huth (recreation director), David Boyer (councilman), Joseph Conapinski (league president), Mayor James Nahas, John Malinchock (secretary), James Beckett (treasurer), John Chuma (councilman chairing recreation), and Joseph Probition (recreation board president).

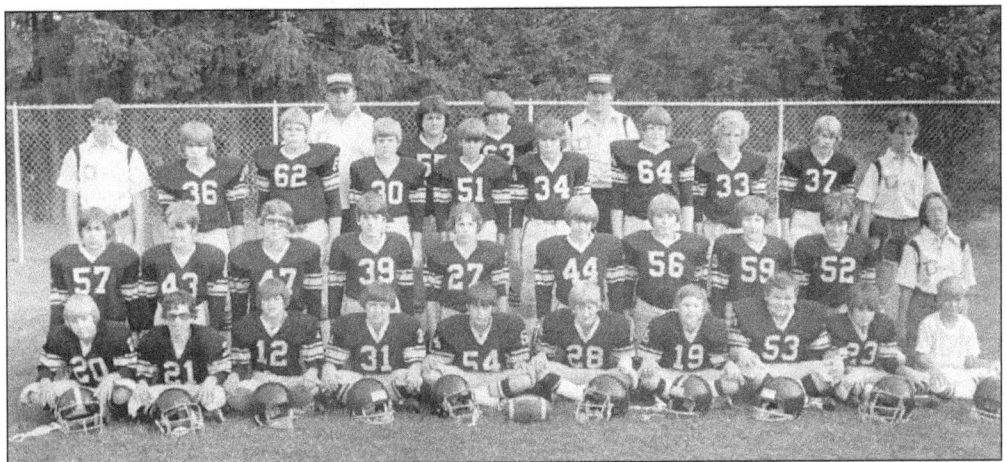

Members of the 1978 Frackville Midget Football Squad included the following, from left to right: (front row) Harry Dillman, John Molnar, Joe Kosmisky, Jim Pollock, John Neary, Francis Gaughan, Ron Oravitz, Joe Pellock, Dennis Mallams, and Bill Molnar (manager); (second row) Andy Hoysock, Francis Russell, Jeff Grove, Dan Sleva, George Norwich, Scott Houser, Bobby O'Neill, Joe Reba, Del Phillips, and Debbie Dillman (manager); (third row) Mark Wasilewski, Joe Andrewsky, Bob Gray, George Horas, John Seasock, Jim Gervel, Duane Dean, Ray Walsh, Charles Cickavage, and Bob Oravitz; (top row) George Rushanan (assistant coach), George Schally, Rick Whelchel, and Bob Kraft (head coach).

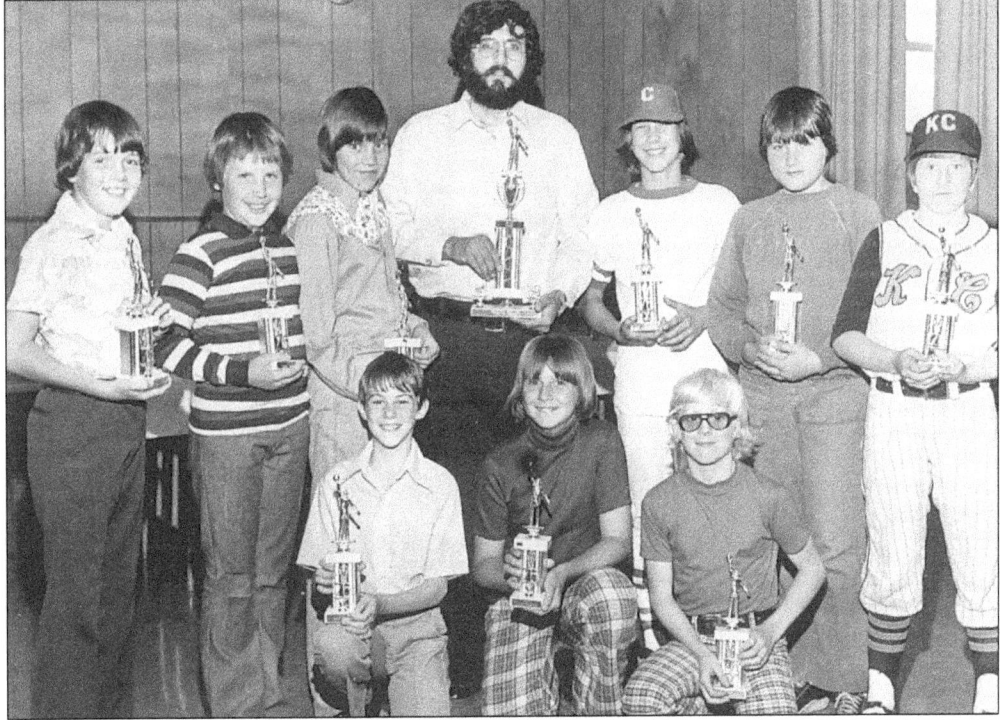

The Elks Class B Champs of the Frackville Biddy Basketball League were as follows, from left to right: (kneeling) Gary Burda, Kevin Damiter, and Matt Smiley; (standing) Michael Shpakovsky, Kurt Watkins, Joe Lesko, John Chuma (coach), Nick Bloschichak, John Griffin, and William Rhoades.

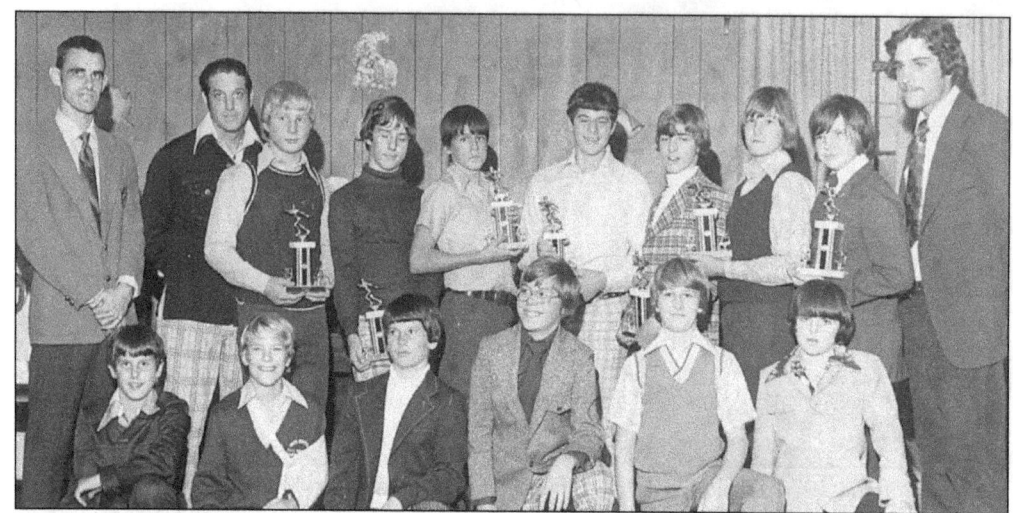

The Frackville Midgets shown here receiving trophies are as follows, from left to right: (kneeling) John Ploxa, David Palsgrove, Chris Conroy, Edward Wascavage, Frank Mastella, and Richard Dietz; (standing) John Lafey, Robert Dietz, Joseph Wright, Daniel Damansky, Robert Neary, Gary Interdonato, James Slatick, Peter Damiter, John Pulaski, and Ronald Rader (coach).

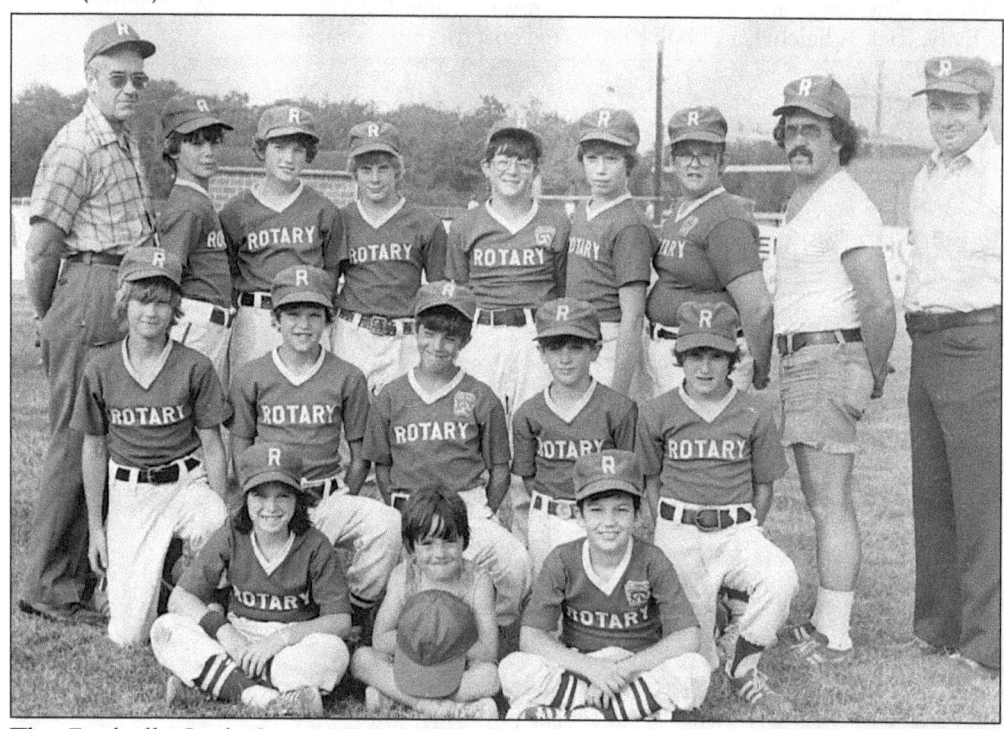

The Frackville Little League Rotary Champs had their first win in 20 years in 1978. Pictured from left to right are as follows: (front row) Francine Susan, Bat Boy, Kurt Mallams, and John Orris; (middle row) Francis Gaughan, Joseph Kosmisky, Pat Beckett, Rick Green, and D.J. Mallams; (back row) Harry Mallams (coach), Ronald Elsavage Robert Susan, Anthony Jordan, Jerry Green, Pat Holawaty, David Cabulis, Dennis Mallams (manager), and Gerald Green (coach).

The 1978 members of the Knights of Columbus Little League Squad, from left to right, are as follows: (front row) Paul Burda, Keith Berkheiser, and Vince Guziewicz; (middle row) Brian Norwich, Scott Gergal, Kathy Giba, and Jay Ziegler; (back row) George Norwich, Bob Judd, Michelle Boychak, and Charles Seasock.

More than 1,000 youngsters participated in the trout rodeo sponsored by the Frackville Sportsmen's Club at Whippoorwill Dam. John Boxter proudly displays his 22.5-inch trout he caught that day.

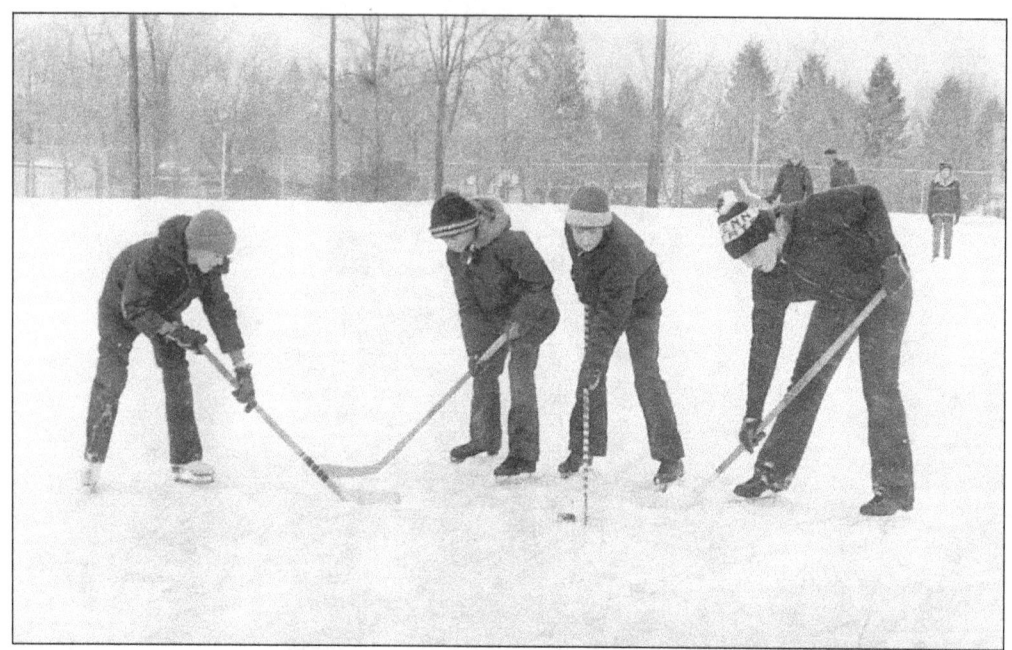

The Frackville Recreation Board sponsored ice hockey games at Frackville Memorial Park. Boys showing their skills are, from left to right, Russell and Michael Seasock, Robert O'Neill, and John Griffin.

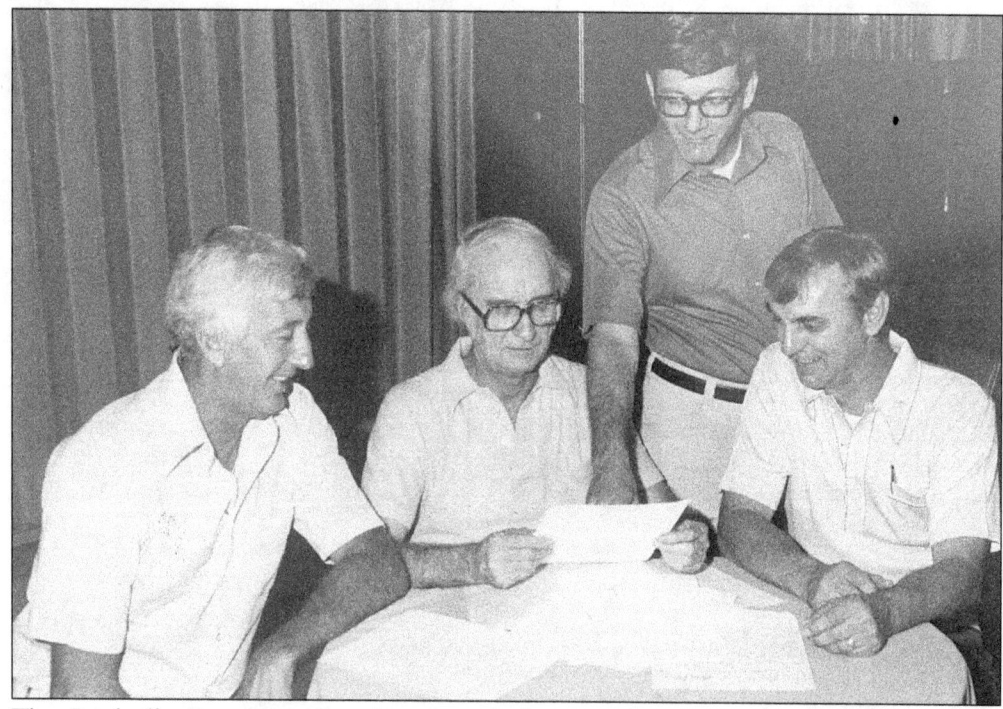

The Frackville Recreation Board sponsored the 14-mile "Grinder Marathon" in 1978. Pictured making plans are, from left to right, Joseph Huth (recreation director), Willard Long (board president), Charles Mackin (marathon runner from Oklahoma and adviser), and Joseph Bluge (treasurer).

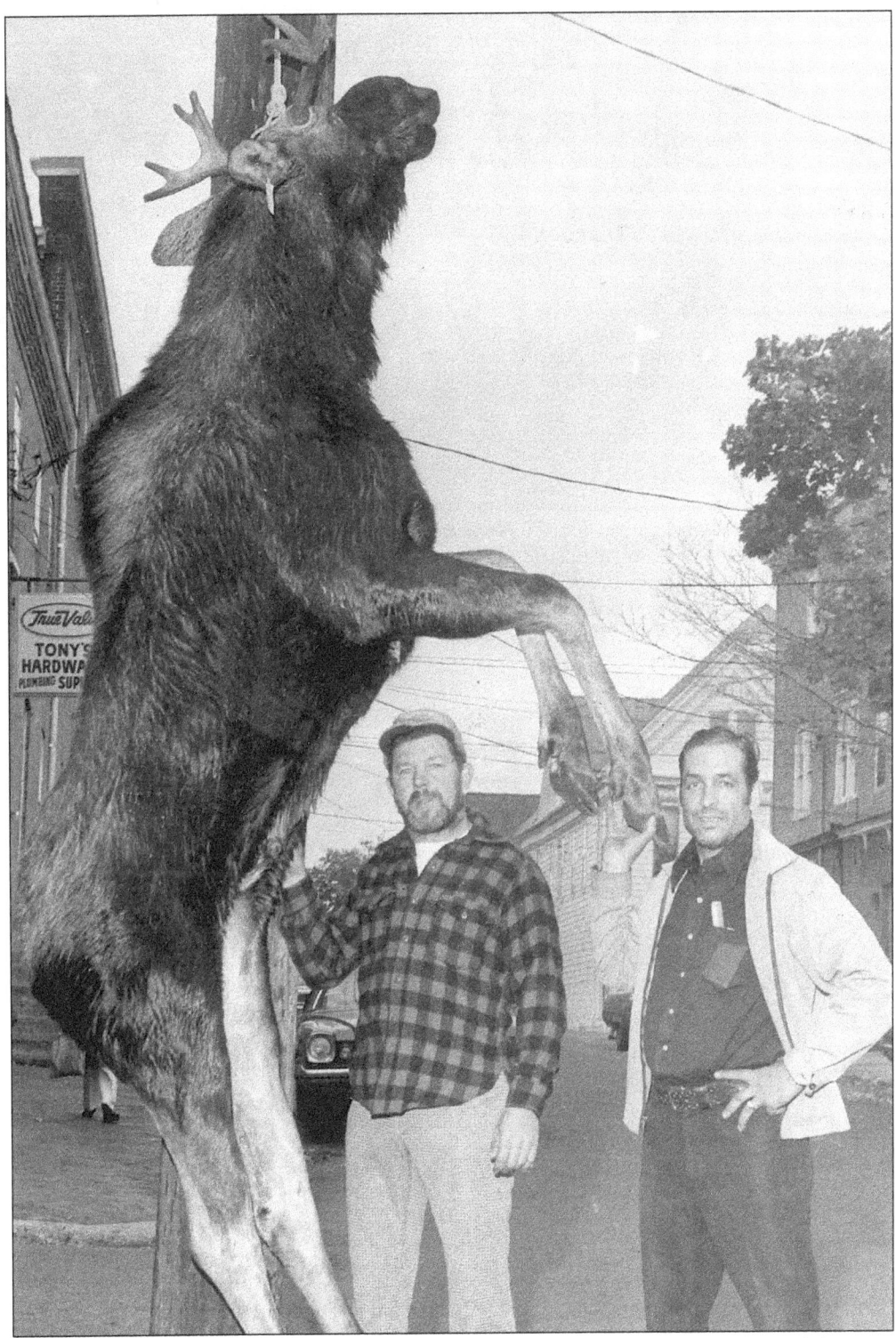

Hunting at Grassy Lake, Ontario, in 1975, Buddy Touchinsky and Jack Russell bagged this 800-pound moose, which hung in front of the Sportsman's Club on West Frack Street.

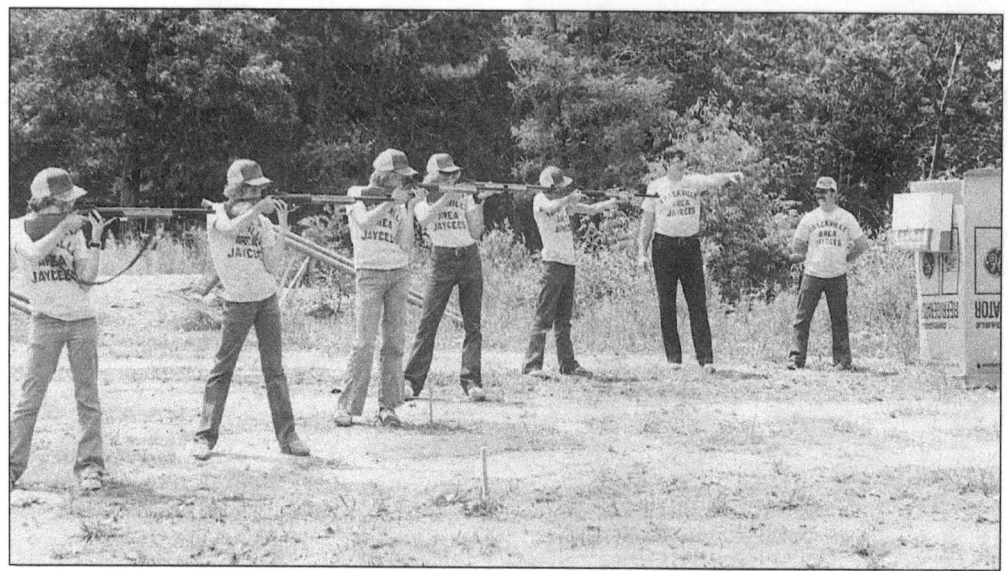

Sharpening their shooting eyes for the National 1979 BB gun championship tournament in Joplin, MO, are members of the State Championship Frackville Jaycees team. From left to right are Michelle Boychak, Brian Paul, William Boxter, Steve Homola, Sheldon Buscavage, Maynard Petri (coach), and Russ Hughes (manager). The group left for the West on July 5, 1979, and were models of sportsmanship in serving as goodwill ambassadors for Pennsylvania in this 43-state competition.

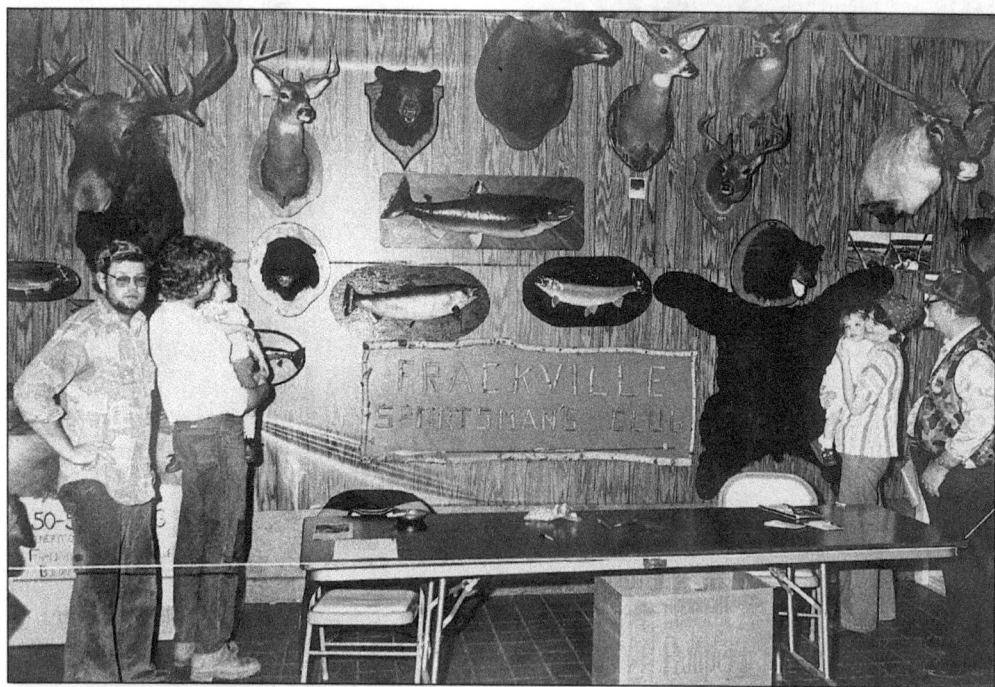

This 1978 display by the Frackville Sportsman's Club attracted many viewers at a sportsmen's exhibit at the Fairlane Village Mall. Pictured are, from left to right, Bob Stepenaskie, Dean Schroyer and daughter Nicole, Margaret Schroyer and daughter Danielle, and Robert Houser.

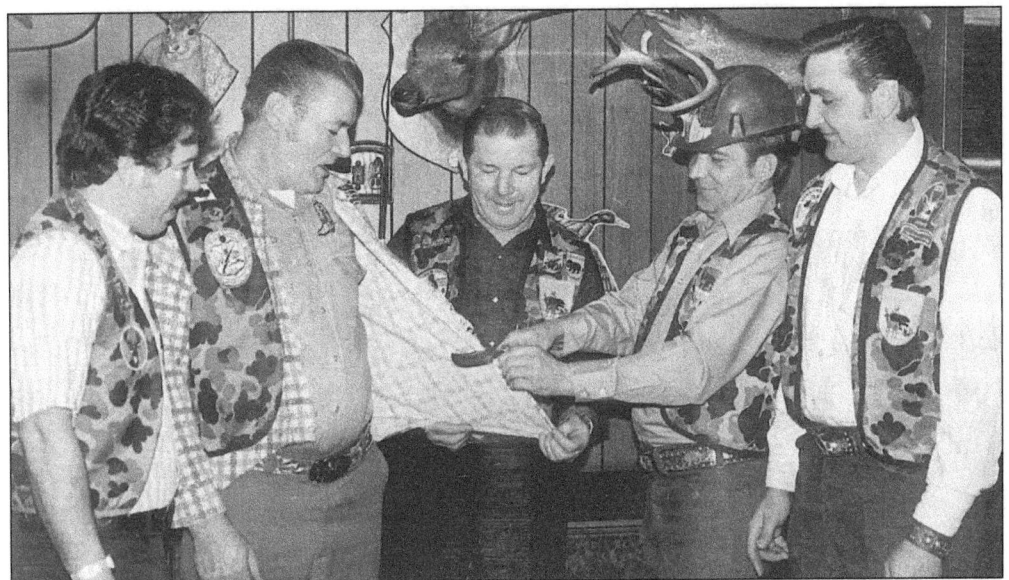

No Deer, No Shirt! Members of the Sportsman's Club who did not bag a deer during the 1980 hunting season had their shirttails cut by their comrades. Lloyd George (left) watches as Sgt.-at-arms Tex Bolton loses his tails courtesy of President Steve Homola, while Vice President Bud Touchinsky (center) and Mike Wargo (right) look on. The ceremony took place at the Sportsman's Lounge.

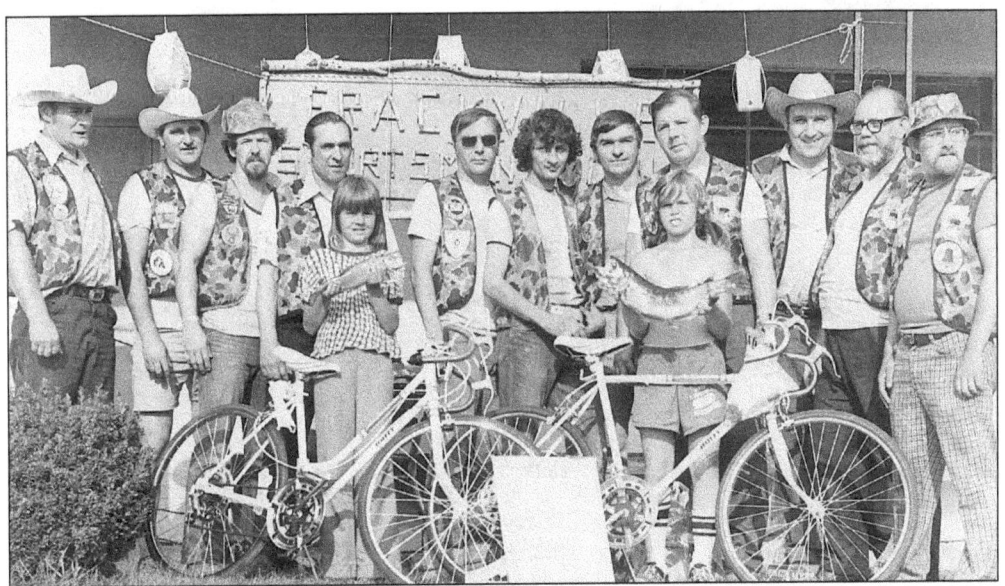

The Sportsman's Club present bicycles to fish rodeo winners Sandra Kroh and Richard Derr. Members standing are, from left to right, Tex Bolton, Michael Wargo, Lloyd George, Jack Russell, Steve Homola, Lawrence Maurer, Ted Deitrich, Buddy Touchinsky, Edward Kelsy, Robert Hauze, and Leo Waskirski.

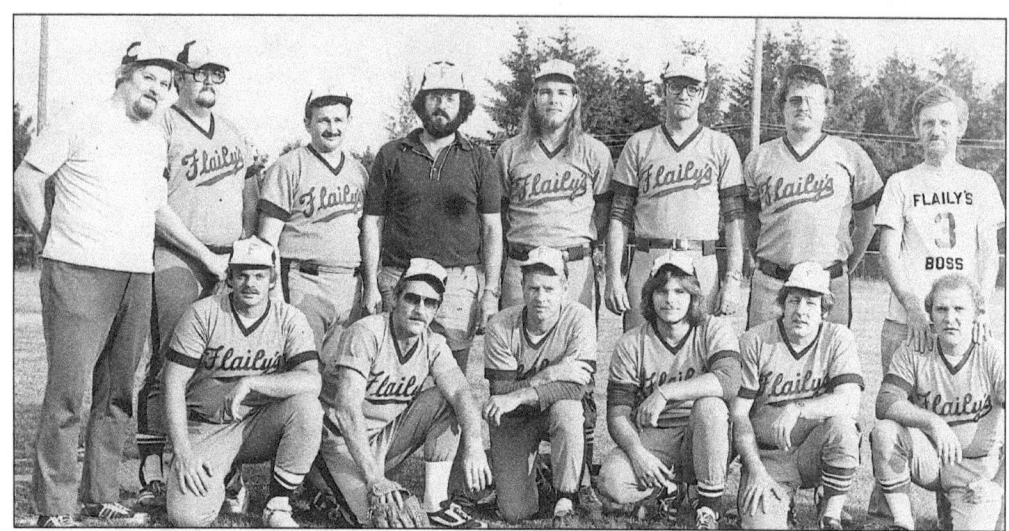

Flaily's first half champs of the Frackville Adult Softball League are as follows, from left to right: (kneeling) Joel Rav, Lee Griffith, Luke Clocker, B. Flaily Jr., David Smiley, and Jerry McCabe; (standing) William Davis, Earl Davis, Paul Dean, John Chuma, Kevin Kessock, Andrew Sweyko, Jack Davis, and Boss Flaily.

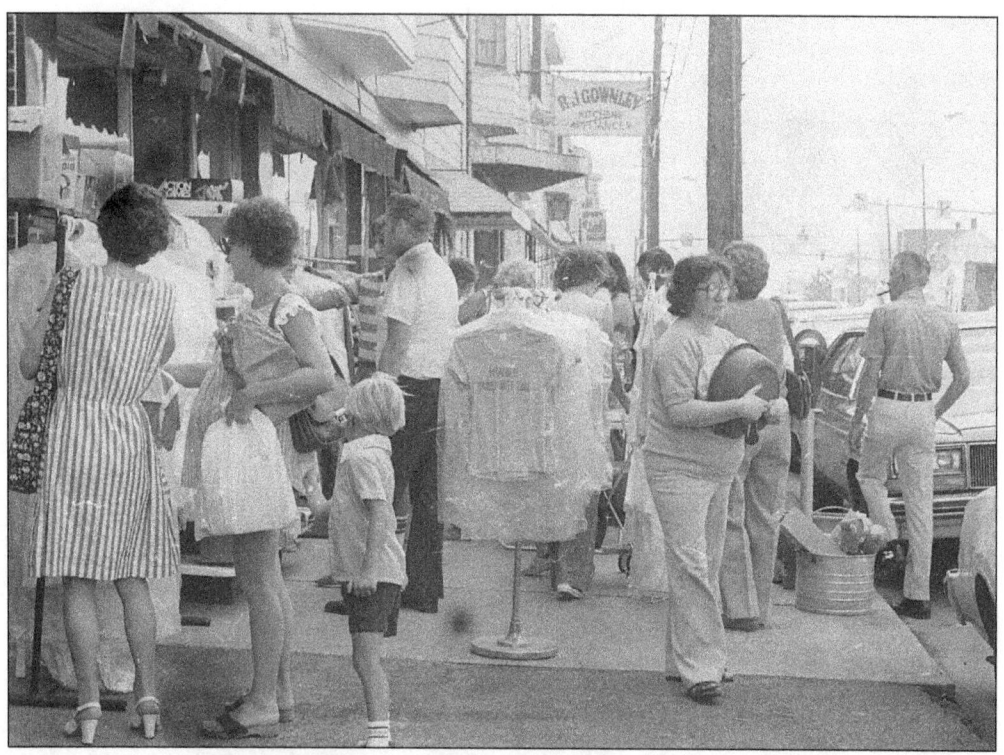

Many county communities have sidewalk sales. Pictured in 1980 are residents searching for bargains in front of John's Mini Mall on Lehigh Avenue.

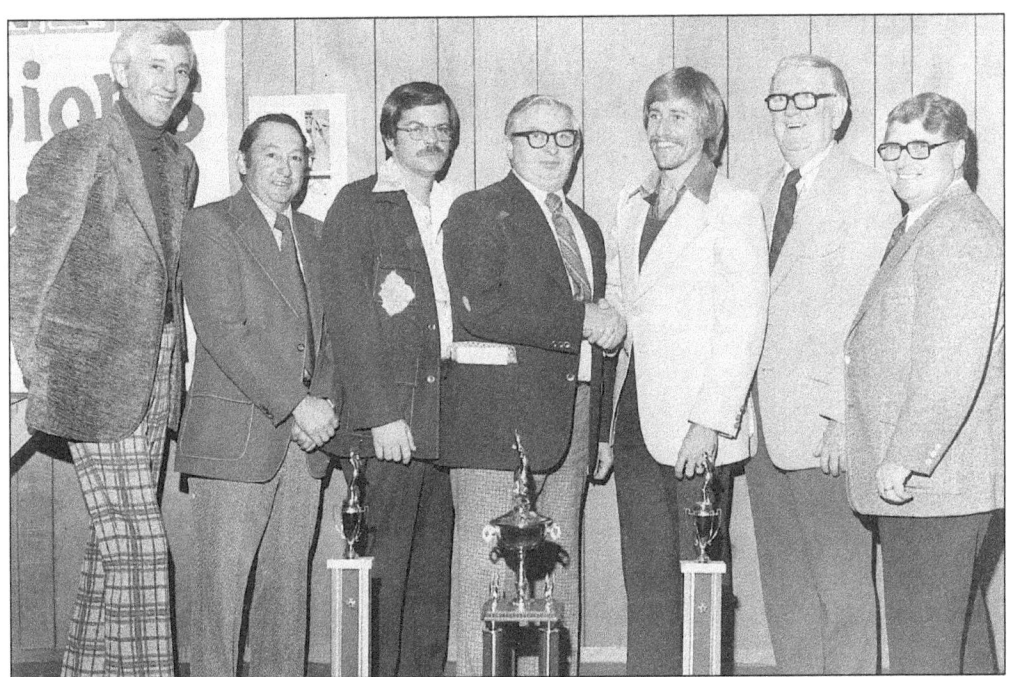

Teener Day was celebrated with a member of the Philadelphia Phillies as guest of honor. Pictured are, from left to right, Joseph Huth, Joseph Probition, James McGrath, Joseph Grabowsky, Thomas Hutton of the Philadelphia Phillies (guest of honor), Walter Jones (master of ceremonies), and Ronald Dixon.

The Morgan team, with a 12-0 record, won the 5th–6th grade division in the Frackville Biddy League. It consisted of the following, from left to right: (front row) John Podany, Richard Richart, Mark Sikora, Gregory Hummel, Jerry Manbeck, Stanley Andershonis, and James Grabey; (back row) John Teijaro, Robert Teijaro, Edward Manbeck, Art Flail, Richard Richart, Michael Slotcavage, Ray Slotcavage, and David Bowen.

The 1979 Eagles Mini Cheerleaders from left to right, were as follows: (front row) Michelle Bainbridge, Tania Belinsky, and Tracy Gawrylik; (middle row) Beth Roberts, Elizabeth Connor, Deena Belinsky, and Petrina Zuber; (back row) Kristin Berkheiser, Lori Hauze, Marianne Barkansky, and Nea Belinsky.

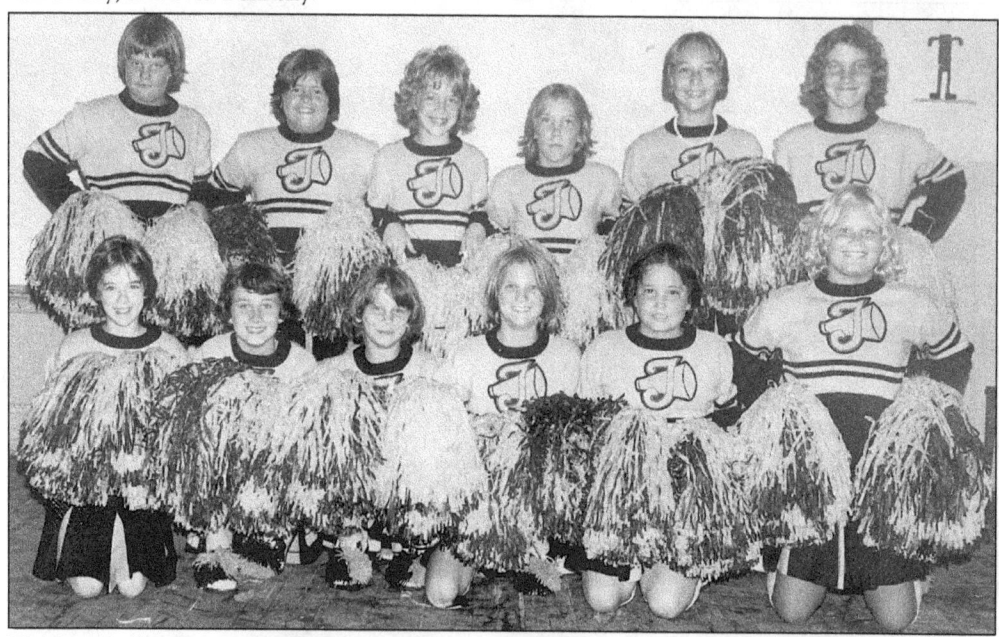

The Frackville Trojan Pee-Wee Cheerleaders smile in anticipation of their team's winning season. They are as follows, from left to right: (kneeling) Kelly Wisincavage, Kelly Walsh, Lisa Bainbridge, Suzie Bolinsky, Amy Hepler, and Renee Boxter; (standing) Pam Gray, Joanne Blozousky, Michelle Barry, Sandy Blickly, Bonnie Morgan, and Mimi Leschik.

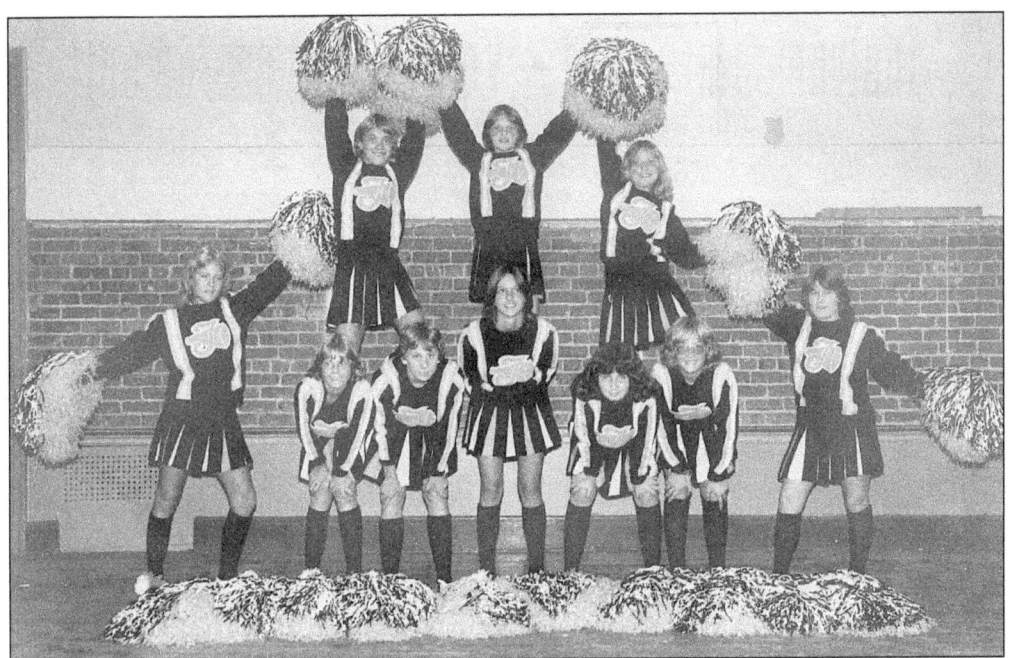

The Frackville Trojan Midget Cheerleaders display their agility in this picture. Shown here, from left to right, are as follows: (standing) Beth Palsgrove, Sharon Wascavage, Denise Belinsky, Ruth Roman, Barbara Bricker, Karen Boxter, and Lisa Hepler; (top) Tracy Buchanan, Monica Kosmisky, and Robyn Gawrylik.

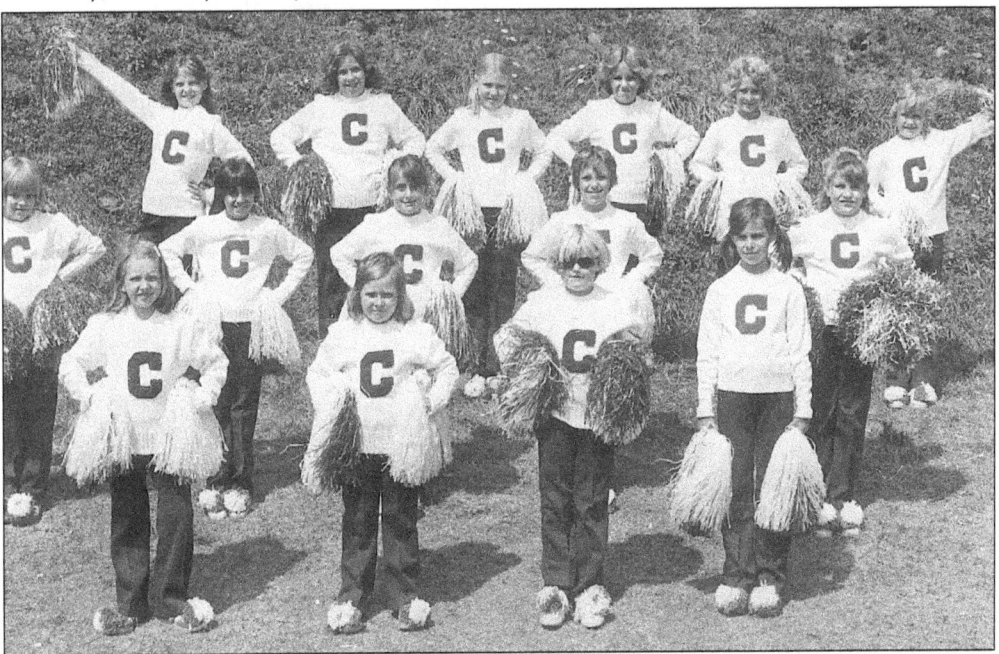

The Frackville Mini Cowgirl Cheerleaders were, from left to right, as follows: (front row) Tammy and Sherry Zimmerman, Kim Ploxa, and Sabrina James; (middle row) Cheryl Wylia, Marguerite Jessman, Dawn Emert, Kelly Montgomery, and Carrie Gnall; (back row) Susanne Roman, Paula Cahill, Michelle Zambroski, Diane Hummel, Christina Eick, and Denise Mack.

Instrumental · and · Vocal · Entertainment!

UNDER THE AUSPICES OF THE

Meredith - Cornet - Band,

OF FRACKVILLE, PA., WILL BE HELD IN

Park Theatre,

Saturday Evening, October 10, 1896.

PROGRAMME:

Opening Address,		W. D. Deifenderfer
Selection,	"Old Kentuckey Home,"	Dalby
Song,		Miss Lizzie Fatkins
Telephone Solo,		Master Charles Speidel
Song and Dance,		Brobst Brothers
Recitation,		Miss Laura Beard
Trombone Solo,	"Tramp, Tramp," and Variations,	Harry Speidel
Song,		Miss Lulu Phillips

INTERMISSION OF TEN MINUTES.

Overture,	"Champion"	George Weigand
Duett,		Evans Brothers
Selection,		Frackville Mandolin Club
Cornet Duett,		Clara and Grace Taylor
Micheal Brobst, in his own original specialty,		"Can't scare me."
Quintette,	"Happy be Thy Dreams,"	Thomas, Shirey, Hahn, Speidel, and Moore.
Cornet Duet,	"Southern Cross Polka,"	Prof. J. A. Taylor and R. Taylor.

The entertainment to conclude with Brobst brothers afterpiece, entitled "George Booveirhome's Troubles."

March,	"Home Guard"	R. Stahl

GOOD NIGHT.

Frackville Star Print.

This is a program from the Park Theater.

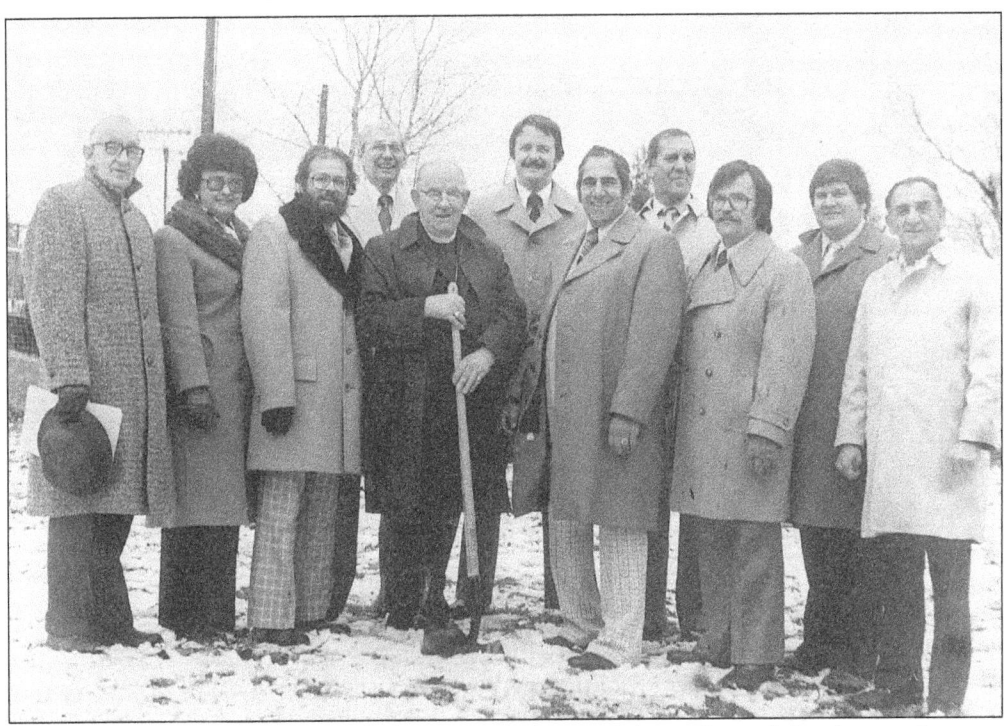

Newly fallen snow failed to chill the warm feelings of the reality of the dream of a new swimming pool at Frackville Memorial Park. Participating in the 1979 ceremony, from left to right, are as follows: (front row) James Hahn and Marie Robbins of the Pool Association, Donald Dillman (borough council president), Rev. Walter Hengen (who offered prayer), Paul Anthony, John Fields (attorney), John Domalakes (attorney), and Mayor James Nahas; (back row) Walter Baran, Charles Miller (attorney), and Al Gricoski, all of whom were members of the association.

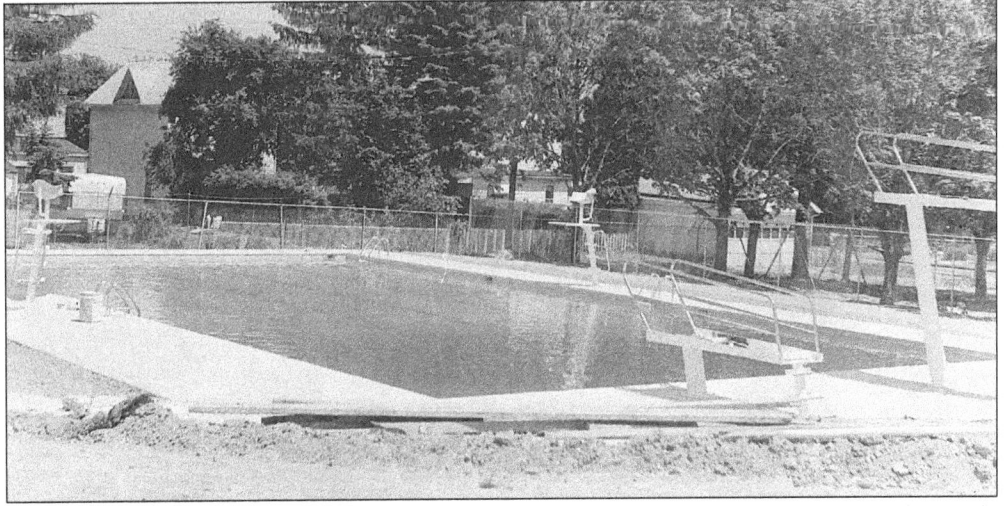

Frackville's olympic-size swimming pool opened July 15, 1979. The $103,000 was raised entirely from local contributions, with no government grant or loans. The Youth Conservation Corps program of the County Economic Opportunity Cabinet assisted in the finishing touches on the bathhouse, the laying of sod, and beautifying the surroundings.

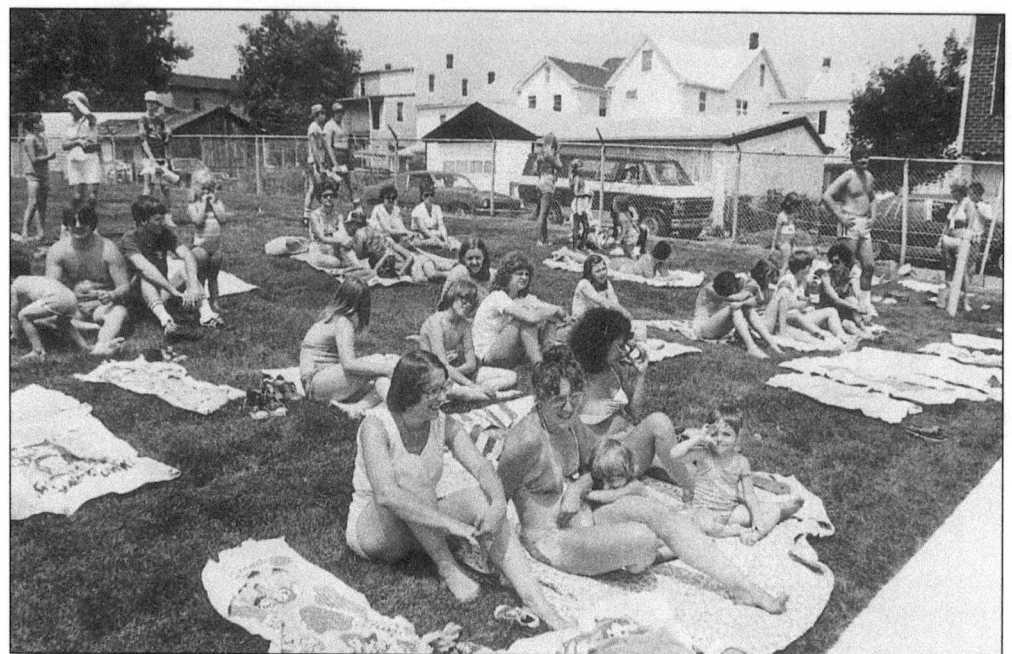

It was a perfect day for the opening of the new pool—hot, sunny, with a cooling breeze every now and then. These bathers watched the opening ceremonies as they lay in the sun on the new lawn.

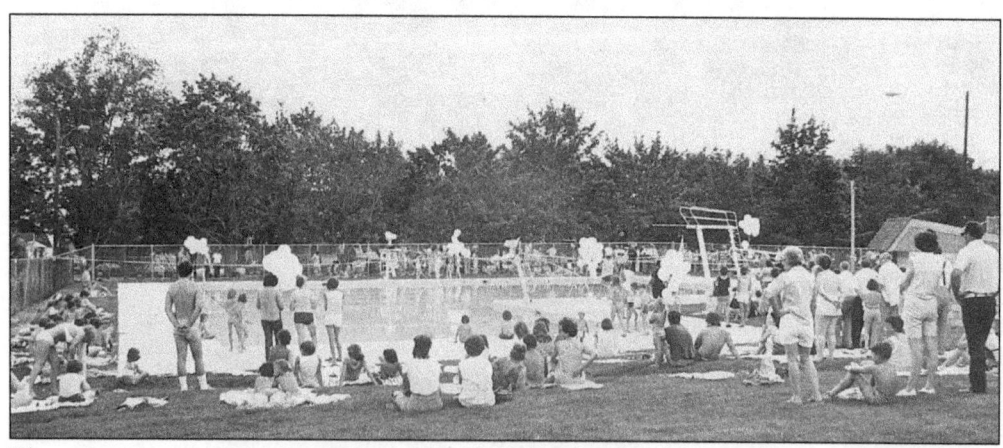

These anxious swimmers waited to take that first dip in the new pool at the Frackville Community Pool Complex, Frackville Memorial Park, on opening day, July 15, 1979.

Six

Etcetera

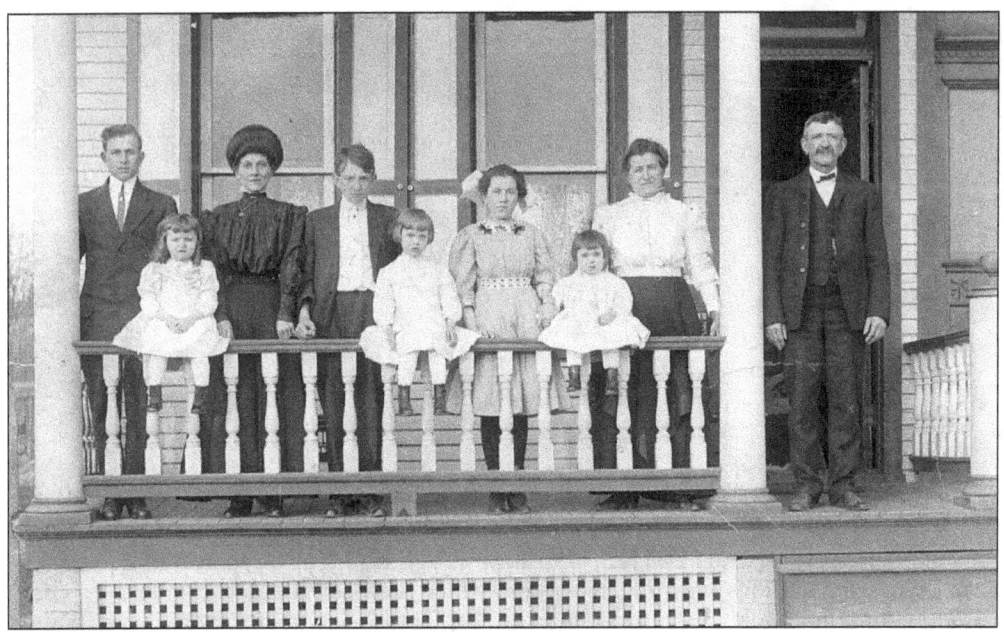

This postcard was received at the Frackville Post Office in 1998 and passed on to me. Pictured are, from left to right, Jack, Beulah, Walter, Carrie, Evelyn, and Harvey Haupt. The children were not identified. In the 1900 census, Mr. Haupt was listed as having a livery stable on Washington Street. Can anyone identify the address of this house?

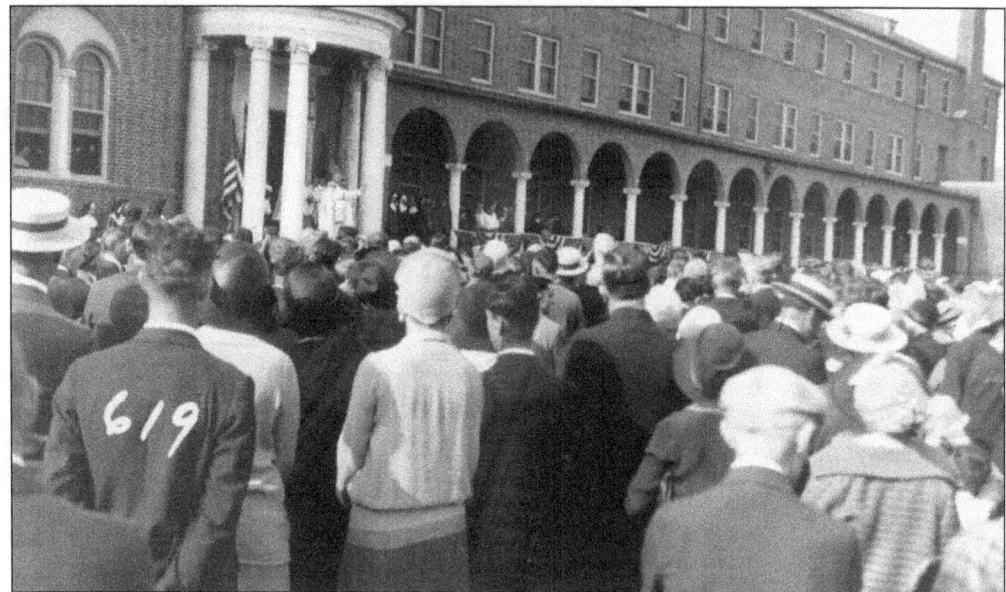

The Immaculate Heart Academy was a private academy for girls when it was dedicated September 11, 1927. In 1952, it was converted to a co-educational high school, and in 1968 the Immaculate Heart High School and Shenandoah Catholic High School merged to form one institution—the Cardinal Brennan High School.

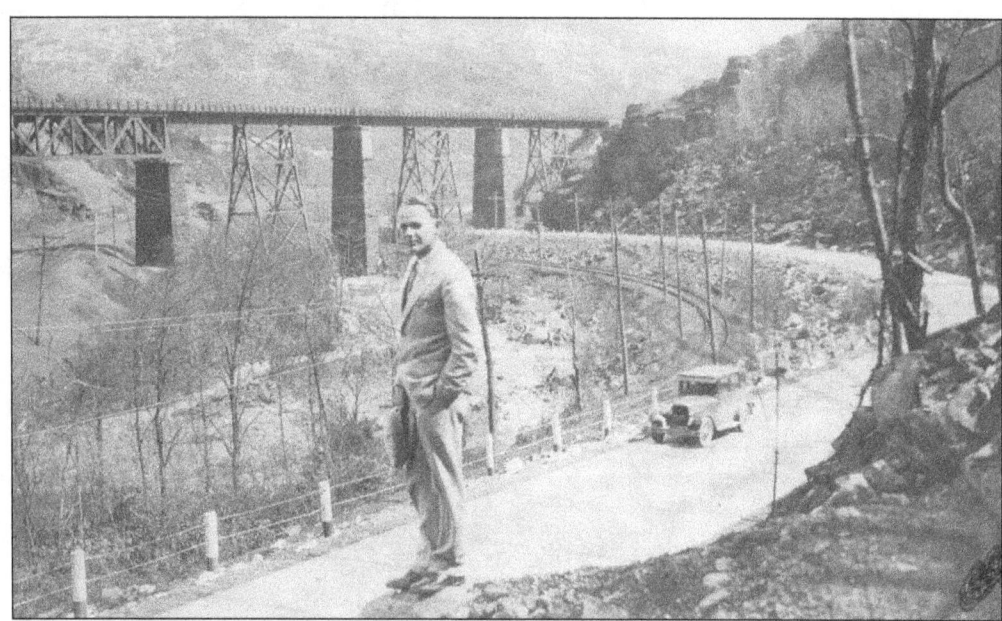

Al Bobbin, standing along the Mill Creek gorge, which runs south from Frackville to St. Clair, views the three modes of transportation in 1927. Two of the major railroads serving the county in the old days are on the left. The Pennsylvania Railroad ran over the high bridge while the Reading Railroad ran under the bridge (far left). The trolleys ran on the track at center, along the highway where the 1927 Chevy is parked. All the rails are gone now, and the bridge was dismantled in the late 1960s.

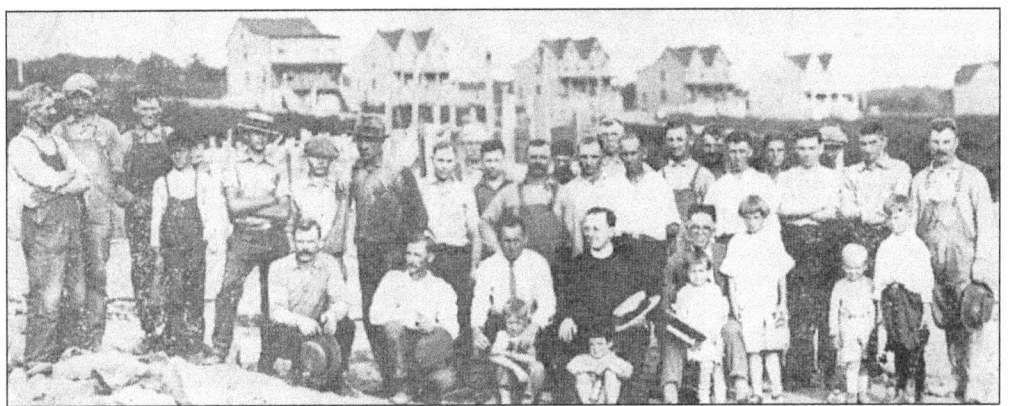

A group of Polish immigrants helped dig the foundation of St. Ann's Church on Line Street in 1924. Rev. Stanley J. Garstka is seated in the front.

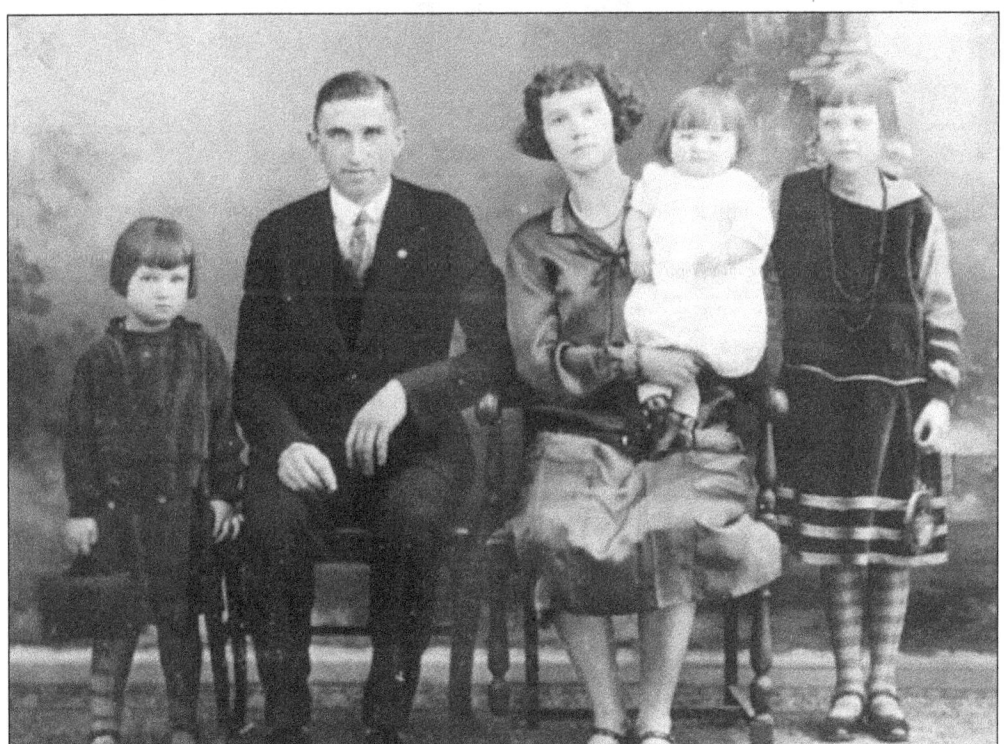

Many immigrants from Eastern Europe settled in our area because of the jobs available at the anthracite mines located here. Pictured are, from left to right, Eugenia Gibowicz, Joseph Gibowicz, Anna Gibowicz (holding Lorraine), and Dorothy Schlitzer. Mr. Gibowicz became a naturalized citizen on June 9, 1924.

Chief of Police Michael Petronko and Sgt. Edward Shearn look over law books at their headquarters on June 6, 1972. In January 1979 the headquarters moved to the Lincoln School Building at Center and Frack Streets, and in 1982 it moved to the Senior Citizens Building at East Frack Street and South Broad Mountain Avenue.

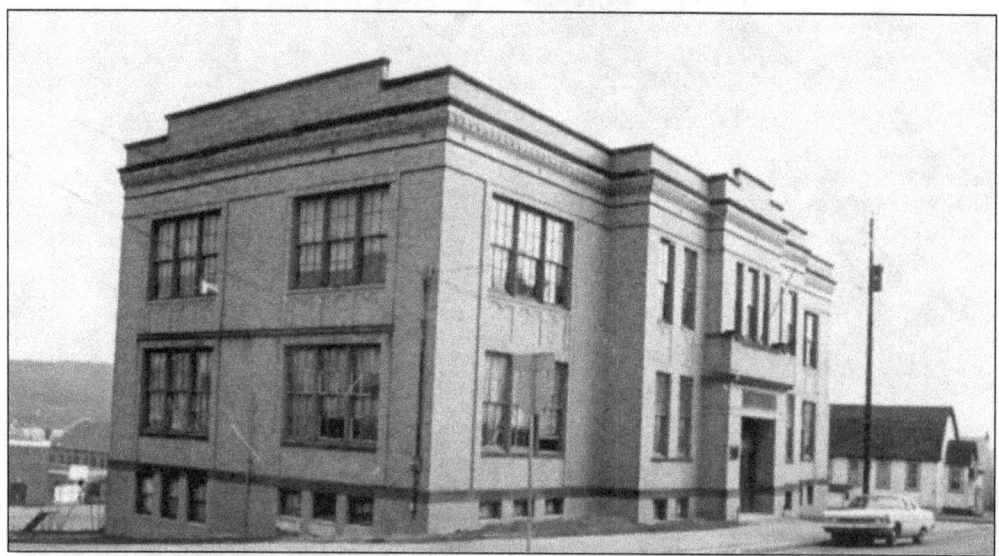

The Lincoln School Building at Frack and Center Streets was the home of the police and senior citizens in 1979. After they vacated the building, it was converted to the Lincoln apartments.

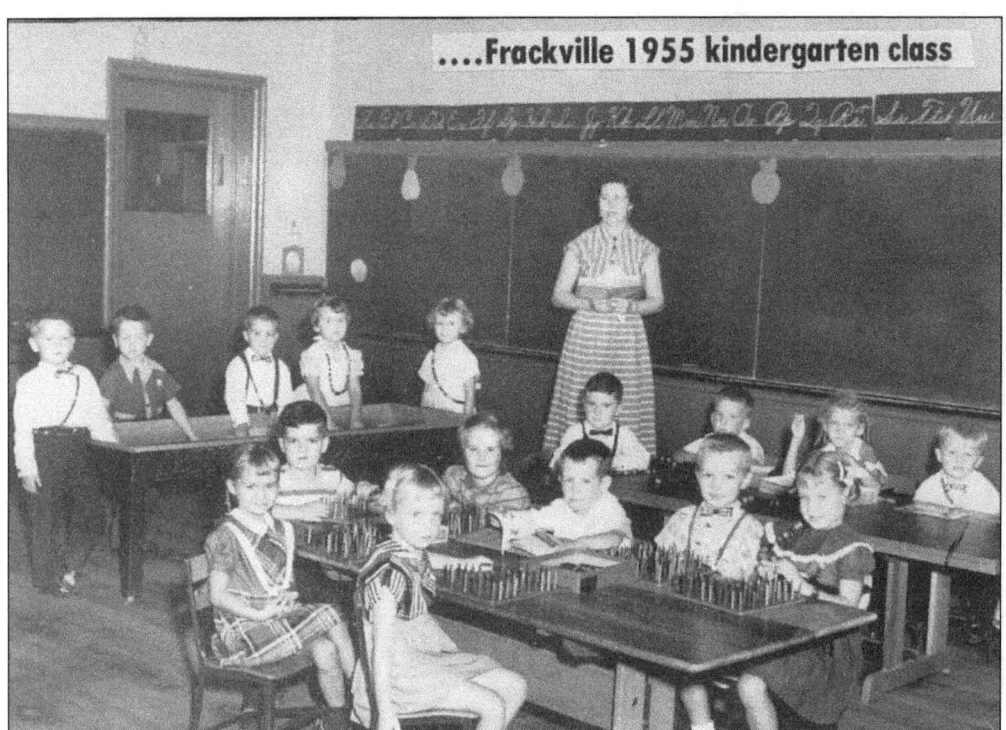

Mrs. Helen Socker's 1955 kindergarten class grew up in an era that brought an end to nostalgic little school districts. By the time these students graduated in 1967, Frackville no longer had its own school district but was swallowed up by the sprawling North Schuylkill Jointure. Around the sandbox at the far left are, from left to right, Bobby Hoppes, Donny Yarnell, unidentified, Suzanne Mykolayko, and Phyllis Hutera. Seated at the front table are, clockwise from the young lady closest to the camera, Regina Tyson, Cheryl Eiche, unidentified, Debbie Morgan, unidentified, Dennis Stanton, and Debby Stanton. At the back table are, from left to right, Jody Webb, Richard Politowski, Diane Thomas, and Danny West.

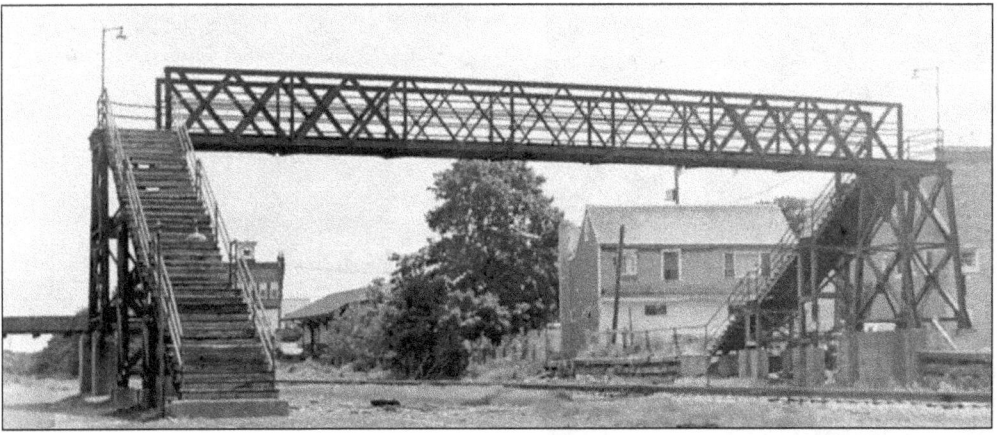

This landmark from the railroad era eventually outlived its usefulness and was demolished. Residents remember the many trains that ran past this spot every few minutes hauling coal hoisted up at the nearby Mahanoy Plane, carrying passengers over the Reading and Pennsylvania tracks between the Mahanoy Valley and Pottsville, and traveling to points elsewhere on the line.

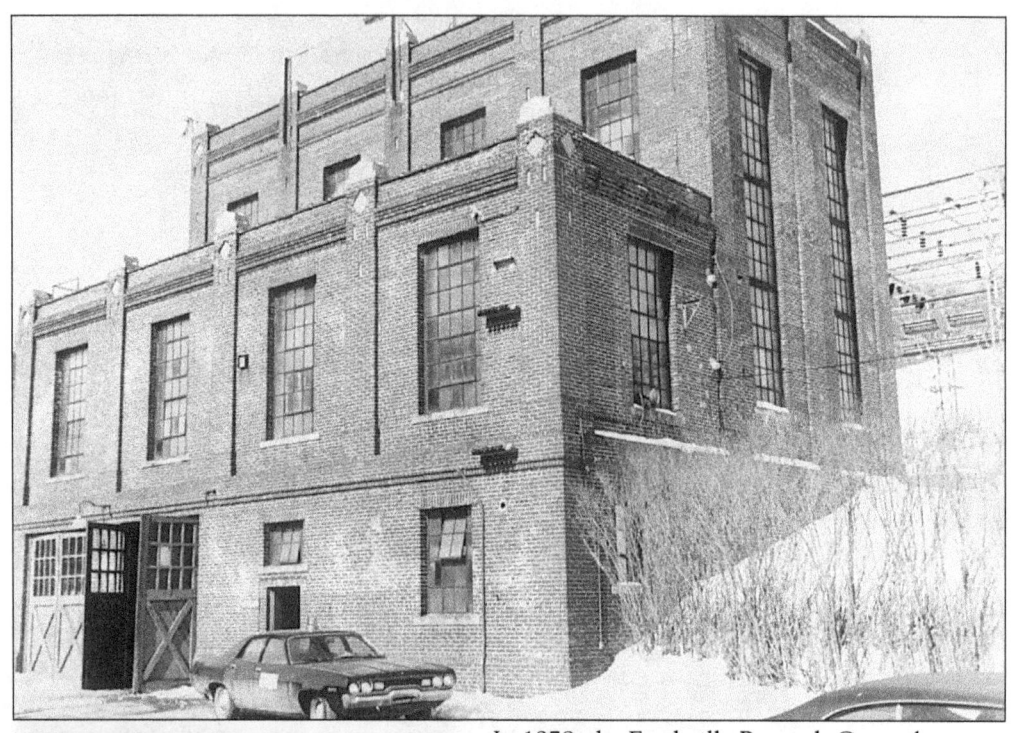

In 1978, the Frackville Borough Council purchased the former electrical substation and the 9.13 acres around it for $10,000 from the Pennsylvania Power and Light Company. It is used for the storage of vehicles and winter materials such as salt and cinders.

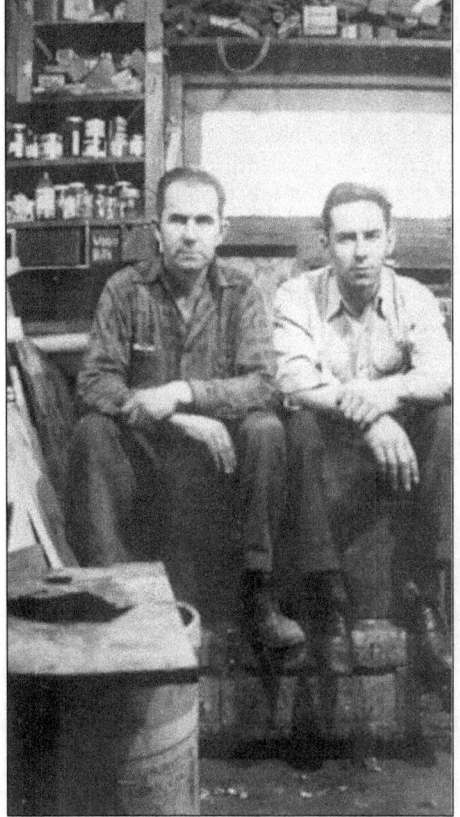

This picture, given to me by the Timmins family, shows Francis and Jack Keifer at their shop on Pine Street near the Little League Field. Mr. Keifer was well versed in Frackville history and rode around town on his bicycle talking to anyone who would listen to stories about Frackville.

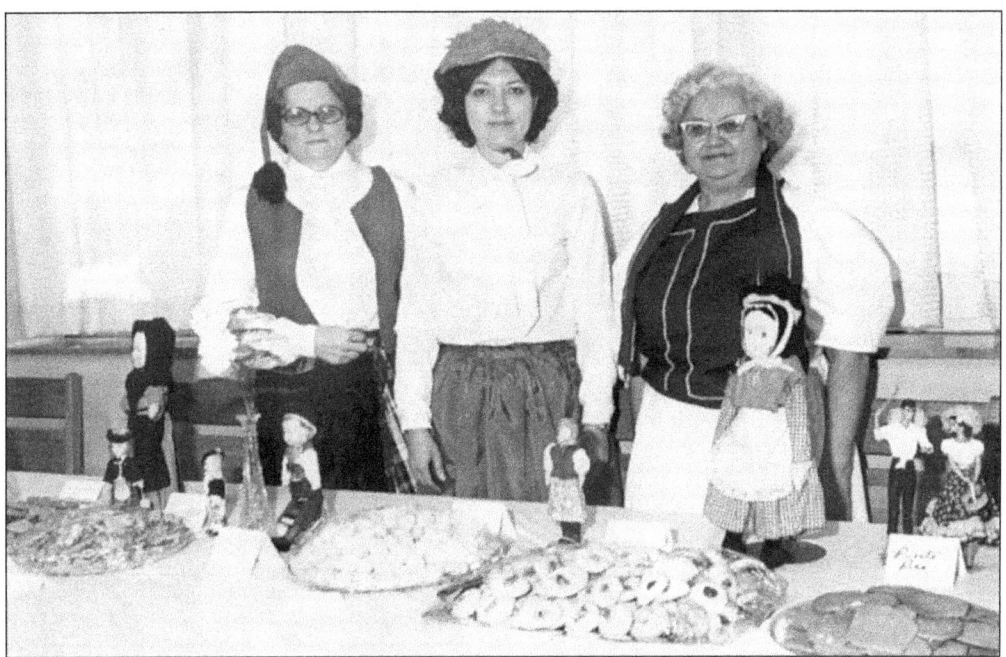

It was like the League of Nations at this mother-daughter tea held by the JOY Class of the Trinity Evangelical Congregational Church in 1978. Among the ethnic representations were Ruth Powis (Italy), Linda Phillips (Germany), and Eva Kline (Greece).

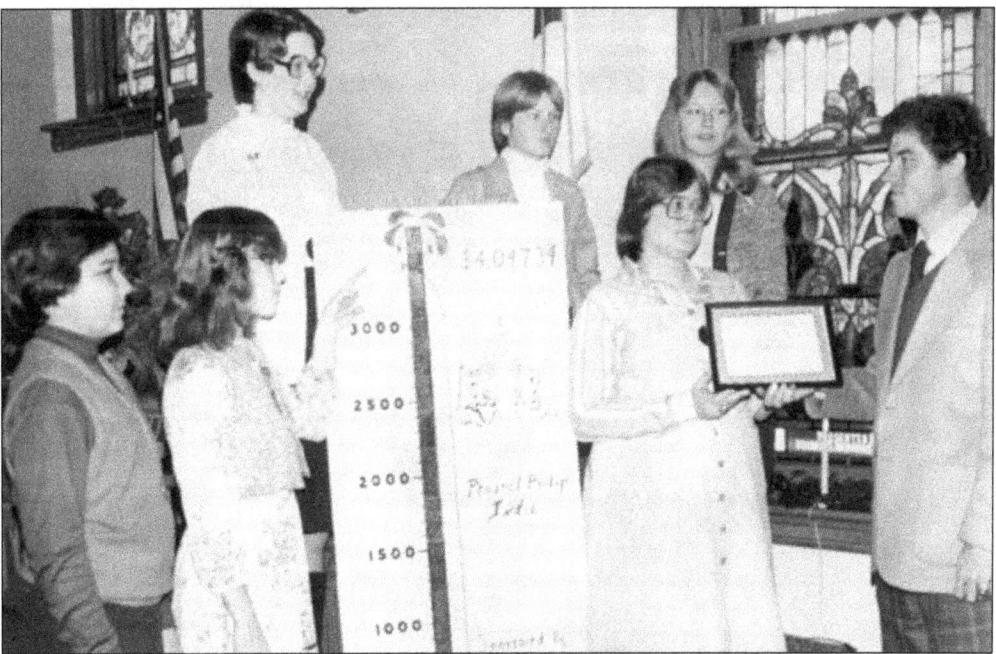

Young people of the Trinity Evangelical Congregational Church raised $4,047 in one year for "Project Phillip" to send Bible packets to India. Pictured are, from left to right, as follows: (bottom) Bill Dixon, Judy Clocker, and Mildred Yost receiving certificates of accomplishment from Bible League representative Rev. William Tate; (top) Barbara Derr, Pat Brayford, and Debbie Davis.

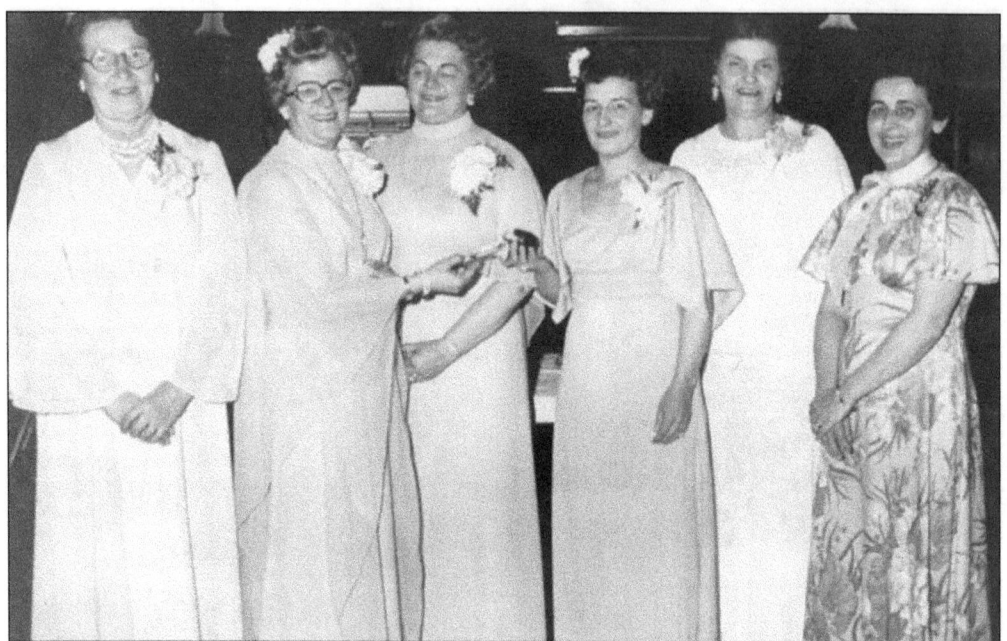

The 42nd anniversary installation dinner of the Frackville Woman's Club was held at Longos in 1978. Officers installed were, from left to right, Nellie Borzak, Kitty Kopey, Dorothy Solinsky, Kathy Judd (the outgoing president), Ann Bendrick, and Joan Halupa. This woman's organization assisted many fund-raising projects in the community but has since disbanded.

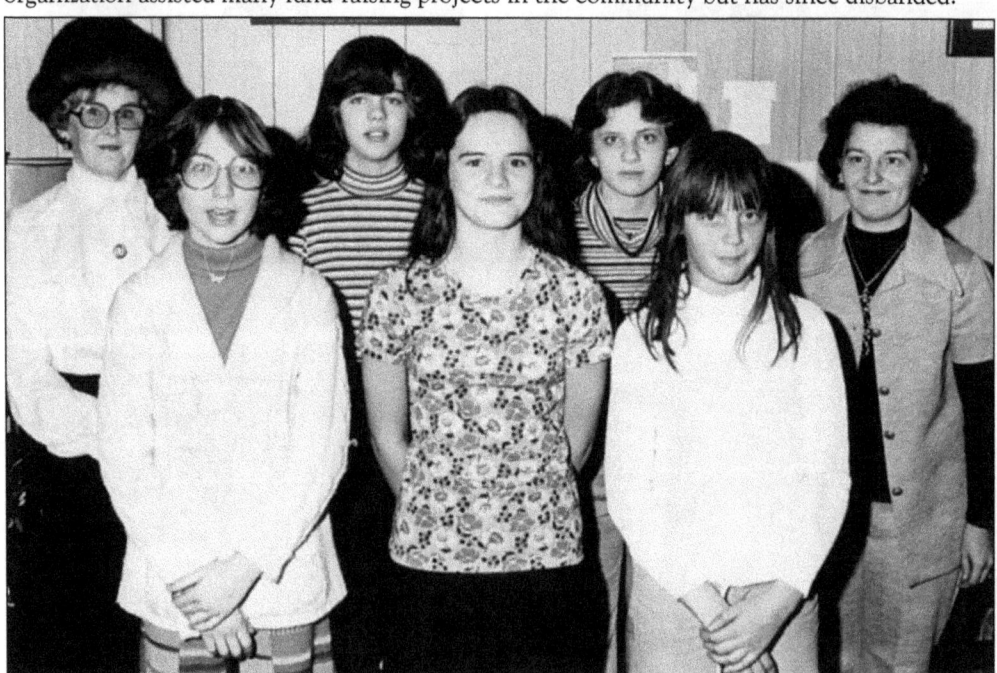

The Frackville Woman's Club held several competitions for young girls, who then represented Frackville in the county creative arts competition. Pictured in 1978 are as follows, from left to right: (front row) Kim Seasock, Lori Shoup (the winner), and Jean Kosmisky; (back row) Rosalie Miller (chairman), Lori Slotcavage, Jean Thomas, and Kathy Judd (president).

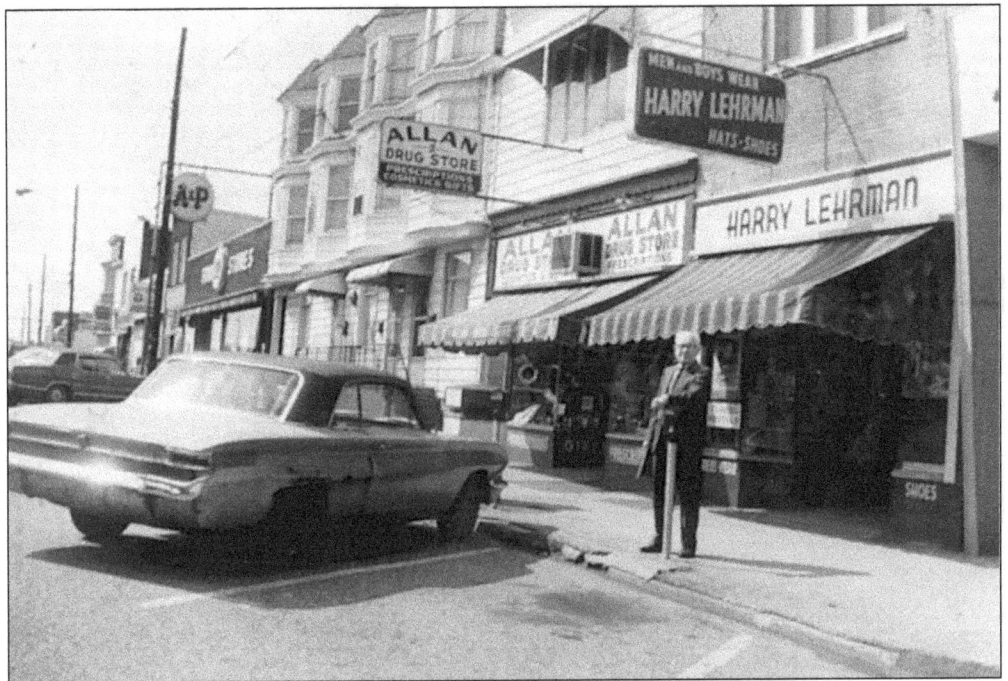

Harry Lehrman is pictured in front of his clothing store at 22 South Lehigh Avenue in May 1975. Allan's Drug Store and the A&P can be seen on the left.

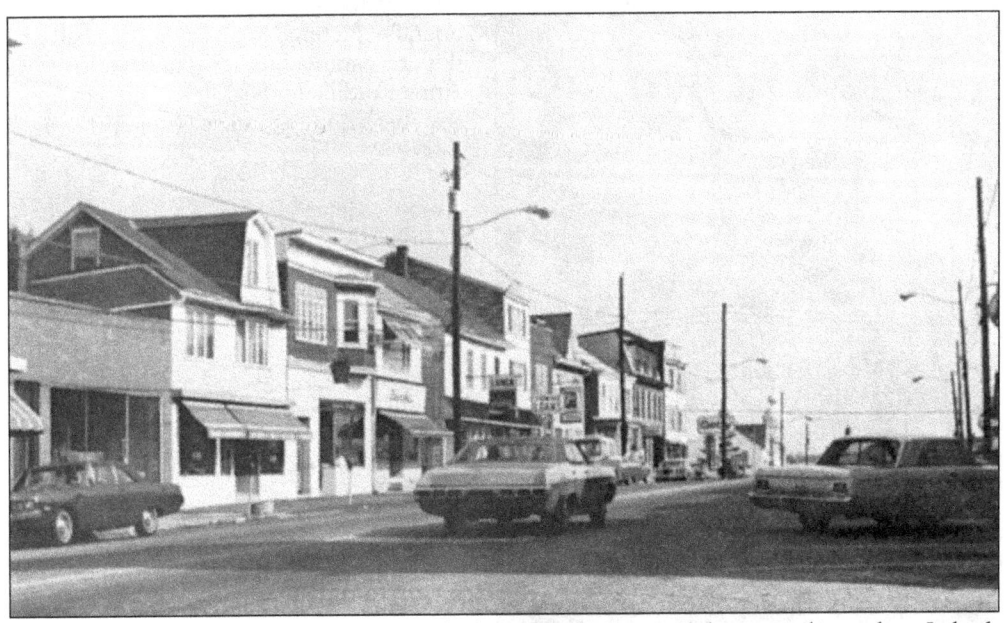

Lehigh Avenue is shown here in a view looking south. Some of the stores located on Lehigh Avenue in 1976 were Clem's Pool Room, Stief's Shoe Store, the Pennsylvania Liquor Store, Blanche's Card Shop, Bender's Cigar Store, Molly's Lunch, and the Towne Loan Company. None of these businesses are at that location today.

A Spring Splash was held in 1979 to raise funds for the new pool. Talented actors, singers, and comedians provided the entertainment and dancing followed to the music of the "Natural Sounds." Pictured in a comedy baseball skit are Vanessa Sterner (pitcher), Jo Anne Kurdilla (at bat), Jean Dillman (catcher), and John Fields (umpire).

Russell Pleva got all wet and was not even in the pool. He was also master of ceremonies and participated in many shows and minstrels held in town. Donald Dillman and Dave Smiley Jr. were the dowsers.

Frackville Cub Scout Pack 92 of St. Joseph's Church participated at the County Scout O'Rama held in Pottsville on May 1959. The theme was "Outerspace" and the Frackville group won high praise for their costumes with their head-gear that lit up as they marched around the darkened auditorium. Pictured are, from left to right, as follows: (front row) Thomas Kopitskie, Tony Baran, David Fennelly, Michael Joseph, James Neary, Jerry Hale, Ray Bendinsky, Dennis Stanton, and George Usupis; (middle row) John Seipp, John Kosick, A. Markowski, unknown, Bill Wolfe, A. Rakowsky, unknown, George Wolfe, Charles Miller, and Randy Ansbach; (back row) James Becker, Walter Swistak, Bill Rogers, Charles Sienkiewicz, Gregory Tyson, Thomas Curry, Bill Curran, John Marhon, James Purcell, John Tomalavage, unknown, and Bill Schappell.

Helen and Pete Kowker are shown at Miami Beach, Florida, in June 1941. Pete was a Metropolitan Insurance man for many years and was very active in community projects. He was an avid historian and kept many files on Schuylkill County. Before his death, he gave me 22 albums of information, which I presented to the Historical Society of Schuylkill County and the Pennsylvania State University Library at Schuylkill Haven.

Frackville had several woman's organizations. Among them were the Union of Polish Women, who celebrated their 50th anniversary in 1979. The officers that year were as follows, from left to right: (seated) Jan Micun and Sophie Hancher; (standing) Regina Petronko, Anna Brennan, Dorothy Wabo, Florence Sienkiewicz, and Cecelia Malinowski.

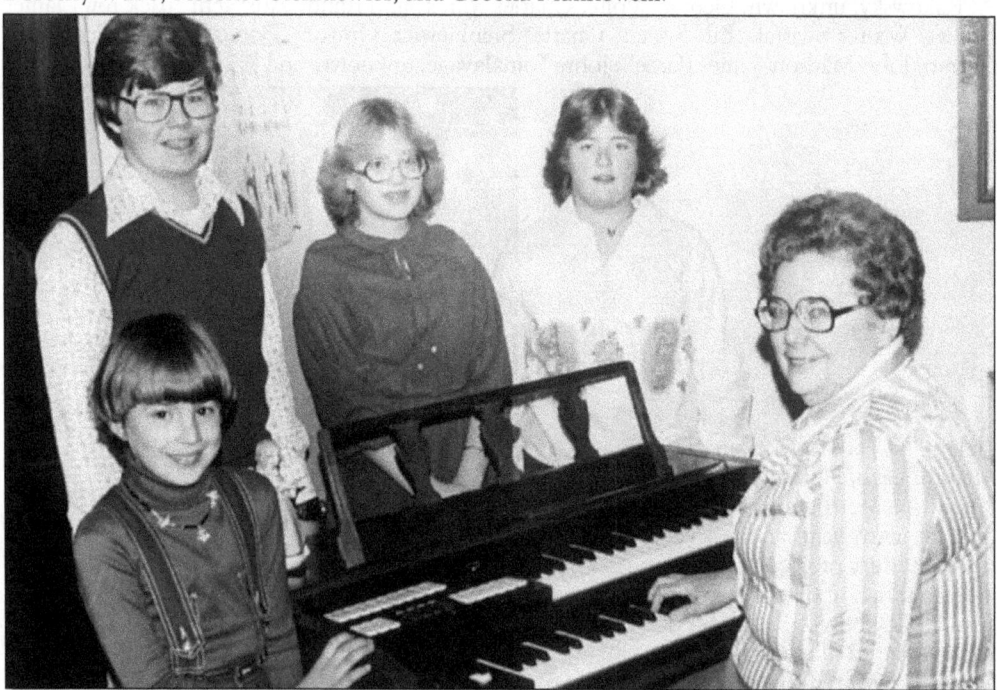

Everyone remembers Miss Helen Everett at her Music Studio on South Nice Street. She is pictured at the organ in 1980 with award-winning students Maria Canavar (organ), Bruce and Lori Berg (piano), and Cindy Hampton (vocal).

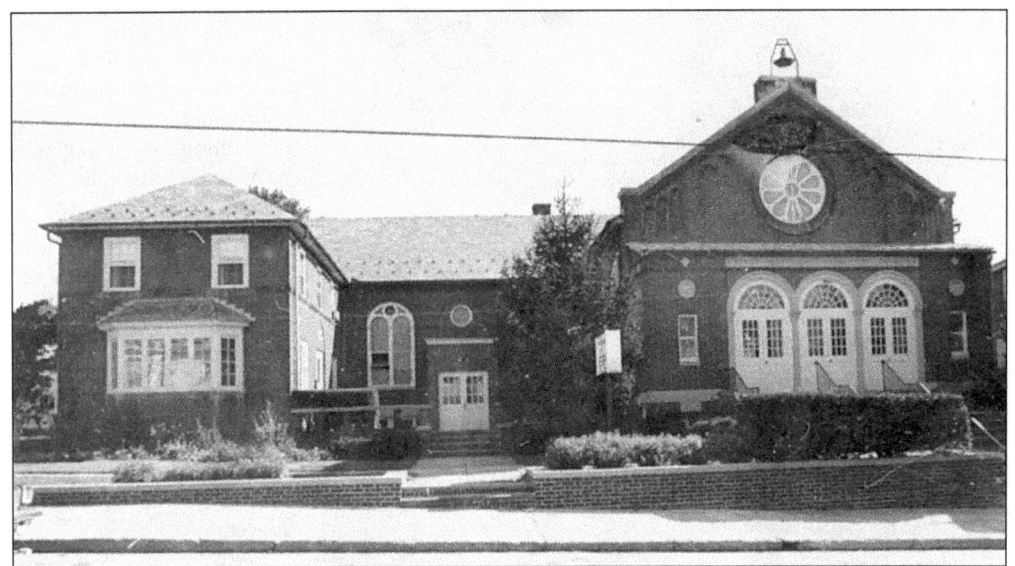

Pictured is the religious complex of the First United Methodist Church (the church, parsonage, school, and fellowship hall) when they celebrated their 100th anniversary in 1980. The church was built on a lot donated by Daniel Frack.

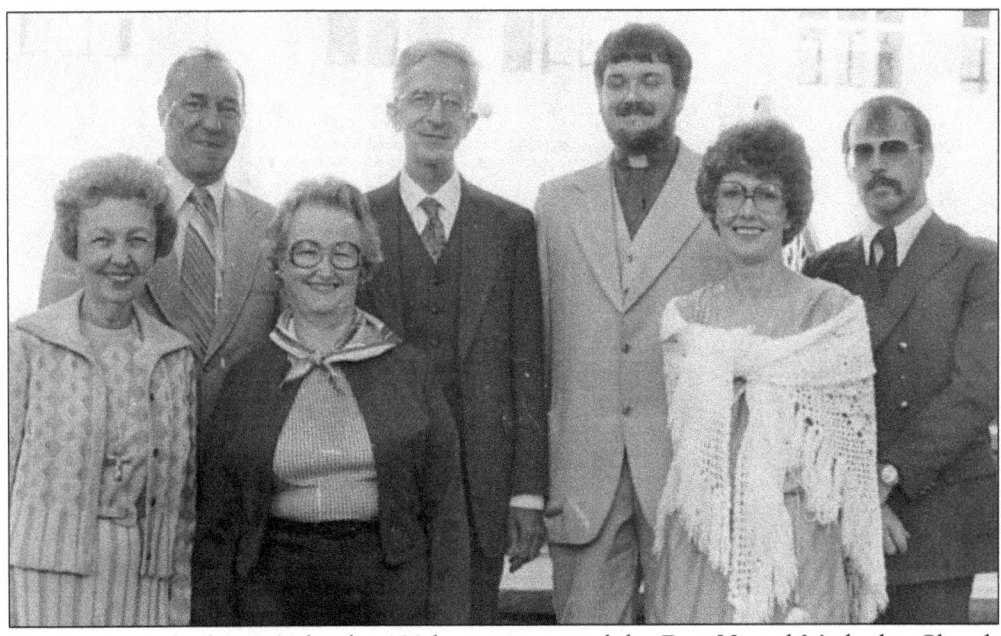

Dignitaries at the banquet for the 100th anniversary of the First United Methodist Church were, from left to right, Mrs. Thomas J. Lewis, Mrs. Harold Scheick, Mrs. Russell Hughes, Mr. Wilbur Rubright, Rev. Harold Scheick, Rev. Dale Lewis Miller, and Russell Hughes.

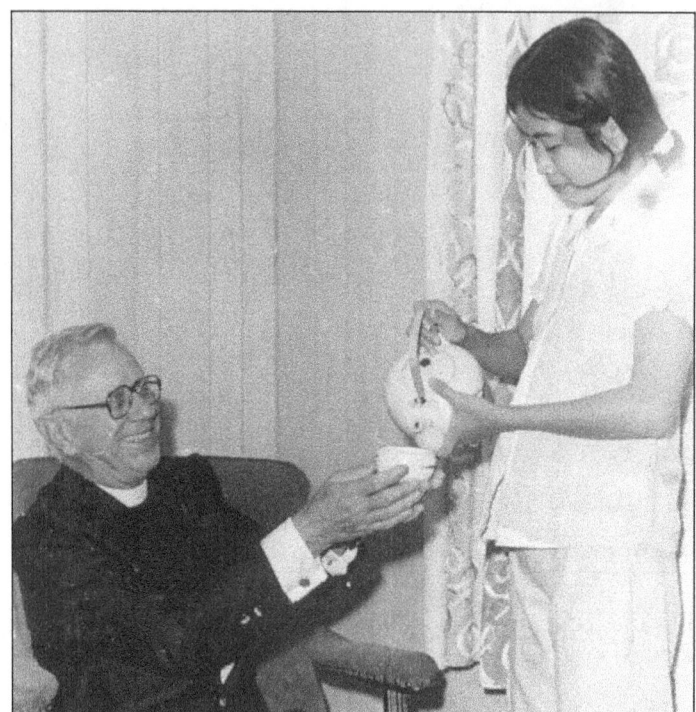

In 1979, St. Ann's Church was the first congregation to sponsor Vietnamese refugees to our community. They provided a furnished apartment at 54 North Lehigh Avenue to two brothers and two sisters who had been separated from their parents in Vietnam. Fourteen-year-old To-Que Mai served tea to Rev. Joseph Rapczynski. Other family members were 16-year-old To-Que Lang, 22-year old To-Quoc Khuong, and 15-year-old To-Quoc Phong.

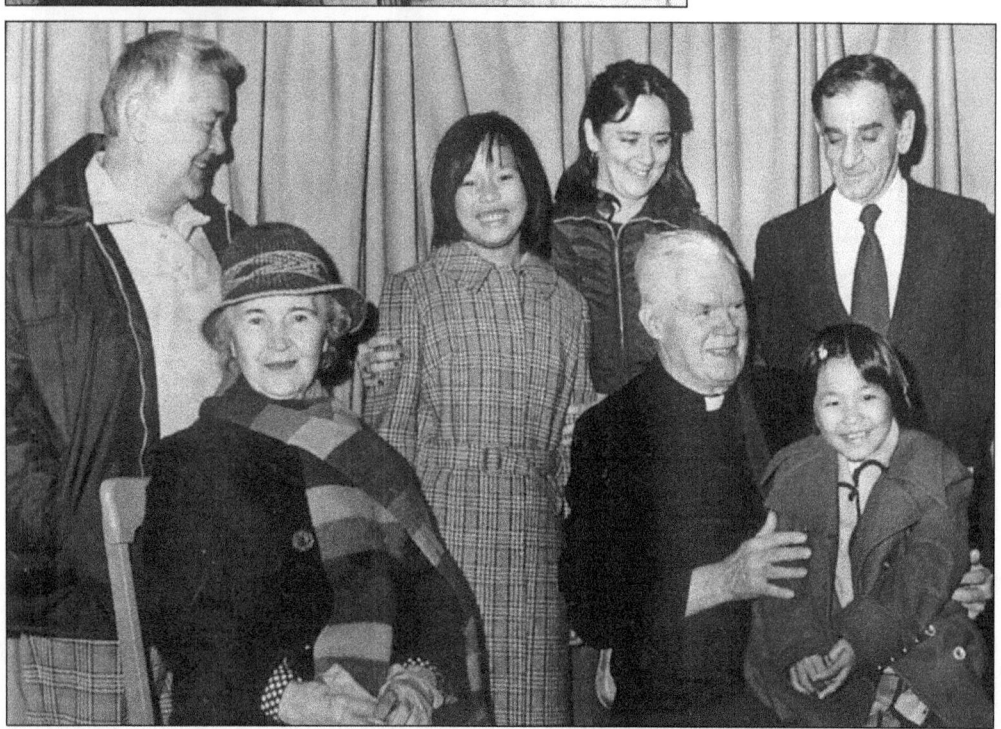

Frackville welcomed a second Vietnamese family, sponsored by St. Joseph's Church. The family consisted of parents and three children. Pictured are the following, from left to right: (seated) Mrs. Ethel Miller and Rev. William Conley (holding Khuu Thu Cuc); (standing) Police Sgt. Edward Shearn, Khuu Xuan Mai, Mrs. Grace Sankus, and Mayor James Nahas.

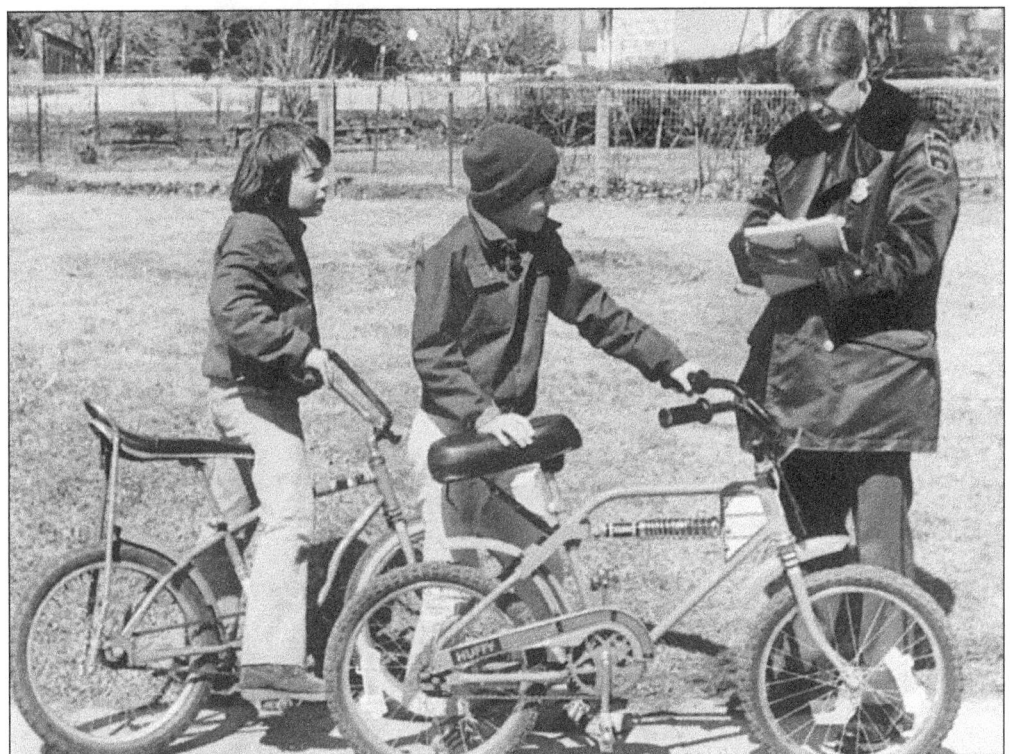

The Frackville Police Department register all bicycles in the community. Pictured in 1979 are Edward Hoffman and William Rumbel with their bicycles and Police Officer Jack Shearn recording the information.

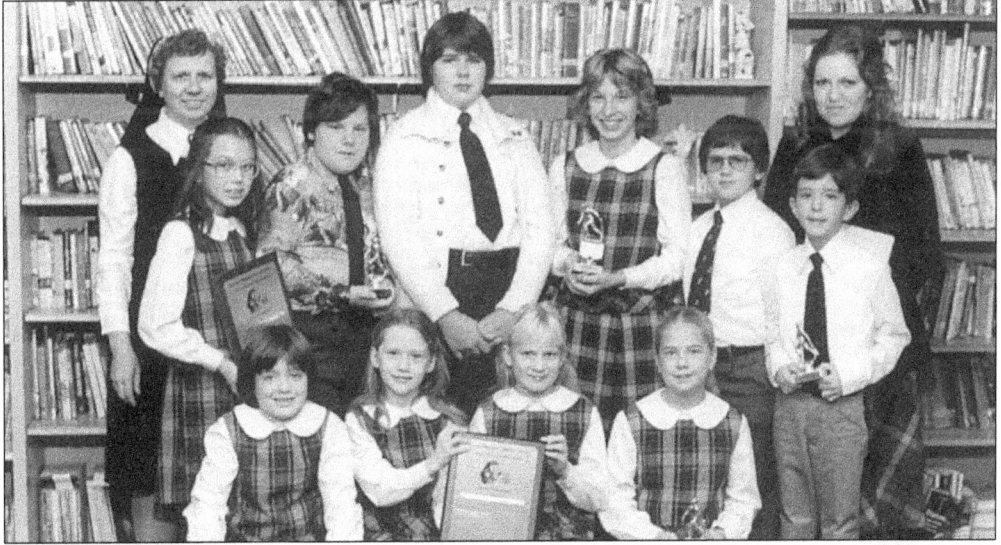

The Multiple Sclerosis Read-a-thon winners from the Catholic schools in 1980 were, from left right, as follows: (seated) Ann-Marie Squeglia, Jennifer Naspinski, Carrie Little, and Sandra Gurka; (standing) Margaret Esquival, Sister Stephen Marie (principal), John Martofel, Zachary Navit, Michelle Pastula, Donald Navit, Michael Mohutsky, and Miss Ellen McCormick (teacher).

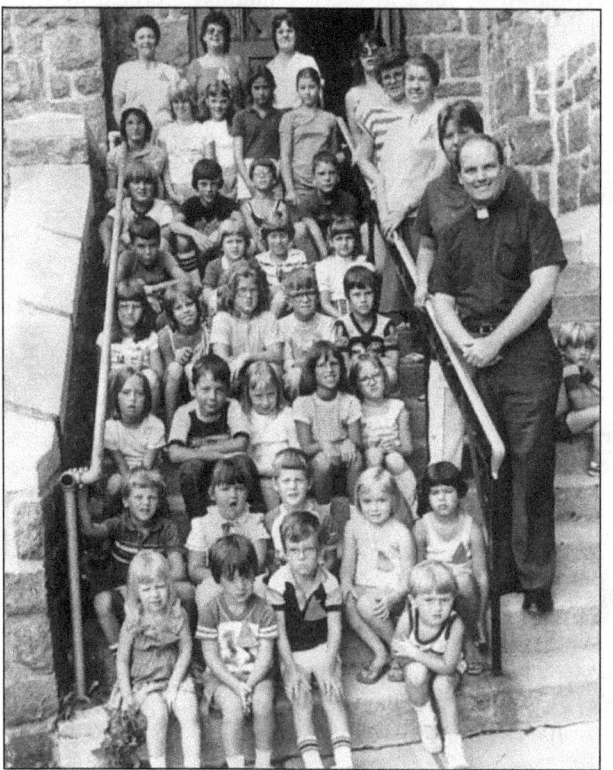

This 1924 photo shows the Vacation Bible School of the Zion Lutheran Church during the tenure of Rev. Gallenkamp as pastor. The church, built at a cost of $5,000, was dedicated on October 20, 1895, and was used until 1925, when they moved to their present site at Oak and Nice Streets. This lot was occupied by a home that was moved to South Nice Street to make room for the church, and the building now serves as the parsonage.

This 1983 photo shows the Vacation Bible School of the Zion Lutheran Church with 30 children and 10 teachers. They studied the seasons of the sun and the holidays of the church. Rev. David W. Eisenhuth was pastor at this time.

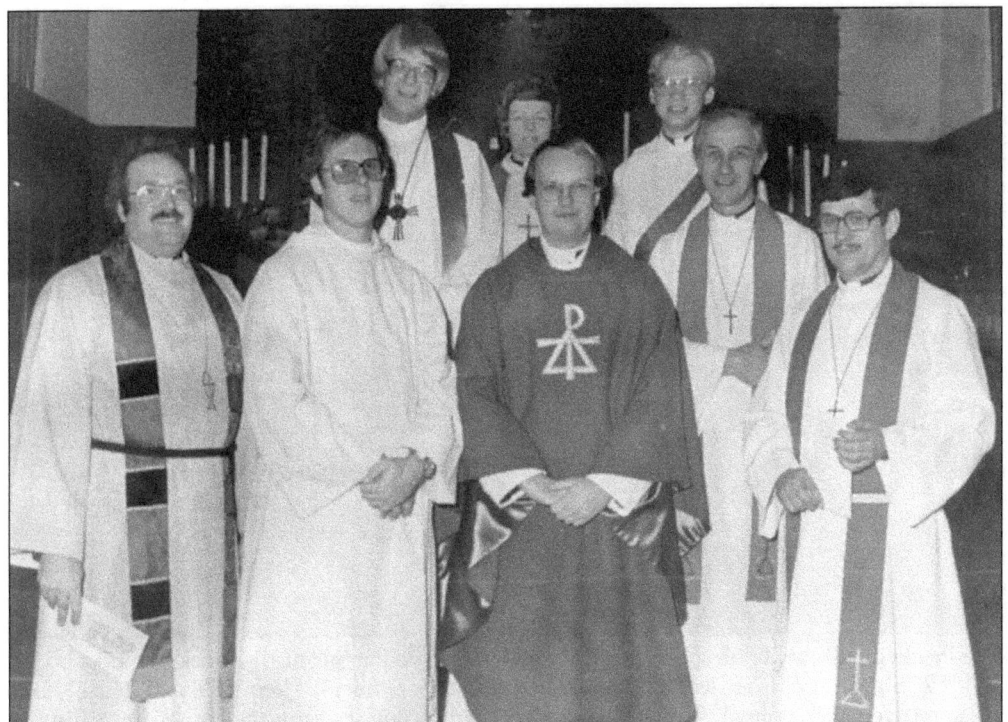

On November 8, 1981, the Rev. David W. Eisenhuth was installed as pastor of the Zion Lutheran Church. Pictured are the following, from left to right: (front row) Rev. Henry G. Fromhartz, Seminarian Roger Quay, Rev. David Eisenhuth, Rev. Harold Weiss, and Rev. Guy Grube; (back row) Rev. Robert Kysar, Rev. Myrna Kysar, and Seminarian John Garber.

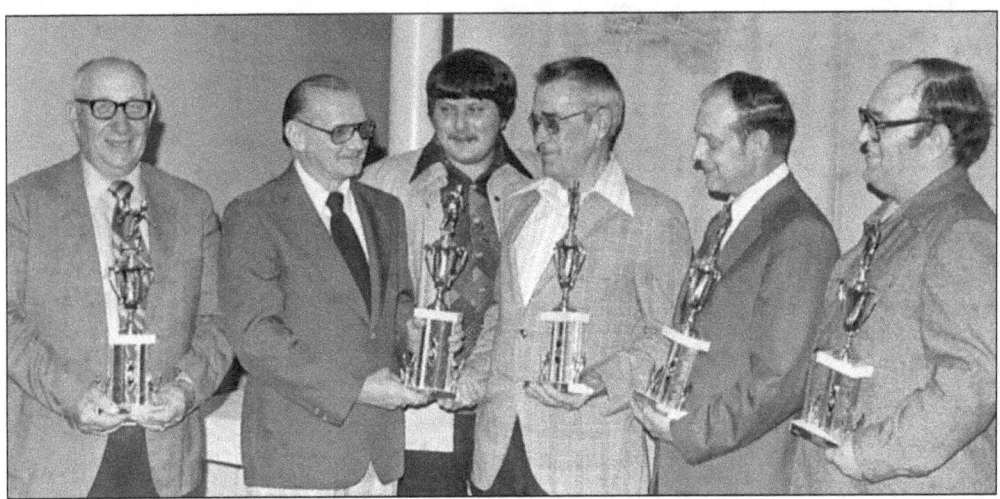

The 1978 bowling champs of the Lutheran Holiday Lane Bowlers were, from left to right, George Ebert, William McClaren, Thomas Whery, Harry Mallams, James Miller, and Art Siecavage.

The Frackville Rotary Club sponsored the Red Cross Bloodmobile at the Frackville Elks Lodge in 1982. Shown are, from left to right, Barbara Galley (donor), Ellen Sullivan (nurse), Bill Kaladas (five-gallon donor), William Davis (three-gallon donor), Ellissa Sherman, Betty Runkle (nurse), and Eve Alshon (committee member).

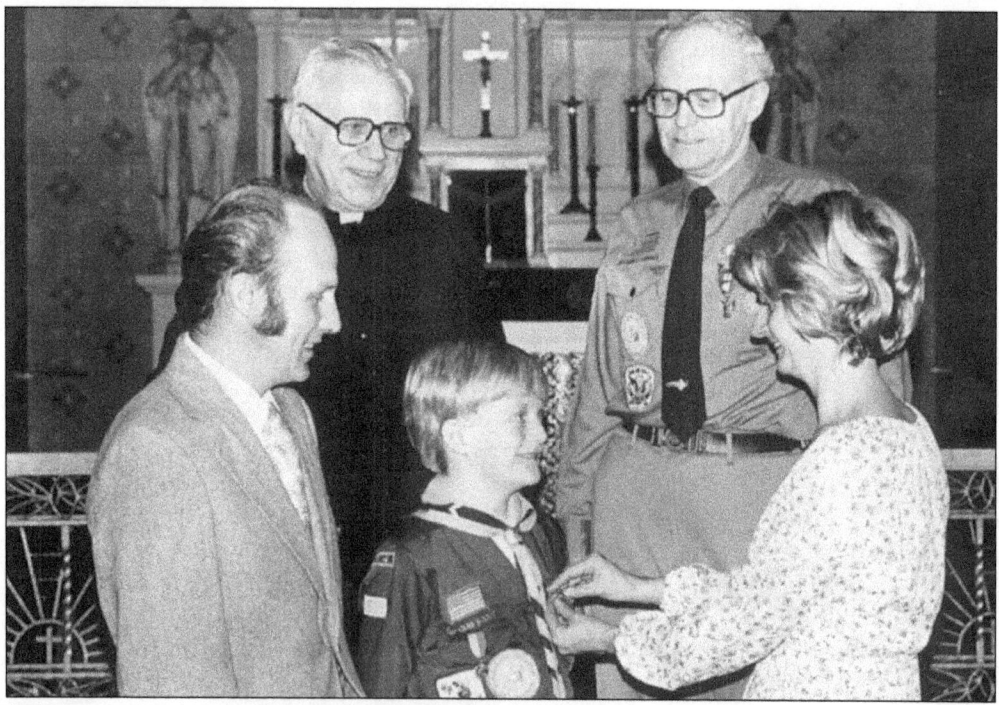

Cub Scout Kenneth Martin Jr. receives the Parvuli Dei award at St. Ann's Church in 1979. His parents, Mr. and Mrs. Kenneth Martin Sr., Rev. Joseph Rapczynski, and Cubmaster Robert Berg attended the special service for the Cub Scouts and their leaders.

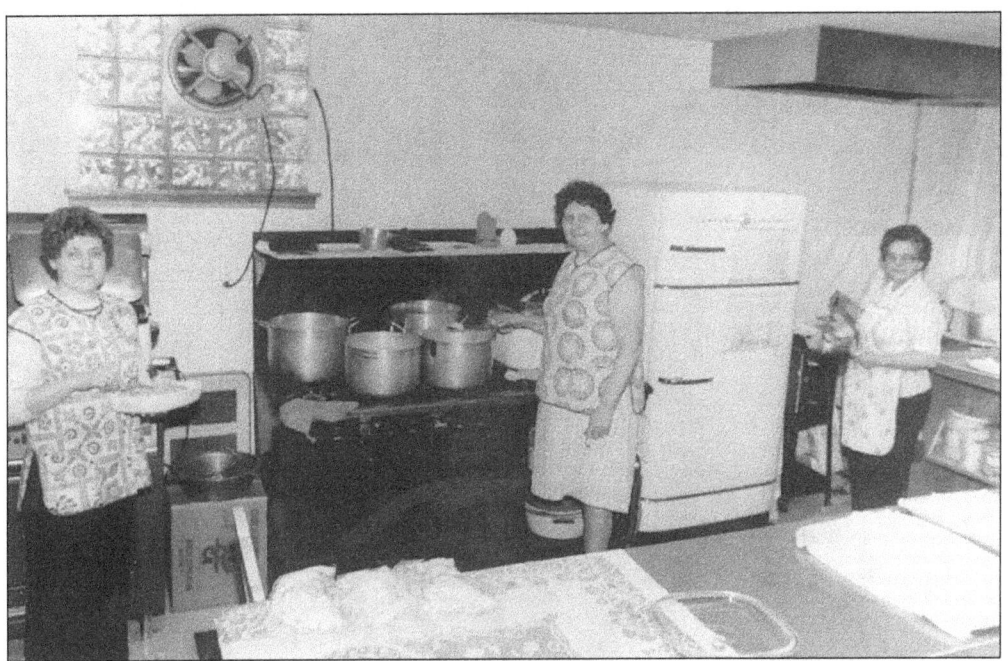

Many churches in our area have food and bake sales. Pictured are ladies of the Holy Ascension Orthodox Church making their most popular seller—the Pirogie. Matushka Ropitsky (left) is packing an order, Ann Yatcilla is standing at the boiling pot, and Teresa Basara is frying the delicious treat.

If there was anyone who had a spiritual influence on the parishioners of the Holy Ascension Orthodox Church, it was Rt. Rev. Basil Gamble, who served from 1924 to 1968 and was well loved by his flock. The church celebrated its 75th anniversary on September 30, 1990.

Stanley Matlowski was born in Poland and migrated to this country in 1923 at age 10. He operated the L&M Sales food store at 59 North Railroad Avenue for many years. In 1975, he was the recipient of the God and Country award from the Knights of Columbus for his service to area residents and civic groups.

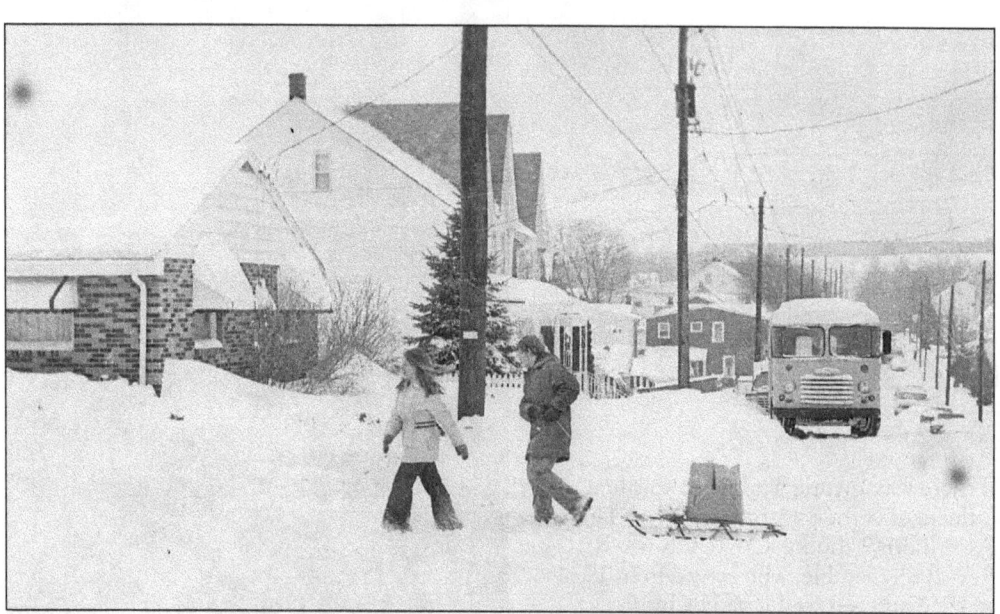

Remember the 1979 snowstorm? This unidentified couple hurried home with groceries mounted on their sled. They are pictured on the corner of South Nice and West Chestnut Streets.

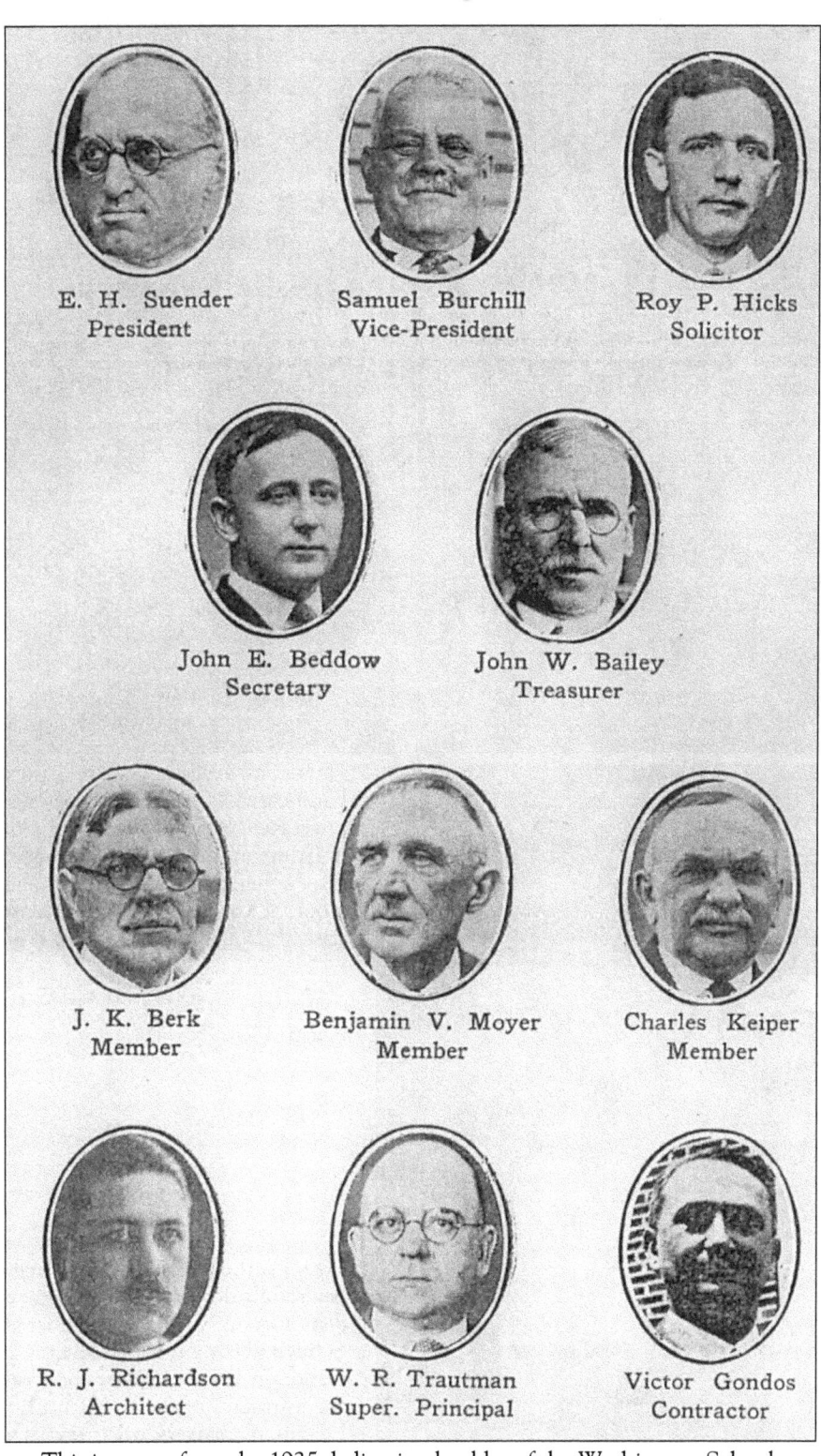

This is a page from the 1925 dedication booklet of the Washington School.

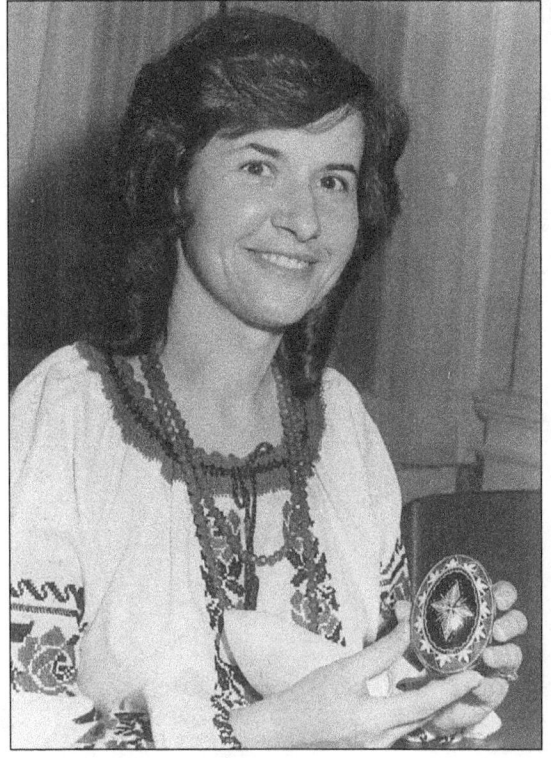

Henry Pascavage of Frackville presents a hand-carved crucifix to newly ordained priest Rev. John M. Fields in 1986. Looking on is the pastor of St. Michael the Archangel Ukrainian Catholic Church, Msgr. Joseph Batza. Henry Pascavage died on August 23, 1998.

Pysanky, the traditional art of making beautifully decorated Easter eggs, was demonstrated by Marie Hancher at the Schuylkill County Arts and Ethnic Center in 1982. Mrs. Hancher is also the instructor of the St. Michael's Ukrainian Dancers, who perform all over the country.

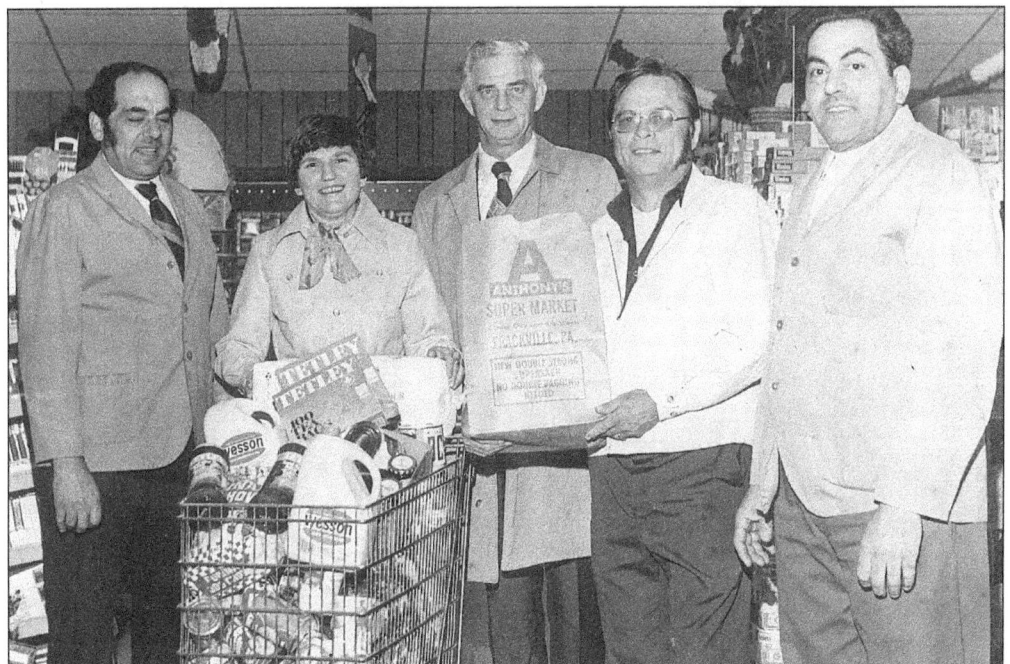

During the 1976 centennial year of Frackville, another anniversary was observed as the Anthony Super Market celebrated the 50th anniversary of its founding. Pictured are, from left to right, Michael Anthony, Anne Corinchock (with a basket of groceries that she won), Tetley representative James Ebling, John Corinchock, and Joseph Anthony. The store is now operated as TJ Barts Supermarket.

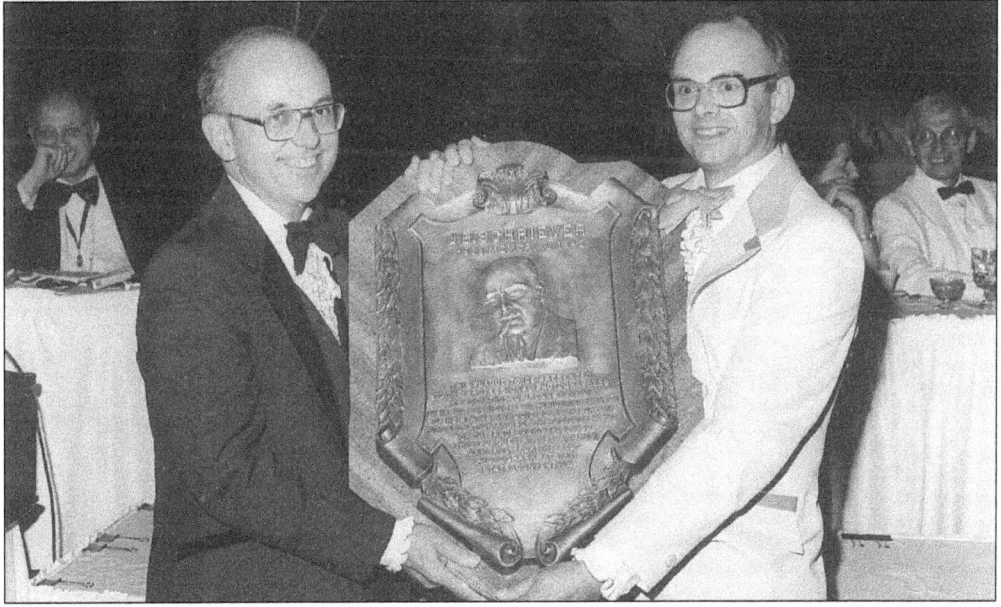

David Lee presented Ernie Garbarino with the James B. Schriever Memorial Trophy during Photography Week in 1980. Ernie was a past president of the Professional Photo Association of Pennsylvania and the Northeast Pennsylvania Professional Photo Association. Today, the studio is owned by Cindy and Bill Turner.

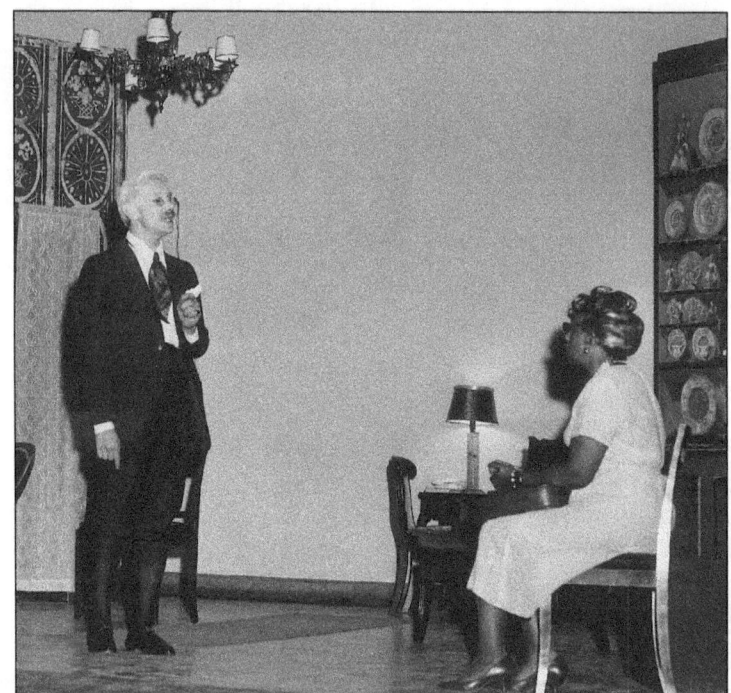

Jack Allen, of 9 East Frack Street, graduated from FHS in 1947 and pursued an acting career in New York City. His credits include parts in *Picnic*, *The Glass Menagerie*, *Brigadoon*, and many other Broadway productions. Pictured here, he is the only sighted member for the production of *Curious Savage*, with a drama group sponsored by the Lighthouse, the New York Association for the Blind.

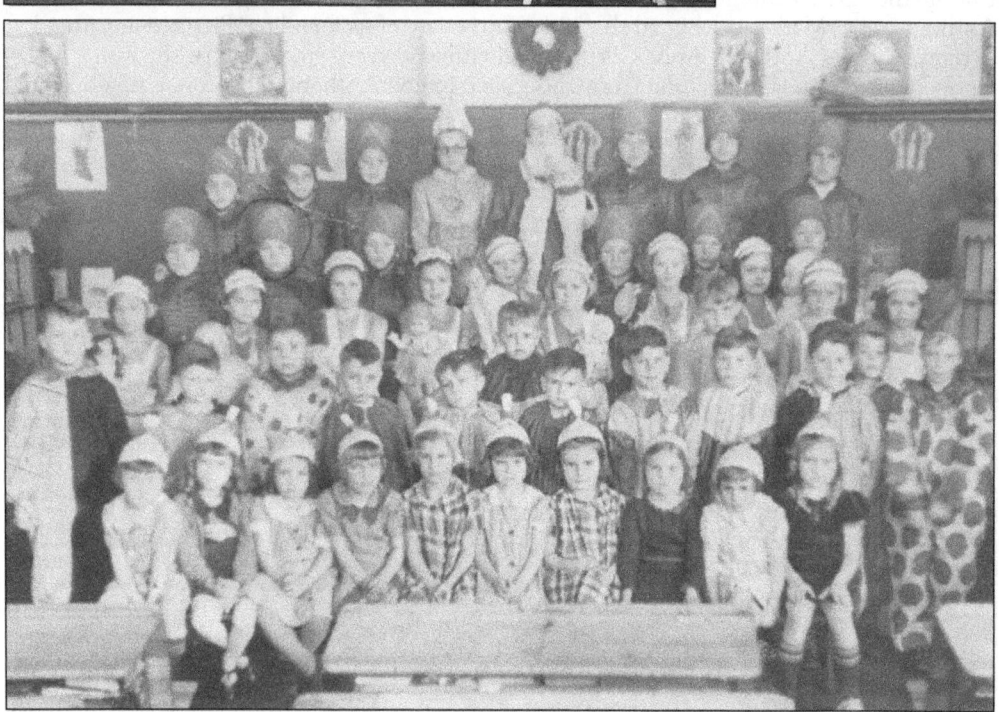

The students of the Lincoln School performed this Christmas production in 1937. The only student who pursued an acting career was John Tamashunas (stage name Jack Tamas), the toy soldier to the right of Santa. John graduated from FHS in 1944, served in the Korean War, and attended Dennison University in Ohio. He has had character parts on *All in the Family*, the *Red Skelton Show*, and the *Danny Kaye Show*, and was under contract to CBS for seven years.

Iron Mike Kushwara (left) squares off against opponent Pete Suskey with former world heavyweight champion Jack Dempsey (center) as referee at the Wilkes-Barre Armory on February 3, 1931. Mike lost by a TKO when his shoulder clicked out and Manager Al Janetti jumped into the ring to call off the fight. Note Dempsey's autograph at right bottom.

BEQUEST

I'd like to think when life is done
That I worked hard but had great fun
In helping people get to know
About our Borough long ago.
Old Frackville Tales was just the start
Of future plans dear to my heart.
So files and pictures — an historian's treasure,
Are set for research, reminiscing, and pleasure.

—by Lorraine Stanton

"Jacob Pauly was a First Defender with the longest Civil War service record in the anthracite region. On the same day upon which the news was flashed to Schuylkill County that the South had opened a great conflict at Fort Sumter, he pledged himself to enlist. When the recruiting office opened in response to Lincoln's call for volunteers, his name was among the first on the roll."

FRACKVILLE CIVIL WAR VETERANS

PENNSYLVANIA VOLUNTEERS

Jacob Pauly, Co. E, 5th Regiment
Daniel Reicheldifer, Co. A, 48th Regiment
Charles C. Wagner, Co. B, 19th Regiment
 and Co. E, 27th Regiment
Joseph Guinther, Co. C, 116th Regiment
James Beggs, Co. D, 14th Regiment
Jacob Rubrecht, Co. D, 167th Regiment
Otto Speidel, Co. D, 186th Regiment
Frank Klees, Co. E, 6th Regiment
 and Co. G, 129th Regiment
Henry H. Price, Co. A, 48th Regiment
*Benjamin Bixler, Co. F, 173rd Regiment
William Fennel, Co. G, 16th Regiment
John Mengel, Co. G, 167th Regiment
William W. Wertz, Co. I, 95th Regiment
Benjamin Dillman, Co. I, 151st Regiment
Daniel Dillman, Co. I, 151th Regiment
Alias Fenstermacher, Co. K, 16th Regiment
Andrew Calahan, 48th Regiment

PENNSYLVANIA CAVALRY

Samuel Winn, Co. F, 7th Regiment
Samuel Kramer, 7th Regiment
William Breslin, Co. F, 7th Regiment
Reuben Wagner, Co. L, 1st Regiment
Peter Yoder, Co. C, 167th. Penna. Infantry
Richard Morgan, asst. engr. on the
 U.S. Navy ship *James Adger*
Joseph F. Seaman, served at the capture
 of Atlanta

Sgt. Paul L. Berger graduated from FHS in 1944. He was considered missing in action on March 24, 1945, was awarded the Purple Heart, and later declared dead. The statue in front of the Memorial Monument at Frackville Memorial Park was presented in his honor by the Class of 1944. The following is a list of Frackville's deceased in our country's wars.

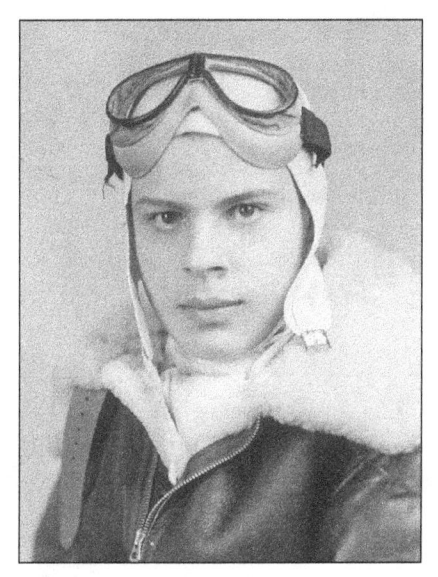

In Memoriam
No Greater Love Hath Any Man than This—
That a Man Lay Down His Life for His Friends

World War I
Kowker, Anthony J.
Scott, Kenneth J.
Samkavitz, Anthony
McGinnis, Bernard
Coxon, Harry Allen
Curry, James Francis
Groff, Oscar
Kostishak, Michael
Kuhutick, Wassel
McAndrew, John
Murphy, Walter A.
Stank, Joseph
Crane, John W.

World War II
Harris, William E.
Seaman, Edward
Stevens, Samuel
Olshalsky, Stephen
Webb, Joseph
Stefanic, Michael
Boner, Francis
Hahn, George
Mucha, George
Harris, Thomas
Atkins, Levi
Burns, Leo
Supernavage, Edward
Panchison, Michael
Moyer, Philip
Polinsky, Peter
Heinly, Bertram G.
Bensinger, Howard
Eisenhart, Paul
Miller, William C.
Zelasney, Stanley
Peteritas, William J.
Davis, David M.
Zemaitis, Joseph
Berger, Paul
Urban, Andrew
Kneib, Thomas
Keysock, Paul
Hartz, Edmond J.
Polinsky, Michael
Williams, Ted
Holowaty, M.
Monroe, Robert
Snyder, Paul M.
Geary, Albert
Bogden, William
McLaughlin, Thomas
Misunas, Anthony
Novick, Leonard
Williams, Manetho
Chrin, Stephen
McGrath, Martin
Polinsky, John
Comac, Peter
Murdock, Charles
Shervilla, Albert
Griffiths, John
Thomas, Russell
Howachyn, Michael
Fellows, Robert
Curry, Francis X
Naydock, Samuel
Johnson, George W.
Andrews, Donald
Andrews, George
Mallick, Stephen
Semrod, Gordon
Timmins, Warren
Stefanick, Nicholas

Korean War
Michael Tartar
Leonard Bendinsky
John Dzienis
Wayne R. Caton
Joseph S. Purcell
Ralph A. Miller
Andrew Barokoskie
Allen Sherry
Vernon Sherry

Vietnam War
Stephen C. Brisuda
Paul F. Kostick
John J. Farnsworth

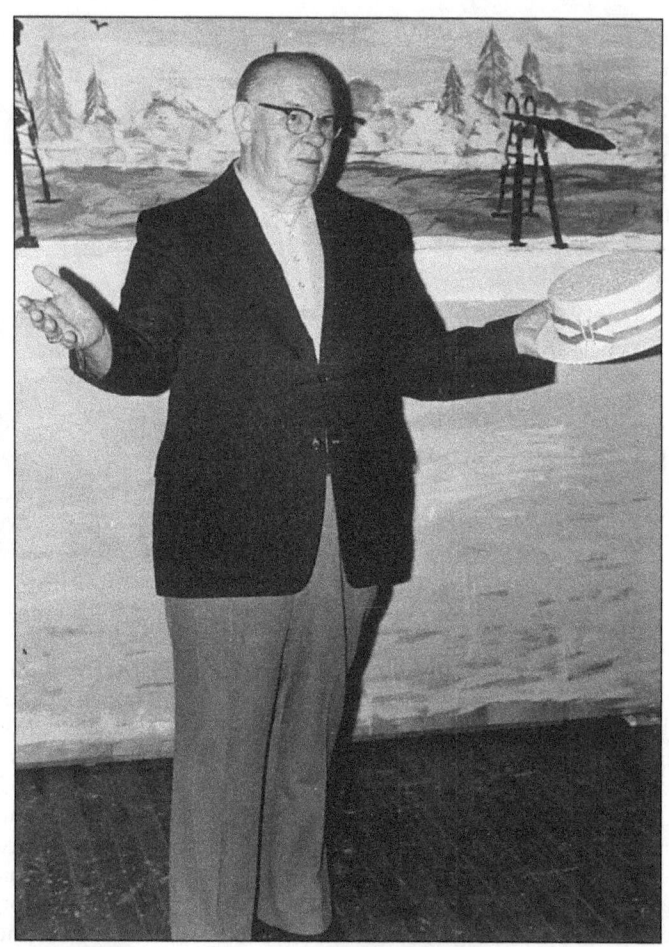

Frackville has received many compliments in its 100 years. None came with more drama than when Rev. Walter Hengen took stage at the 1979 Spring Splash for the new pool fund, when he stole the show with a song parody entitled "That's What Frackville Means To Me." It went like this:

The town I live in,
A town that's clean and neat,
The grocer, milkman, baker
And the people that I meet,
The children on the playgrounds,
The faces that I see,
All races, all religions
That's what Frackville means to me.
The place we work at,
The workers by our side,
This wondrous town of Frackville
Where our people lived and died,
The mayor and the council,
Well serving you and me
The howdies and the handshakes
That's what Frackville means to me.

The things I see about me,
The big things and the small,
The cops that guard our children
And the doctors at our call,
The weddings in our churches,
The laughter and the tears,
The town that's been a good town
For over a hundred years.
This town we live in,
The stores, the clock, the pool
Our youth who need to have fun
But who must obey the rules,
The churches, schools, fraternities,
The blessings that I see,
But especially the people,
That's what Frackville means to me.

www.ingramcontent.com/pod-product-compliance
Lightning Source LLC
Chambersburg PA
CBHW080856100426
42812CB00007B/2054